TIBETAN
FURNITURE

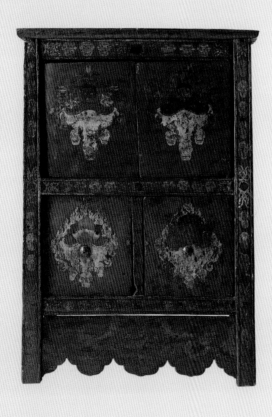

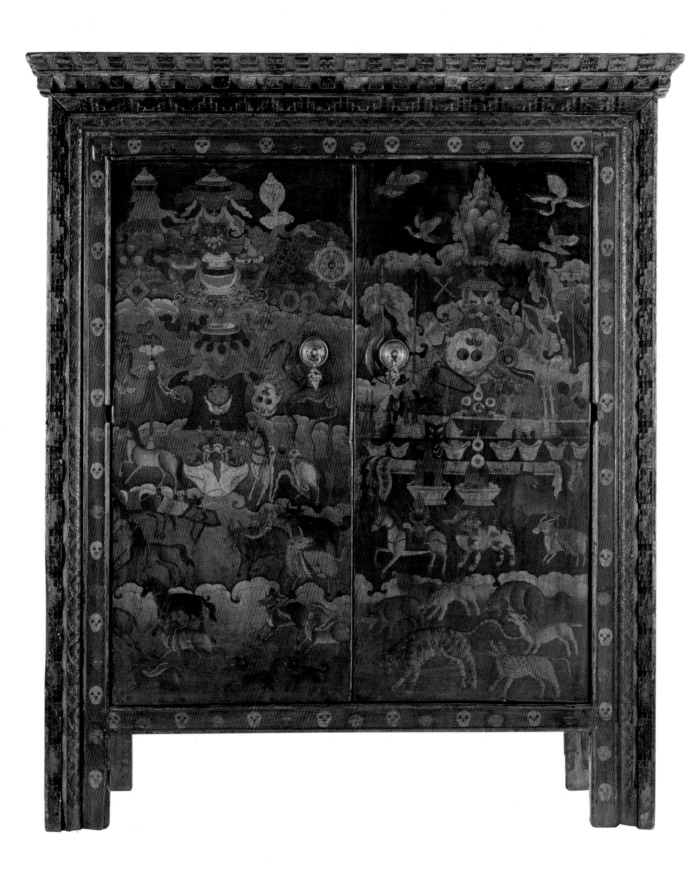

TIBETAN FURNITURE

CHRIS BUCKLEY

FLOATING WORLD EDITIONS

First edition, 2005

© 2005 by Chris Buckley and published by Floating World
Editions, Inc., 26 Jack Corner Road, Warren, CT 06777. Protected
by copyright under the terms of the International Copyright
Union; all rights reserved. Except for fair use in book reviews, no
part of this book may be reproduced for any reason by any means,
including any method of photographic reproduction, without per-
mission of Floating World Editions, Inc. Printed in China.

10 09 08 07 06 05 8 7 6 5 4 3 2 1

ISBN 1-891640-20-8

Library of Congress Cataloging-in-Publication data available

Jacket front: Offering cabinet dedicated to a fierce Tibetan deity,
18th or 19th century; p. i: Offering cabinet painted with a vari-
ety of offerings to fierce deities, 18th century; p.ii: Offering cabi-
net decorated with offerings to Palden Lhamo and Pehar, 19th
century; p.iii: Detail of painted tabletop with flying horse and
qilin amidst waves, 19th century; p. iv (below): A free-standing
prayer wheel in a decorated surround, with images of the Three
Protectors of Tibet and other deities; jacket back: Painted wood-
en chest, circa 16th century.

All photographs by Chris Buckley.

ACKNOWLEDGMENTS

A great many people have helped in the research and preparation of this book. In Lhasa I would particularly like to thank Chili, She La and Tom Me, Tenzin Norbu, and their families for their hospitality and for sharing their advice and experience with Tibetan furniture old and new. Conversations with them and with others in Lhasa provided me with a great deal of insights and leads to follow up on in my travels around Tibet, many of which I was later able to confirm at first hand.

I am grateful to John Vincent Belleza and Philip Denwood for reading the draft manuscript and providing detailed comments and perspectives that helped me to write a better book. John Vincent Belleza provided valuable information on indigenous Tibetan traditions and helped open my eyes to the wider context of Tibetan culture. Philip Denwood applied his formidable knowledge, particularly to the section on Tibetan motifs and symbols. I have benefited greatly from their experience and scholarship. Any errors that remain in the text are fully my responsibility.

I would like to thank the following people for graciously allowing us to photograph fine examples of Tibetan furniture from their collections: Li Jian Guang and Bu Lan, Handel Lee, Zheng Ke Feng, Rachel Speth and Jeffrey Delkin, Paige Mushinsky and Mark Budden, Karma Dorje, of Shop 3 on the Barkhor, and San Lun. This material forms the bulk of the examples of furniture in the second part of this book.

I would also like to thank my wife and partner, Shelagh, who read and corrected this manuscript more times than I care to recall, and who kept me going with constant encouragement and the occasional kick.

In addition to firsthand experience, I have been fortunate in being able to draw on a great deal of recent scholarship on Tibet and its unique artistic tradition. The following works and their authors deserve special mention (see also Recommended Reading).

ON TIBETAN PAINTING AND DESIGN

Wisdom and Compassion: The Sacred Art of Tibet, by Marylin Rhie and Robert Thurman
Worlds of Transformation: Tibetan Art of Wisdom and Compassion, by Marylin Rhie and Robert Thurman
Tibet: Tradition and Change, by Pratapaditya Pal, et al.
Tibetan Art: Tracing the Development of Spiritual Ideals and Art in Tibet, by Amy Heller
Tibetan Symbols and Motifs, by Robert Beer
The Tibetan Carpet, by Philip Denwood
Tibetan Art: Towards a Definition of Style, edited by Jane Casey Singer and Philip Denwood

These works provided the benchmark for understanding the evolution of Tibetan painting styles and the Tibetan decorative tradition. The first three were particularly helpful in providing examples of the complex Host-of-Ornaments designs found on some Tibetan offering cabinets.

ON CHINESE AND CENTRAL ASIAN TEXTILES

When Silk Was Gold: Central Asian and Chinese Textiles, by James Wyatt and Anne Wardwell
Treasures in Silk: An Illustrated History of Chinese Textiles, by Feng Zhao
Heaven's Embroidered Cloths: One Thousand Years of Chinese Textiles, by Chris Hall, et al.

These works and others on Chinese and Central Asian textiles provided cross comparisons and allowed the construction of a rudimentary chronology for many designs from the region. They were invaluable in helping to sequence and in attempting to date many Tibetan furniture designs.

On Tibetan furniture

Tony Anninos's articles in *Arts of Asia* entitled "Tibetan Furniture" and "Painted Leather Boxes," published in 1997 and 2000 respectively, were also a source of inspiration. Tony Anninos was the first to highlight the connection between Chinese textile designs and Tibetan furniture designs, a connection which provides benchmarks for understanding and dating many Tibetan decorative motifs.

And finally, of course, I would like to thank the source of these wooden creations that so delight and intrigue us: the many anonymous Tibetan furniture makers and artists whose works of beauty and wonder, spanning seven centuries or more, fill the pages of this book.

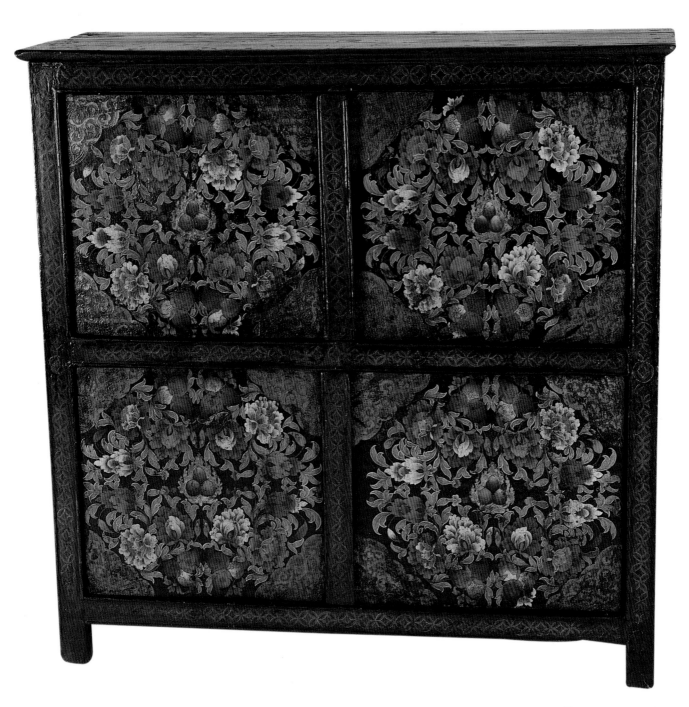

CABINET DECORATED WITH AUSPICIOUS DESIGNS OF FLAMING JEWELS, FLOWERS, AND FRUIT, WITH A COIN-MOTIF BORDER. 18TH CENTURY.

INTRODUCTION

Over the past decade a great quantity of beautiful and surprising antique furniture has come out of Tibet, much of it finding its way through Nepal and China and eventually into private collections in Asia and in the West. This trade has brought to light a tradition which was previously almost unknown outside of its own native land. On encountering this furniture, initially in the antique trade in Hong Kong and later in the company of one of Beijing's leading enthusiasts and collectors of Chinese and Tibetan furniture, Li Jian Guang, I was captivated both by the intricacy and variety of the designs and by the richness of the colors. Many of the pieces of furniture I saw were also very old, with a significant number apparently dating to the seventeenth century or even earlier. The great age of some of these objects is particularly exciting since in most other cultures it is rare to find furniture that is more than a couple of hundred years old.

Thus a region that was remote and not noted for its wealth seemed to have been the source of a dazzling tradition of furniture-making and decoration. The examples I saw encouraged me to return to Tibet to look for furniture in its original locations and to find out what it was used for, and to try to discover why such a rich tradition appeared in this apparently inhospitable region. At the same time I collaborated with Li Jian Guang and other collectors to find and photograph some of the better examples in private collections and to place them in their Tibetan context. This book is the result of that effort.

This is a unique time in the history of Tibetan furniture. Several factors have come together to make this book possible that will probably not occur again. Tibetans value their painted furniture highly, but they do not have a strong reverence for age and for antiques for their own sake, and the cash offered by furniture dealers provides a strong incentive to sell. As a result Tibetans are often willing to part with older furniture items at the same time as refurbishing their homes and

temples with the newly made items that they prefer. There is a healthy and growing business within Tibet making and painting new furniture, including some items of very high quality. Workshops in Lhasa and elsewhere are producing new carved and painted woodwork, some of which is of a very high quality, both for religious and for household use. Older pieces that are still in their original locations are becoming increasingly scarce, however; a great many have already been scattered to homes and collections in the West. This provided another motivation to record this tradition while some older items are still with their Tibetan owners.

Traditionally, the romantic view of Tibet has been that of a land which stands apart, cut off from the outside world. The artistic and cultural output of Tibet, including its furniture, tells a different story. Tibetans are a people with a unique identity who have nevertheless been open to ideas and styles from many different parts of Asia, especially India, Central Asia, and China. The people who created and used the furniture in this book were cosmopolitan in their tastes and familiar with the sophisticated artistic products of neighboring countries. Some Tibetans achieved positions in which they commanded considerable wealth and power, either through trade or business or through their positions in the great monastic institutions. Their choices of furniture reflected their tastes and their outlooks on life.

The echoes of contacts with peoples all over Asia can be traced in the designs found on Tibetan furniture, recording a complex history of cultural and trading exchange. In recent centuries the dominant artistic force has been China and the influence of Chinese decorative arts is a constant theme running through painted Tibetan decoration from the sixteenth century onward. Despite this influence Tibetan artisans rarely copied designs precisely; rather they adapted and modified the motifs and the decorative styles they saw to suit their own ends, so that Tibetan furniture cannot be mistaken for or confused

FACING PAGE: OFFERING CABINET DEPICTING VALUABLE TEXTILES, SILVER INGOTS, BOWLS OF GEMS, AN ASS BEARING A FLAMING JEWEL, A SNOW LION, AND VARIOUS WILD BEASTS, COLLECTIVELY PRESENTED AS A SYMBOLIC OFFERING TO THE PROTECTOR GOD PEHAR. 19TH CENTURY.

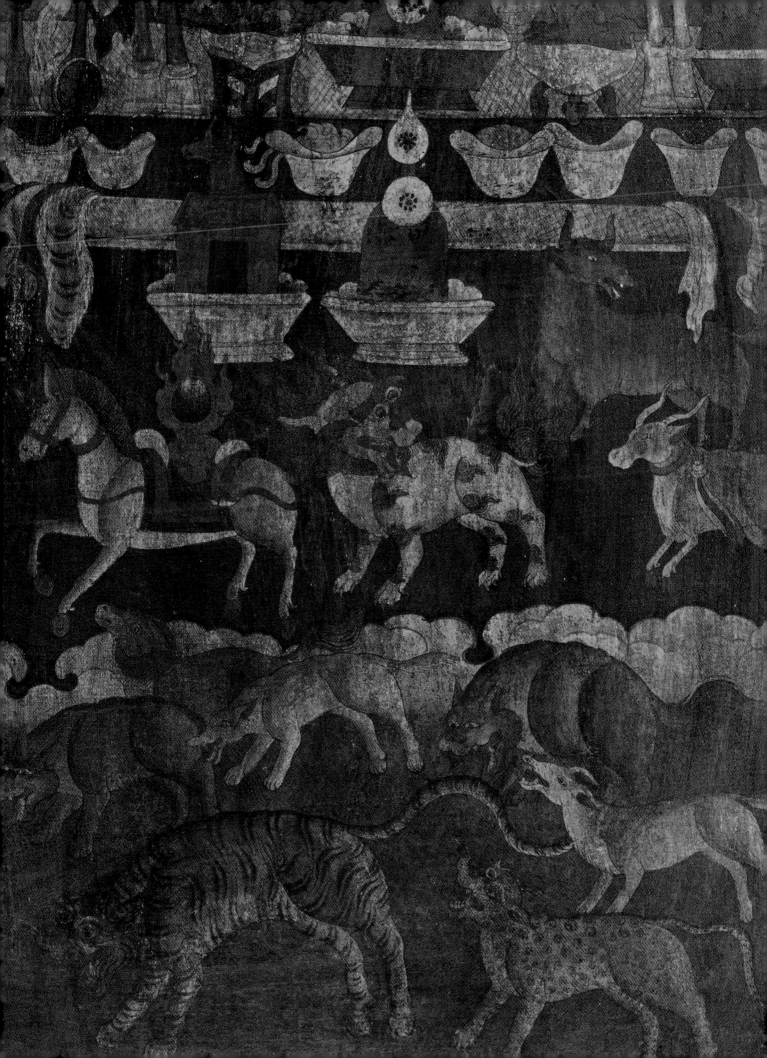

with work from other cultures. It also includes a greater variety of designs and motifs than in many other Asian traditions, perhaps because of the varied influences and long history.

HOW THIS BOOK IS ORGANIZED

The first four chapters of this book explain the forms and uses of Tibetan furniture, the construction and decoration of the main types, and the history of some of the designs. The final, and largest, chapter presents selected examples with descriptions that expand on some of the themes from earlier chapters. The examples I have chosen illustrate the range of types of furniture in Tibet and the range of decoration, both painted and carved. In most cases I have chosen them mainly for their beauty, though I hope that this book is more than just a catalogue of attractive pieces.

I have included examples of all the main furniture types in this book; however, in terms of total numbers my choices are biased towards chests. This is partly because I have a personal fondness for chests and partly because this type of furniture was produced over a longer period in Tibet than most other types. The broad rectangular face of a wooden chest is a canvas on which Tibetan painters were able to give full rein to their talents and in doing so they recorded the changing history of Tibetan decorative styles.

ESTIMATING THE AGE OF TIBETAN FURNITURE

As I have attempted to put dates to the selected furniture pieces I have shown, some words of explanation and caution on this topic are necessary. All dates given to furniture, in common with most other works of art, are estimates. There is no absolutely reliable method for dating furniture, particularly since it tends to change hands and change location during its useful life.

Nevertheless, when looking at any historical object the first question we generally ask is "How old is it?" This is important because viewing and handling objects from daily life are among the most direct ways in which we can make contact with bygone eras. However, everyday life is not kind to objects in daily use such as furniture. This is why ancient furniture from, for example, five centuries ago is much more difficult to find than Chinese tomb ceramics from much earlier periods. The tomb ceramics have laid in the ground untouched and may be in pristine condition when they emerge, whereas the survival in reasonably good condition of an item of furniture used daily is a game of chance in which the odds get longer as time passes. As a result, from a personal standpoint I view a Tibetan chest that appears to date to the fifteenth century with greater awe than many a pot unearthed from far earlier times.

The only objective methods available for dating wooden furniture are radiocarbon dating and dendrochronology (dating via the study of tree growth rings). Radiocarbon dating has been tried several times on Tibetan furniture, although the most that this technique can do is give an approximate date when the tree that was used to make the boards was felled. Given the Tibetan habit of saving and reusing old timber, the dates that these methods give must be viewed with caution.

Despite these difficulties there are other clues that can be used to establish an approximate chronology for Tibetan furniture and make estimates of when items were made. The condition of a piece is not a particularly useful guide, except insofar as some ancient surfaces such as crackled paint are difficult to copy convincingly, so condition can be a useful means of spotting modern copies. Construction and finishing technique are far more useful, however, and can give valuable indication as to when a particular piece of furniture was made. Items that were made during the nineteenth and twentieth centuries, when furniture was being made in larger quantities in Tibet, often show signs of techniques used to simplify and streamline production, such as the use of gesso for outlining designs and the use of gold paint in preference to the more demanding gold leaf technique. Complex Chinese-style cabinetry techniques were also adopted relatively recently in Tibetan furniture-making history, so that these features make it relatively easy to spot many nineteenth and twentieth century furniture items, which are also the most abundant in Tibet.

Decorative details are also a valuable source of clues as to date of manufacture. Decoration on all types of objects, including furniture, paintings, ceramics, and textiles, follows changes in style and fashion over time, and Tibetans enjoyed and participated in these fashions.

Though there is no established chronology for Tibetan furniture to draw upon it is nevertheless possible to compare with works in closely related and better-studied fields in order to make reasonable guesses.

A promising future source of information on the dating of furniture may be the furniture shown in Tibetan paintings. A couple of examples are included in this book, though this area has not yet been researched in detail. One challenge is that Tibetan artists tended to paint idealized or even fantastic furniture shapes in their paintings and it is difficult to disentangle what is real from artistic license.

Taking all these issues into account, the dates that I have given in this book are estimates based mainly on construction method and style of decoration. I have compared furniture designs with the better-understood field of Tibetan *thangka* and mural painting styles and the field of Chinese decorative arts, where a large amount of well-documented material is available. Because of the uncertainties of basing dates on style, however, a substantial margin for error applies. In each case my suggested date should be understood as a best guess. In many cases, particularly with older items, it is reasonable to assume that the true date might lie a century or more on either side of my estimate; thus in a case where I have estimated that a particular item is from the seventeenth century, a range of sixteenth to eighteenth century may be plausible. I am sure that some estimates will need to be revised as more information and material become available for study.

THE DECORATED SIDE PANEL OF A CHEST SHOWING A SCENE FROM A FORMAL GARDEN, WITH ROCKS, PLANTS, AND EXOTIC BIRDS. THIS TYPE OF SCENE INSPIRED BY CHINESE ART IS SOMETIMES FOUND ON FURNITURE FROM THE EASTERN SIDE OF TIBET, WHERE THE INFLUENCE OF CHINESE STYLES IS STRONGEST.

LAND AND PEOPLE

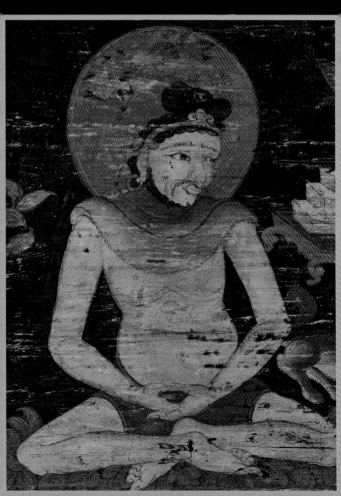

How did Tibet come to produce such striking and unique furniture? At first sight it seems an unlikely place to give birth to such a tradition. Tibet is a high plateau ringed by mountains, with a harsh dry climate over much of the central and western parts (fig. 1) and with extensive tree cover only in the east and parts of the south. The average height of the plateau is around 4,000 meters; except for some farmland in the valleys most of it provides little more than sparse grazing. It has never been densely populated and today it has just a few million people distributed over an area larger than Western Europe. Most Tibetan settlement is concentrated in the valleys in the southern and eastern parts of the plateau, where there is relatively good farming land. The population of the higher parts of the plateau was traditionally limited to nomadic herders.

Today "Tibet" is synonymous with the Tibetan Autonomous Region, part of the People's Republic of China. Yet the area that is culturally Tibetan extends further and includes parts of the surrounding Chinese provinces of Sichuan, Yunnan, and Gansu to the east and Qinghai to the north. There are also Tibetan "kingdoms" to the west in Ladakh (part of India) and to the south in Bhutan and Mustang (part of Nepal). In all these areas dwell people who are recognizably Tibetan, speaking dialects and variations of the Tibetan language and using Tibetan-style furniture. The cultural and linguistic variations between these parts are often quite striking, however. For example, a Tibetan speaker from the central regions may have difficulty understanding a fellow Tibetan from an eastern region.

As a result of the dry climate and the generally high altitude, wood for furniture and building material has always been a scarce and precious resource in Tibet, particularly in the central and western regions, where fewer trees grew. There is evidence of this, for example, in old records of disputes between monasteries over the rights to cut timber. Today the only parts of the Tibetan plateau with substantial forests are the valleys on the eastern and southeastern edges of Tibet, which are lush and green. These areas have supplied timber for hundreds of years and they have a continuing tradition of forestry and woodworking.

Nowadays larger pieces of timber for making furniture or building houses often have to be hauled over long distances. Once while walking in Mustang, part of present-day Nepal, I caught sight of a huge, swaying bundle of timber on the steep mountain track. As I got closer I could see that there was a Tibetan man underneath, bent double with the weight. He told me that the timber was to be used for building a new house. He had already been carrying the bundle on his back for two days from the nearest paved road and he told me that he would need at least one more day to reach his destination. This is a story often repeated in the remoter parts of the Tibetan plateau, and illustrates why wood was regarded as a precious resource in much of Tibet, to be conserved and reused whenever possible.

Scarcity of wood lies behind one of the special features of Tibetan furniture. The wood used is usually of indifferent quality and often includes recycled pieces. Instead of focusing on making items from precious hardwoods like their counterparts in other parts of Asia, Tibetan furniture makers instead displayed their talents through the medium of surface decoration, including carving and painting. The results they attained from indifferent beginnings in materials are often astounding.

TIBETAN RELIGION

The twin driving forces behind artistic creation in Tibet were the desire to make beautiful objects for practical use and for religious devotion. Many objects were commissioned so that they could be given as donations to the monasteries and temples. This generated merit for the donor as well as practical benefit to the institutions. This aspect goes some way to explaining the richness of Tibetan arts and the care and attention put into decorating many items with an everyday function, such as a a tea table or a chest for storage. Another consequence of the close connection between religion, the monasteries, and daily life is that an understanding of Tibetan religious beliefs, at least at a basic level, is one of the keys to understanding Tibetan arts and culture. In the case of furniture the uses and decoration of some important types are intimately related to religious beliefs, even when the item is used in the home.

1. Skies over a monastery in Ladakh, on the Tibetan plateau.

Tibetan Religion

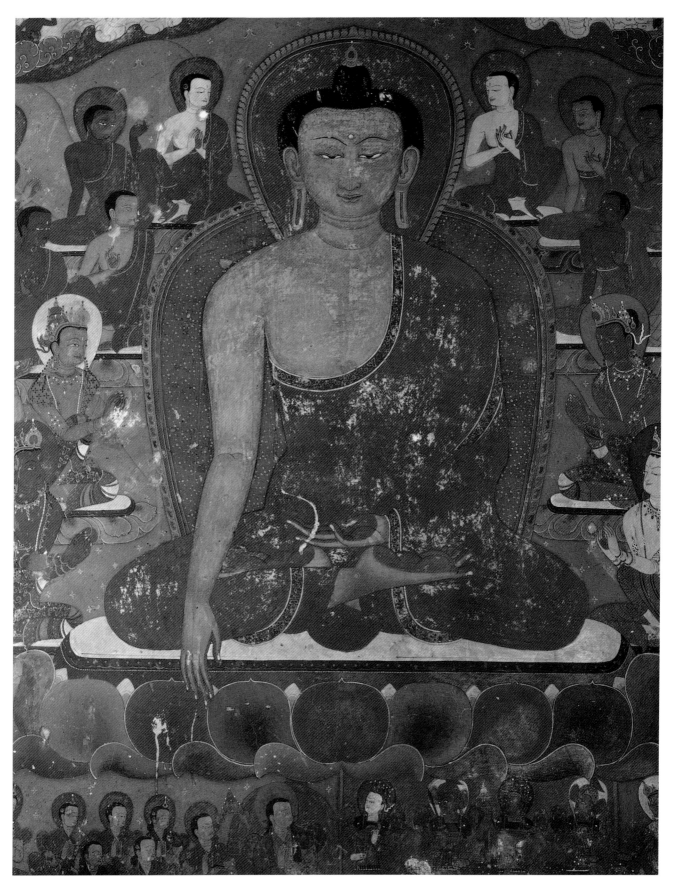

2. Mural of the Buddha surrounded by adoring disciples and bodhisattvas, Shalu monastery, central Tibet. 14th century.

Tibetan religion can be difficult to grasp because of its enormous panoply of strange deities and unfamiliar ideas. All religions tend to incorporate some mysticism and obscurity in their attempts to express the inexpressible, which makes the task of understanding them even harder. In this chapter I provide a brief account of some of the main Tibetan beliefs and their origins. As well as being helpful for understanding how religion is practiced, this is also important for understanding how Tibetan society is structured. This in turn helps explain the uses to which Tibetans have put their furniture. It also helps to place in context many of the decorative themes found on Tibetan furniture. The common thread that runs through Tibetan life is the connection of the spiritual with the mundane that can transform acts of everyday existence into religious expression.

Tibetan religious practices and beliefs come from a variety of sources. The dominant religion today is a variety of Buddhism, a religion that has its origins in northern India. In parallel with Buddhist concepts there is also a rich variety of belief and folklore that originated locally in Tibet and that is intermingled with the more orthodox version of the faith

TIBETAN FOLKLORE AND PRE-BUDDHIST RELIGION

Tibetans, particularly in rural areas, regard their lives and landscape as being populated with spirits and gods of various kinds. Much local folklore and ritual are associated with the driving away or propitiating of these spirits. These practices, together with the stories that accompany them, have their origins in Tibet and still form an important part of religious belief, existing in parallel with the more organized forms of religion.

Many of the decorative designs on Tibetan furniture also have their origins in local culture and beliefs. Since the ascendancy of Buddhism to a dominant position in Tibet, however, the interpretations of these designs have tended to be given a Buddhist gloss, obscuring their ancient roots. Research in this area is at an early stage, though pioneers in the field such as John Vincent Belleza have made progress in identifying ancient dwellings and petroglyphs. This research has already shown that even such obviously Buddhist symbols as the

chorten (the Tibetan word for *stupa,* a reliquary structure) were present in early Bon belief and have a much longer history than previously suspected.

BON

In addition to local beliefs associated with particular places there is also an organized religion known as Bon that claims to represent the original indigenous belief system of Tibet. Like their Buddhist counterparts, practitioners of Bon maintain temples and monastic orders in various parts of Tibet. At a superficial level their temples and ceremonies look similar to Buddhist ones, though their practices differ in some respects and their fundamental texts are different. The most obvious difference to the casual observer is that Bon pilgrims circumambulate holy centers in the opposite direction (counterclockwise) to Buddhist pilgrims. Bon religious art also looks similar at a superficial level to Buddhist art and Bon deities and decoration share the same symbols (the wheel, snow lion, flaming jewel, etc.), differing in the precise attributes and gestures of the deities. The main exception to this shared symbolism is the counterclockwise rotating swastika (*yungdrung* in Tibetan) that is the key symbol of the Bon faith, as opposed to the clockwise rotating form favored by Tibetan Buddhists.

I have not had the opportunity to examine much furniture in situ in many Bon temples, not least because there are few temples surviving in an undamaged state and fewer still that retain furniture from earlier times. It is possible that a good number of furniture items in this book came from Bon temples or households; however, because of the common decorative vocabulary shared by Bon and Buddhist traditions it is not often possible to distinguish the two. One exception to this is an unusual chest with a counterclockwise swastika (see fig. 69), which almost certainly came from a Bon establishment.

TIBETAN BUDDHISM

The dominant religious force in Tibet today is a variety of Buddhism based on ancient Indian teachings but with a strong local Tibetan flavor. It is important to a discussion of furniture because it is widespread and because it maintained wealthy and impressive monastic orders until the middle of the twentieth century. These orders,

including the Gelug, Kagyu, and Sakya, were responsible for commissioning (or receiving as gifts) large amounts of furniture and other furnishings, and their tastes and beliefs have had a major influence on Tibetan furniture and decoration.

Buddhist teachings originated between 500 and 400 BC in northern India, a place with a culture and history very different from those of the Tibetan plateau. Siddhartha Gautama, who came to be known as Shakyamuni (fig. 2), developed the earliest form of Buddhist philosophy. He grew up as a wealthy prince in a noble family, but eventually renounced all his riches in favor of a life of meditation and search for truth. His teachings offered his followers guidelines for living a virtuous life and a means of coming to terms with the hardships experienced along the way.

Shakyamuni is commonly referred to as the Buddha, though many other enlightened individuals are also referred to as Buddhas in the Buddhist tradition. The goal of most Buddhists is to reach enlightenment in the same way that Shakyamuni did. This may be achieved in one lifetime or take many lifetimes to attain. Connected with this is the notion of gaining merit through virtuous deeds such as gift giving, pilgrimage, and prayer, which can help with progress toward enlightenment by ensuring a favorable rebirth.

From the earliest times Buddhist followers founded monasteries. These were communities whose residents attempted to emulate directly Shakyamuni's life, renouncing personal material wealth and devoting themselves to study and meditation. Lay followers, who were believers in Buddhist teachings but maintained secular lifestyles, supported them. In this way two different paths were made available to Buddhist followers, one the path of a monk or a nun, the other being the path of the lay believer who gains merit by supporting the communities of monks with gifts and alms. These two ways of life are still an important feature of nearly all Buddhist societies today. They also define the very structure of Tibetan society. The culture of gift giving in particular is the basis of many of the lavish furnishings of Tibetan monasteries.

Three different main strands of Buddhism exist today in different regions of Asia. They are known as: Theravada (sometimes called Hinayana), Mahayana,

and Vajrayana (more commonly known as Tantric Buddhism). The type of Buddhism adopted by Tibetans was the form to develop last, Tantric Buddhism, which is nevertheless built on a foundation of common ideas that are shared with the other two branches. It is helpful to look at all three types to understand the religion that most Tibetans follow today.

THERAVADA

The school of Buddhism that claims to represent the earliest Buddhist teachings is called Theravada. Its texts consist mainly of teachings attributed directly to Shakyamuni and his immediate followers. One of the most important legacies of this school is a set of rules for monks and monasteries. These rules form the foundation for Tibetan monastic life as well as for Buddhist monastic communities in other parts of Asia. The Tibetans eventually developed what were probably the greatest of all Buddhist monastic institutions (fig. 3).

The Theravada school also recorded the story of Shakyamuni's life and his attainment of enlightenment (Buddahood), which still serves as a model for followers everywhere. These fundamental stories and teachings form a large part of the introductory courses of study for novice Tibetan monks.

MAHAYANA

The second type of Buddhism is called Mahayana, literally the Great Way. Mahayana teachings added new ideas to the earlier teachings, one of the most important of which is the concept of the bodhisattva. Bodhisattvas are beings who are fully enlightened but have chosen to dedicate themselves to helping others rather than passing into Nirvana, a realm beyond the cyle of death and rebirth. Mahayana Buddhism also posits the new idea that Buddhist followers must work and pray for the enlightenment of all mankind rather than just their own enlightenment. Meritorious deeds can benefit everyone. These can include giving alms to monasteries, building stupas and temples, reciting prayers and even visiting and walking around sacred places, giving rise to the idea of the Buddhist pilgrimage.

Of the three strands of Buddhism, Mahayana Buddhism spread the furthest from its origins in India, traveling along the northern Silk Road from the first

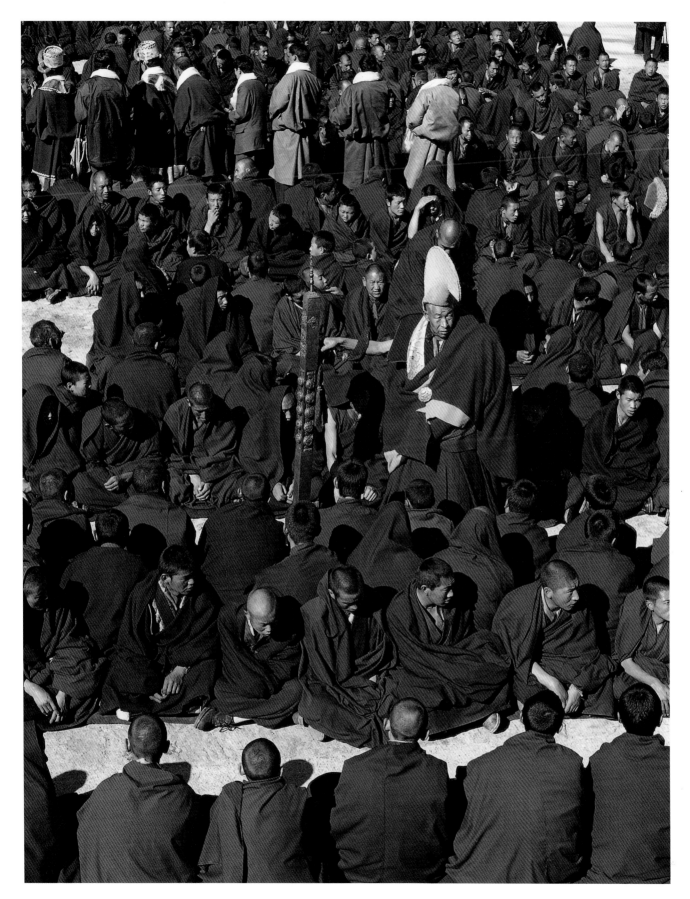

3. Monks at Nechung monastery near Lhasa, receiving alms from townspeople during a ceremony at Tibetan New Year.

Mahayana

7

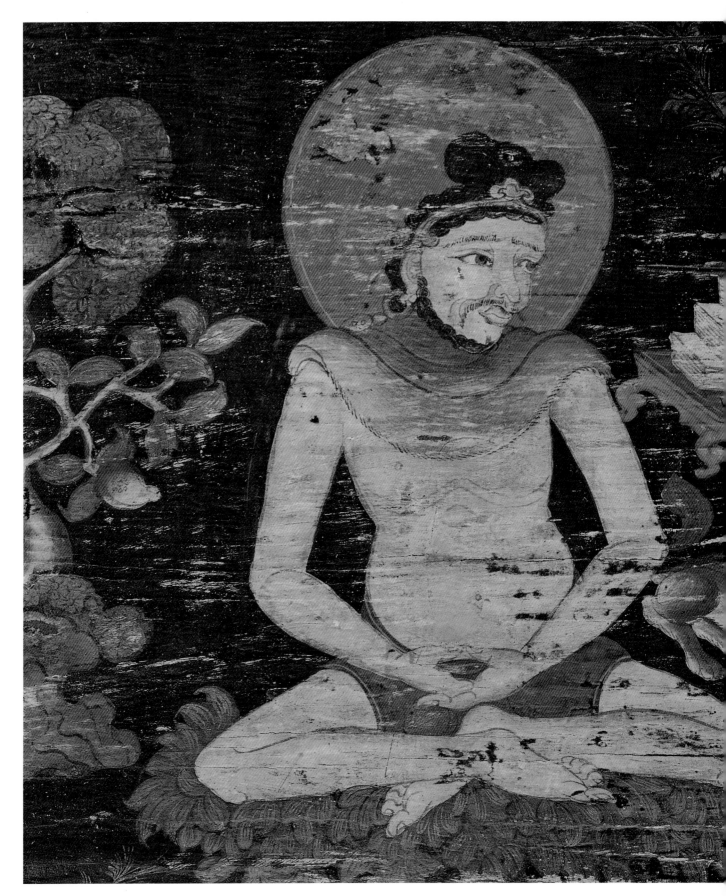

4. An Indian sage in meditation in an open-air setting, one of a trio painted on a Tibetan chest. 17th or 18th century.

century onward and finding converts in Central Asia, China, Korea, and Japan. It is still the dominant form in Vietnam and China. Mahayana ideas are also fundamental to Tibetan Buddhism. The bodhisattvas in particular are important figures in Tibetan worship, and several of them occur universally in Tibetan art. Paintings of Buddhas and bodhisattvas sometimes occur on specialized furniture types with uses related to worship, for example, on the wooden frames surrounding prayer wheels.

TANTRIC BUDDHISM

Tantric Buddhism, the variety followed by most Tibetans, is built on the foundation of the philosophy of the Theravada and Mahayana forms but adds some new methods and teachings intended to provide faster routes to enlightenment. Although some of these may seem obscure on first acquaintance, they have had a deep impact on Tibetan Buddhism and on its decorative arts, including the painted designs on some types of furniture.

Tantric Buddhism developed, like the other strands of Buddhism, in northern India. This is a region that has an ancient tradition of the lone, wandering ascetic (fig. 4) who rejects conventional society in order to meditate in the wilderness. Indian society finds a place for such wandering sages and ascetics from various religious sects and supports them even today. It was a group of these ascetics called the Mahasiddhas who developed Tantric Buddhism.

Through advanced meditation techniques these early Tantric thinkers claimed to have developed more effective and rapid routes to enlightenment than were possible under Theravada or Mahayana schools of thought. Tantric Buddhists rely in large part on study under a guru, or personal teacher, for transmission of their teachings, which are focused more on meditation and practice than on religious faith in the usual sense. This emphasis on the guru (*lama* in Tibetan) later became a central feature of Tibetan Buddhism as well.

One of the most remarkable and interesting features of Tantric Buddhism is the depiction of what appear to be fierce gods with angry countenances, sometimes surrounded by flames and scenes of violence and destruction (fig. 5), seen on certain furniture with specialized uses, as well as in paintings, on some textiles, and even

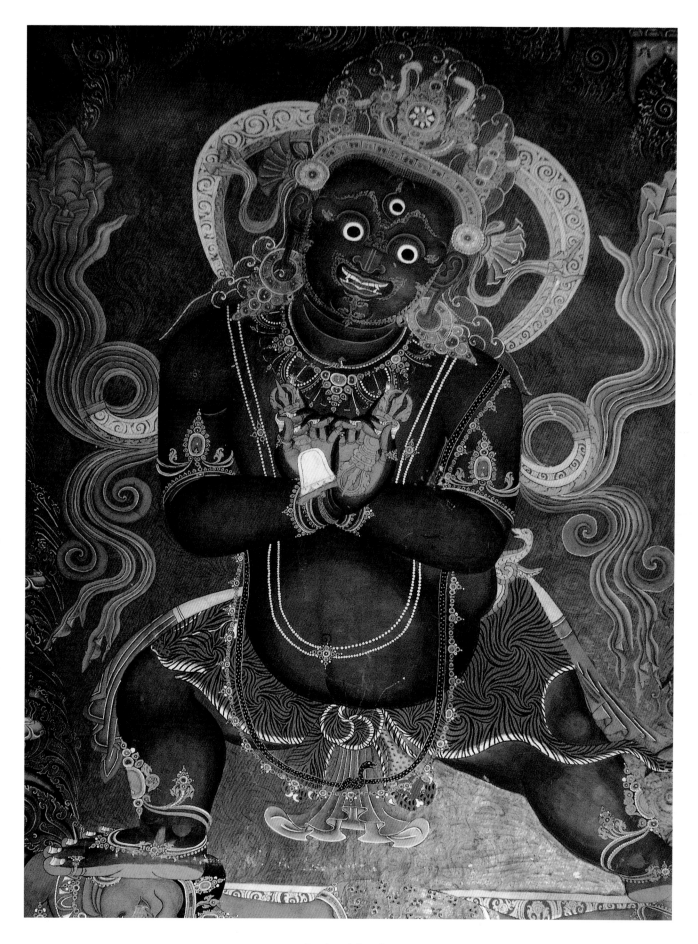

on carpets. Taken out of context these scenes are sometimes misunderstood as simply depictions of demons; in fact their meaning is more subtle. Many of these deities serve a dual function as powerful protectors and also as aids to meditation for advanced practitioners. The violent scenes are intended to assist us in developing a sense of detachment from material things, all of which are considered ultimately useless and devoid of meaning.

Tibet has a wide range of wrathful gods, some of whom represent local pre-Buddhist gods who have been tamed by Buddhism and now serve as protectors of the faithful. Furniture for use in worship of these deities, with its highly distinctive decoration, is described in a later chapter, Furniture for the Wrathful Gods.

MONASTIC LIFE

For the Buddhist faithful in Tibet there are several ways to gain merit. One of the most important ways is to become a monk or a nun and to dedicate one's life to religion. It is also considered an honor and a source of merit if a member of one's family takes monastic vows, and many families with several sons have at least one in a monastic order. Another way to gain merit is by supporting the monasteries directly, by giving alms in the form of food or money, or by helping to build new monastic buildings or donating goods such as furnishings

and carpets. As a result of this support some monasteries grew into large and powerful institutions with hundreds or even thousands of monks. They resembled small cities (see fig. 17) and naturally produced all the items needed for daily life, including a great deal of furniture both for religious and mundane use. Some beautiful furniture items were used in the private quarters of senior monks.

The monastic orders gradually acquired political and material power as well as religious authority, and over time they came to be the effective rulers of Tibet. From the sixteenth century until the mid-twentieth century one order in particular, the Gelug, dominated the religious and political life in Tibet. Monks of the Gelug order are distinguished by their crested yellow hats, one of the familiar emblems of modern Tibetan Buddhism (fig. 6).

On entering a well-endowed Tibetan temple one of the first impressions is of the richness of the decoration and the lavishness of the materials used. Gilded statues, silk hangings, elaborately worked paintings on the walls, precious objects in alcoves, and decorated furniture can all be found in temples. A large part of the furniture we have today from Tibet was originally used in the monasteries, though many of these items are similar to furniture for domestic use and it is not always possible to distinguish between the two types.

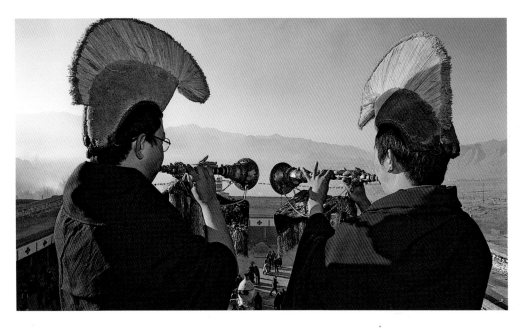

5 (FACING). THE WRATHFUL DEITY VAJRAHUMKARA, PAINTED ON A MURAL AT SHALU MONASTERY. 14TH CENTURY.
6 (ABOVE). MONKS OF THE GELUG ORDER GREETING THE DAWN AT TIBETAN NEW YEAR.

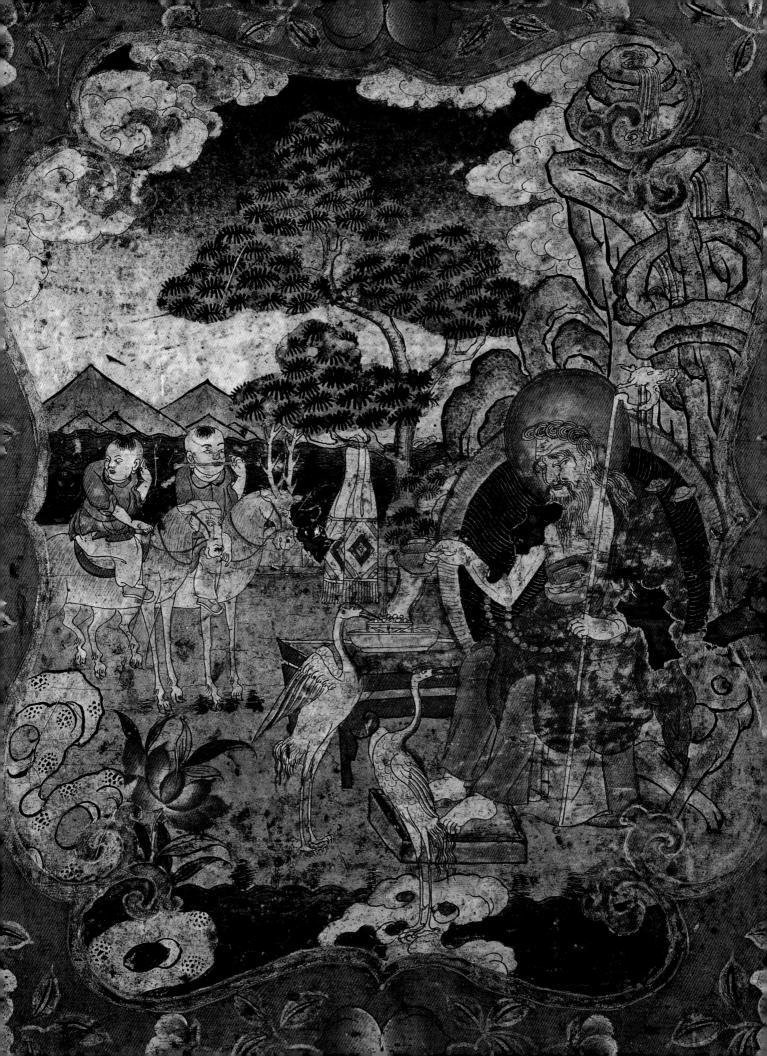

FORMS
AND USES

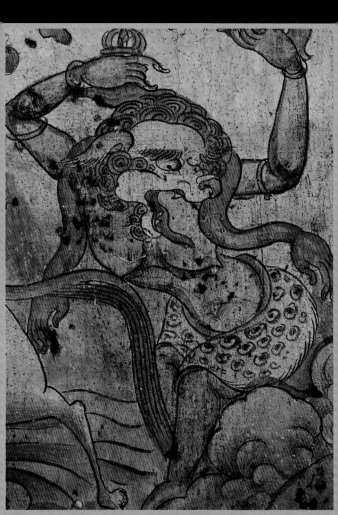

The first part of this chapter is an overview of the materials used in Tibetan furniture and the ways in which it is constructed. The second part describes the types of furniture that were made in Tibet and their history and uses.

MATERIALS
AND CONSTRUCTION

Most Tibetan furniture is fairly rudimentary in terms of its carpentry and underlying construction. Furniture was typically constructed of softwoods such as pine; hardwoods were used rarely since Tibet is poor in these species. The scarcity and value of wood in Tibet are illustrated by furniture pieces in which the wood seems to have been reused. It is quite common to see wood panels in furniture that still have traces of paint on inside surfaces, which show that they were once part of older items. Another sign of the reuse of wood is the incorporation of pieces of timber disproportionately heavy or larger than the design seems to require. In such cases, the maker has likely reused an old board in its original form rather than going to the trouble of reshaping it.

Tibetan furniture often retains the blade marks from hand shaping, especially on the inside, where the finish was not considered important. The joinery used is usually basic and most pieces were constructed with mitered joins that were sometimes reinforced with nails or external ironwork. Cross-members are joined to panels using exposed mortise and tenon joins. In a few cases protruding tenon joints are used, secured with wooden pins (fig. 7). These simple techniques were sufficient over many centuries for constructing chests, small folding tables, and reading desks. Some more complex joinery techniques were introduced from the eighteenth century onwards when larger and more elaborate forms such as cabinets were introduced.

The construction of Tibetan chests illustrates the Tibetan approach to furniture design. Chests are constructed from planks and are reinforced with metal straps at the edges and corners. In many cases the lid of the chest is attached by the simplest possible hinge arrangement of two iron rings, so that the lids have a tendency to wobble around when they are opened. This construction places a great deal of strain on the lid and hinges if they are not opened carefully or if other items are piled on top of them, with the consequence that Tibetan chests constructed in this manner typically have lids that have been repaired or replaced.

Many furniture pieces, especially wooden and leather chests, have metal reinforcing straps that strengthen joints and protect corners from wear. Ironwork seems to have been applied to nearly all wooden chests made in the central regions of Tibet as well as some older examples of other kinds of furniture, partly for strengthening and partly for decorative effect. The tradition of adding ironwork seems to have continued in chest construction for some time after it fell out of use on other furniture types.

Some chests (fig. 8) have three large iron straps on the front. They are often worked in elaborate designs and in some examples the straps extend from the base of the chest almost to the lid. They have been added more for their decorative effect than for the extra strength they give to the chest. On the sides and backs of chests the straps are often quite crudely made since the back of a chest was not intended to be seen.

Eastern Tibet had a more plentiful supply of heavier timber with which to make solid joinery. Consequently eastern Tibetan chests are often significantly heavier than their central Tibetan counterparts, and tend to have more sophisticated joinery with less ironwork.

When cabinets became popular in Tibet from the eighteenth century onwards, the frame-and-panel construction method was adopted for making this type of furniture. In this style of construction the sides and doors of cabinets are made from panels set into a sturdy frame, which was constructed in the same manner as a picture frame (fig. 9). This technique was probably learned from Chinese cabinet makers, who had been using it to make cabinets for at least eight centuries before it became widespread in Tibet.

Cabinet doors are usually hinged by the simplest possible arrangement, with pegs at the top and bottom that slide into notches, avoiding the need for external metal hinges. Again, a similar technique is typical of Chinese cabinet-making and is probably from where the

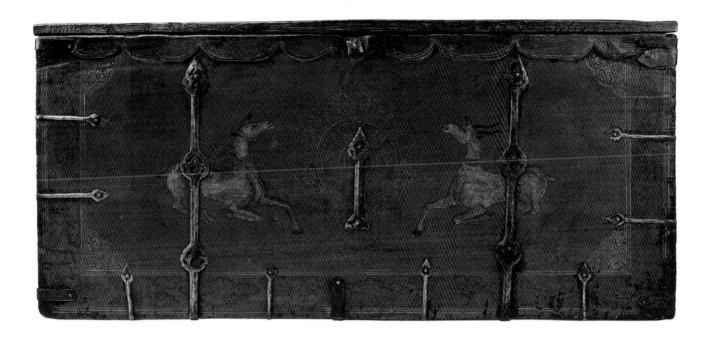

7 (BELOW). PROTRUDING TENON JOINTS HELD IN PLACE WITH PINS.
8 (ABOVE). CHEST WITH DECORATIVE IRONWORK.
9 (RIGHT). CABINET SHOWING FRAME-AND-PANEL CONSTRUCTION TECHNIQUE.

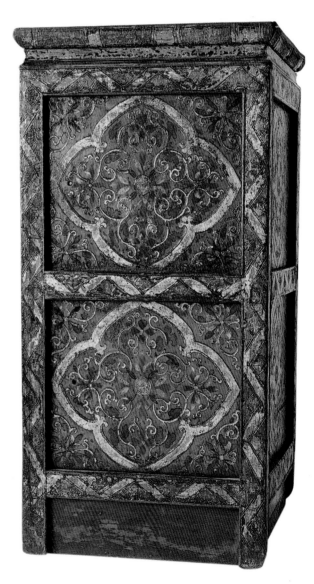

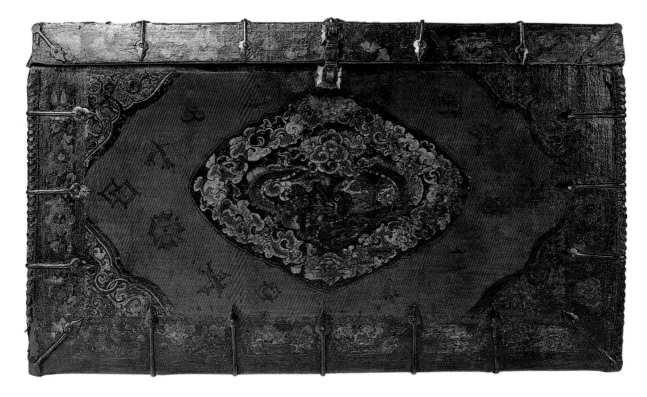

10. Wooden chest covered with fabric prior to painting, and with corners bound in leather. 14th or 15th century.

method derives. The peg-and-notch arrangement has the disadvantage that the pegs are easily broken if the door is opened too far, and consequently many cabinets have repairs to their door pegs.

REPAIRS

Repairs are a common feature of older pieces of Tibetan furniture. Sometimes furniture that was broken during use was patched with timber, but repairs using leather thongs to strengthen and bind together splintered timbers are also quite common. Tibetans had the habit of repairing and salvaging damaged furniture items whenever possible, so it pays to examine any furniture item which is offered with care to try to work out its history. Old repairs do not necessarily detract from Tibetan furniture and sometimes have an interesting story to tell in their own right. Many pieces have been repaired or repainted comparatively recently, however, prior to being sold in the antique trade.

PAINT MATERIALS AND TECHNIQUES

If Tibetan carpentry is unspectacular, it is the painted decoration that renders Tibetan furniture unique and special. Tibet has a tradition of painting that stretches back more than a millennium and that has absorbed ideas and techniques from traditions in neighboring regions, including India, Nepal, and China. It includes the painting of cloth scrolls called *thangka* and murals as well as furniture. In the case of India, Tibetans are the heirs to a tradition that is largely lost in its native country. Tibetan furniture painting uses similar techniques to *thangka* and mural painting. There are several stages involved:

Surface preparation. Wood surfaces were prepared prior to painting by applying various mixtures to seal the surface and make it smooth. In some cases these are thin undercoats; in other cases thicker coatings were applied. The mixture that was used usually consisted of filler such as clay mixed with gum. The treatments vary considerably from item to item, but thick coatings are more often found on older pieces of furniture.

For some Tibetan chests a more complex technique was used to create a surface for painting. The surface was first covered in a layer of fabric, bonded to the wood using gum. A fabric covering has the advantage of integrating the front face of a chest that has been made from

several boards and creating a flat surface. The fabric surface was then prepared by sizing it with a gesso composition consisting of clay or another filler mixed with gum. This was allowed to dry and then smoothed by burnishing with a flat stone, providing an even surface for painting. This is essentially the same technique that is used today for preparing a cloth canvas prior to painting a *thangka*. In some cases the texture of the fabric is not easy to see or is not visible at all, except in places where damage has occurred, because a relatively thick layer of size has been added before paint was applied. In other pieces the texture of the fabric can be seen clearly underneath the painted decoration (fig. 10).

In a few instances the surfaces of chests were covered with yak hide before painting. Some chests with fabric covering also have corner bindings of leather, presumably to prevent the fabric from wearing and fraying at these points. The chest in figure 10 shows this technique as well.

The presence or absence of a fabric layer underneath painted decoration is not a guide to the authenticity nor the age of Tibetan furniture. While it is true that fabric coverings are more likely to be found on older furniture, particularly on older chests of the straight-sided variety, many very old pieces of furniture have no fabric covering. Fabric coverings seem to be more common on furniture from the central Tibetan regions than on those from the far eastern regions, perhaps because the timber available in the central region was of poorer quality and thus there was more reason to cover it up.

It is worthwhile examining fabric coverings closely to discover the history of repairs to chests. The majority of older furniture has repairs and repainting of various ages. Paint can be matched closely when repairs are made but it is very difficult to match the texture of a fabric covering successfully. A mismatch is often a telltale sign of a lid that has been repaired or replaced, for example.

Paint and gesso. To create their designs Tibetan painters used mineral pigments suspended in animal glue, mixed by hand and applied warm. A relatively limited range of colors was available prior to the nineteenth century; the most frequently used were green (malachite), dark blue or blue-green (azurite), deep red (cinnabar), orange (realgar), yellow (orpiment), as well as white (chalk) and black (soot). By the early twentieth century a wider range of pigments and paint materials had become available and the range of colors expanded to include some brighter and lighter shades.

The presence of these brighter colors is a good indication that an item of furniture has been painted or repainted in more recent times. They are especially useful for identifying furniture made in the first half of the twentieth century. Newly constructed copies of Tibetan furniture made for export to the decorative market tend to use duller shades, and sometimes even fake dirt, to attempt to re-create the look of antique furniture, although with a little experience it is still possible to tell the difference.

In addition to paint, Tibetan furniture decorators also made use of gesso to create raised designs and textured surfaces. Gesso is used as a surface preparation before applying gold leaf since it has a slightly tacky surface that the gold can stick to easily. Most gesso decoration on paintings and furniture was finished with surface gilding in this way. Gold paint replaced gold leaf on designs using gesso from the nineteenth century onward.

Gilded gesso was initially used sparingly to provide raised highlights, for example the scales of dragons or gold foliage scrolls in seventeenth and early eighteenth century chests. This produces a very rich embossed effect (fig. 11). In later centuries gesso was used more extensively, especially on furniture produced in the nineteenth and twentieth centuries. Tibetan furniture makers discovered that gesso could be used to demarcate the outlines of decorative designs that had been transferred to the surface by using a template. These gesso outlines could then be filled in with color by apprentices without requiring the services of a skilled painter. This technique suited the needs of workshops producing greater amounts of furniture since it allowed them to streamline their production methods. An example of this method of decoration, which is still used today, is found on a four-door cabinet (see fig. 164).

Finish. The majority of Tibetan furniture was finished with a coat of transparent shellac, which intensified the colors of the painting and provided some protection. In older items the shellac layers applied to the furniture have turned yellowish or brownish with age, altering the appearance of the colors underneath and making them appear darker and warmer in tone.

Modern Tibetan furniture, as well as some antique furniture recently restored in Tibet, has a coating of a modern varnish instead of traditional shellac.

Carving. Many pieces of Tibetan furniture, small tables in particular, include some carved decoration. Both relief carving and openwork carving are found in Tibetan furniture. In the latter variety the carving is pierced all the way through the carved panels.

Most carving was also painted and given a finishing coat. Unpainted carved surfaces are rarely seen, unless they have lost their paint through age or wear.

FURNITURE USE IN TIBET

To understand how Tibetans use furniture it is helpful to consider first how they live. Tibetans follow one of several distinctly different modes of living, each different lifestyle demanding different requirements for furniture. Tibetans may be entirely or partially nomadic, or they may reside in settled communities, either secular or monastic.

NOMADIC LIFESTYLES

Tibetan nomads are herders, tending yak and sheep and moving with their animals. As the seasons change the best grassland for grazing is found in different places, so the herders follow the animals in an annual round. In the case of Tibetan nomads these migrations are limited in terms of distance and most nomads will stay within a well-defined territory. A nomadic tent encampment may stay in place for several months at one grazing ground before being transported to the next location on the backs of yaks or horses.

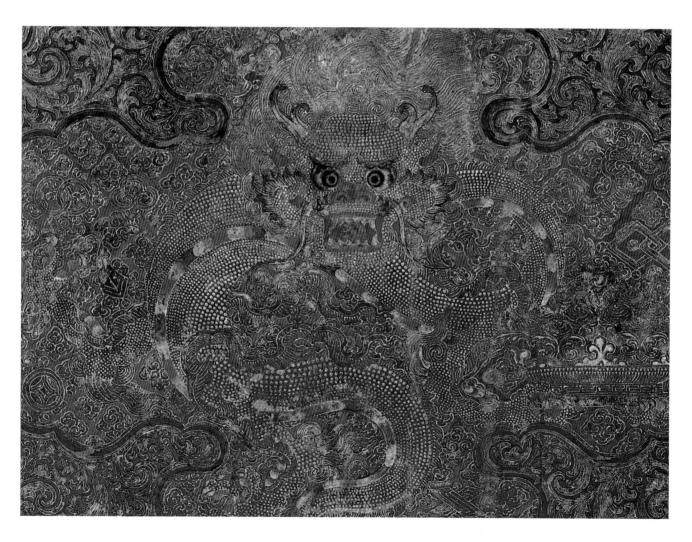

11. GESSO WORK USED TO PRODUCE TEXTURED DRAGON SCALES ON A TIBETAN CHEST. 18TH CENTURY.

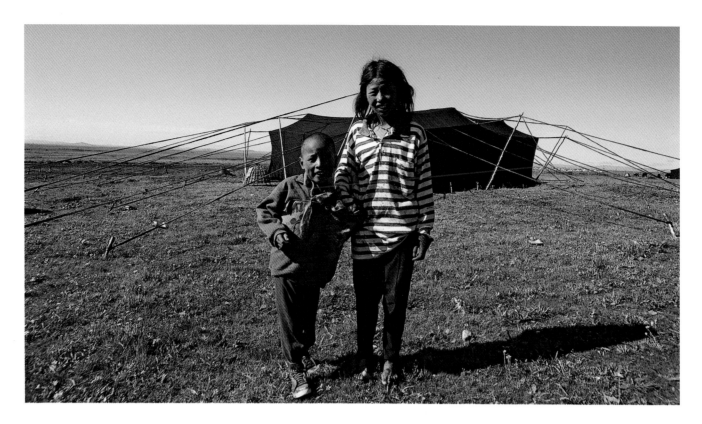

12. Nomad children in front of their home of woven animal hair, near Zoige, Kham region.

Most Tibetan nomads live in a variant of the black tent (fig. 12) that is used in one form or another across large parts of Central Asia. These tents are made from fabric woven from animal hair, usually yak or goat. Some groups in eastern Tibet also make Mongolian-style *yurts*, more substantial round tents made from felt, sometimes with rigid or semirigid sides. Some nomads will also build semipermanent houses at one location in their migration round if they have sufficient means to do this.

There are wide variations in material wealth between nomads in different parts of Tibet. Some groups are very poor, but this is not the case for all, and relatively wealthy nomadic groups are found in some of the more fertile grazing areas, particularly in the east of Tibet. All nomadic groups, regardless of wealth, are selective with their possessions, and portability and weight are foremost concerns.

Inside the tent most of the daily activities take place close to the ground, on rugs or matting. Accordingly, nomad furniture is usually limited to small leather or wooden trunks and low, folding tables. The trunks are used for storage of clothing and utensils while the low tables are used for eating and drinking.

In addition to true nomads who spend the majority of their lives in tents there are also herders who have permanent houses in the valleys, but who take their animals up to high pastures during the summer months and who live in tents for part of the year. Their living styles are similar to the nomads but the tents they use are less robust since they do not have to withstand the winter weather. As with the nomads, the furniture they take with them to the summer pastures tends to be limited to small tables and storage boxes. Some Tibetans who no longer keep animals still keep to the tradition of spending a week or two in an encampment high above the town or village, turning the event into a kind of summer vacation.

The nomadic lifestyle, one of the most ancient in Tibet, influenced the design of tables and chests across all of Tibet. Folding tables (*tepchok*) are extensively used in the towns and settlements as well as by nomads, though this furniture was probably originally designed with portability on the back of a yak or horse in mind. These considerations also influenced the design of many storage chests used by settled Tibetans, which show echoes of designs originally developed for nomadic use.

SETTLED LIFESTYLES

Most Tibetan wooden furniture comes from the homes or monasteries of Tibetans living in permanent settlements. Tibetans following settled lifestyles use a much wider range of furniture than the nomads and their furniture tends to be larger.

Tibetan houses and monastic buildings (figs. 13, 14) are squat, square structures of one to three stories with flat roofs. They are built using tamped earth or stone walls on top of stone foundations, with exteriors often stuccoed and painted. Smaller houses may consist of a single square room with a flat roof and with an iron stove in the center for cooking and warmth. If a family has more than one floor it may use the lower floor for storage and for keeping animals, while the upper floors are reserved for living and sleeping. Larger houses, particularly in Lhasa, are built around a courtyard and can be several stories high. In the center of the courtyard is a standpipe or handpump for water and a basin for washing. Most houses also have one or more flagpoles on the roof from which lines of colorful prayer flags are strung.

Tibetan houses have large flat roofs that are used for a variety of purposes, including drying crops, carpet weaving, and other activities. Recently in Lhasa it has become the fashion among wealthier families to build summer rooms with large glass windows on the upper floors, sometimes with adjoining shrine rooms dedicated to lamas and Tibetan deities. The uppermost floors are associated with the highest status, hence their use for ceremonial purposes or receiving guests. Some of these rooms contain shrine cabinets for statues and occasionally offering cabinets (*torgam*) for housing butter sculpture offerings.

Monasteries are built using essentially the same construction techniques as houses, though many monastic buildings are distinctive (figs. 15, 16) because of the custom of painting them red-brown on the outside, in contrast with domestic homes that are painted white or left earth colored. Monastic complexes vary greatly in terms of wealth and hence in the number of buildings they have. Some of the larger monastic complexes were effectively small, self-contained cities (fig. 17). The most imposing building in a monastic grouping is normally the main temple, an assembly hall called the *dukhang*,

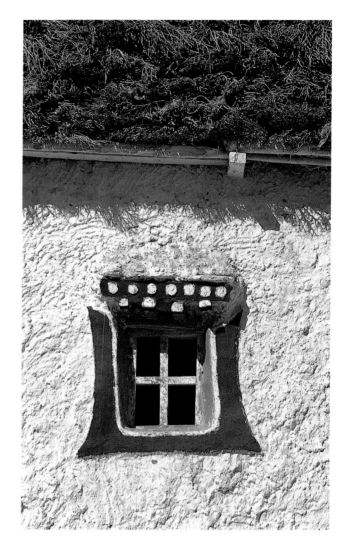

13. WINDOW OF A HOUSE NEAR PURANG, WESTERN TIBET, WITH BRUSHWOOD FOR WINTER FUEL PILED ON THE ROOF.

where daily religious ceremonies are held. In addition to buildings with religious functions the monasteries also have many other buildings with more mundane functions such as large communal kitchens. These are filled with huge blackened hearths and great numbers of shiny copper pots. Some larger monasteries also have luxurious living quarters reserved for visiting religious leaders. These quarters usually include a throne draped in silks and other impressive furniture.

FURNITURE USE IN SETTLED LIFESTYLES

Tibetans living in settled communities, both domestic and monastic, use the same types of low folding tables and portable chests that the nomads use, in addition to which they use some larger types:

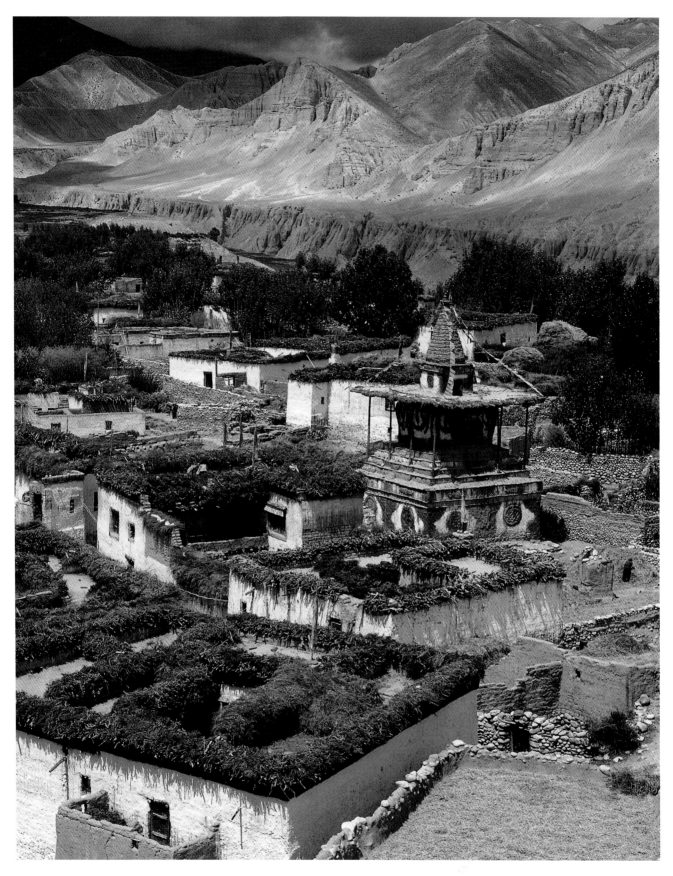

14. TIBETAN VILLAGE IN THE MUSTANG REGION OF NEPAL, SHOWING A PATTERN OF SQUARE HOUSES WITH FLAT ROOFS AND SMALL CENTRAL COURTYARDS SEEN ALL ACROSS TIBET.

Furniture Use in Settled Lifestyles

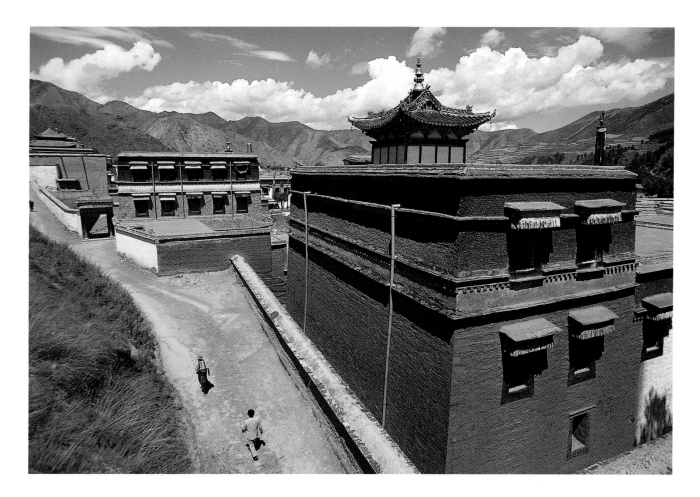

- Large storage chests (*gam*) made of wood
- General-purpose cabinets with two or four doors
- Low tables (*choktse* or *shöchok*), used for meals and drinking tea)
- Special reading desks (*pegam*) for reading religious texts and for use in religious ceremonies
- Other special types of furniture with religious functions such as prayer wheels, cabinets for holding butter offerings in shrines, shrine cabinets for holding images, and butter lamp stands.

The most numerous types of Tibetan furniture are the general-purpose items such as chests, cabinets, and low tables. Other types of furniture such as the prayer wheels, offering cabinets, and reading desks were produced in smaller numbers because they had more restricted functions associated with worship. It is sometimes wrongly assumed that these special types of furniture were used exclusively in monasteries. Many of the smaller offering cabinets and prayer wheels in fact come from the homes of wealthy families who maintained

15 (ABOVE). MONASTIC BUILDING AT XIAHE, KHAM REGION.
16 (BELOW). MONASTIC BUILDING, LAKHANG MARPO, AT TSAPARANG, WESTERN TIBET.
17 (FACING). PAINTING OF MONASTIC "CITY" AT TONGREN, AMDO REGION, WITH MONKS ENGAGED IN RITUAL DEBATES BY THE RIVER. 19TH CENTURY.

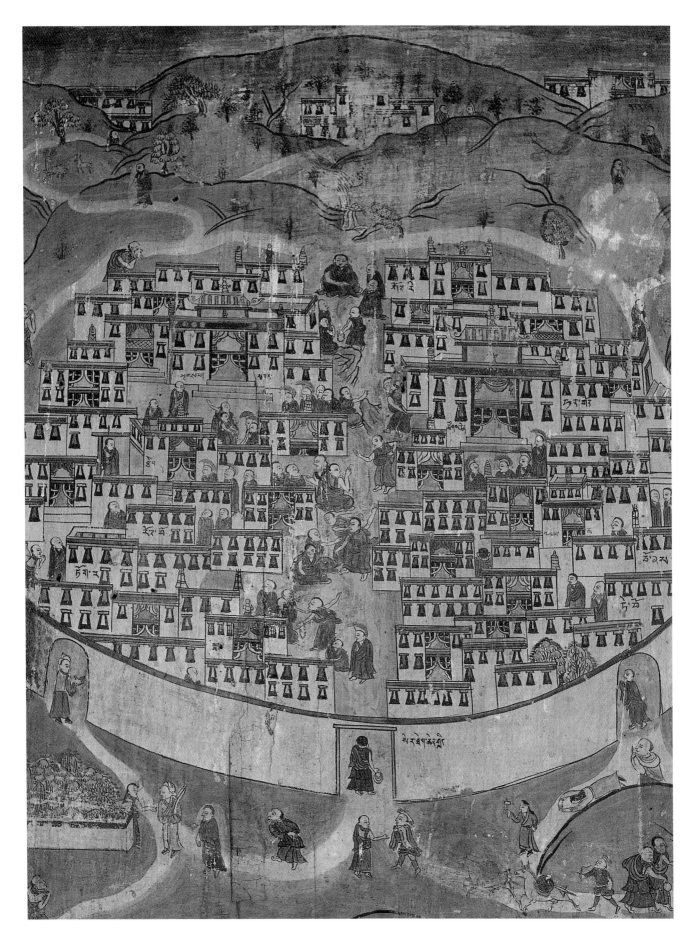

Furniture Use in Settled Lifestyles

shrines within their houses, sometimes in a special room or more often in a corner of the main living room. Special types of furniture for use in connection with offerings made to protector deities are described in more detail in the chapter Furniture for the Wrathful Gods.

To understand how Tibetan furniture forms accommodate their functions and differ from other furniture traditions it helps to compare Asian domestic living styles. Scholars have identified two basic patterns of furniture use: a ground, or mat-level, style and an elevated, or chair-based, style. Most societies in earliest times favored ground-level living, in which people relaxed by sitting on mats or rugs. Some civilizations, such as that of central China, evolved to chair-based lifestyles similar to those that are now nearly universal in the West. In the case of China this transition began around the fifth century and was virtually complete by a millennium ago. Other civilizations such as Japan and Tibet have retained their ground-level living styles into modern times.

The two types of lifestyle need different kinds of furniture. Elevated living styles use chairs and stools and the high tables that go with them. Ground-level living tends to use low tables; the surfaces of these low tables also tend to be smaller since it is more difficult to reach across a large table from a low sitting position.

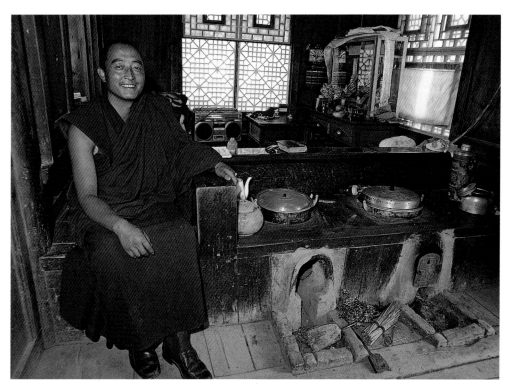

18 (ABOVE). RELAXING AND DRINKING BUTTER TEA IN A CONTEMPORARY LHASA HOME, SITTING ON A CARPETED PLATFORM (DENKYA).
19 (LEFT). A MONK IN THE AMDO REGION SEATED ON THE EDGE OF A SLEEPING PLATFORM, WHICH CONVENIENTLY HAS FACILITIES FOR COOKING BUILT IN.
20 (FACING). *PEGAM*, A DESK USED BY MONKS FOR SUPPORTING MANUSCRIPTS AND RITUAL OBJECTS DURING CEREMONIES. 17TH OR 18TH CENTURY.

The majority of Tibetans still retain a modified form of ground-level or close to ground-level style in their daily lives. Seating and sleeping tend to be on rugs laid around the edge of tents or rooms in houses, often raised up on a low platform (*denkya*). The sitting and sleeping areas in many Tibetan houses are covered in colorful and beautiful rugs, woven locally from wool produced by nomadic herders. The rugs are used both for sitting and sleeping and provide essential insulation in winter.

In wealthier homes in the towns the rug-based seating arrangement evolved into platforms around the edges of rooms, with rugs laid on top for insulation and comfort. These have increased in height in more modern homes, in some cases almost to modern chair height, but the basic living pattern is unchanged (fig. 18). For this reason there are very few chairs among traditional Tibetan furniture. The only "chairs" traditionally used were thrones that were occasionally built for people with special status, especially head lamas.

Homes in northern and eastern Tibet sometimes have heated seating and sleeping platforms, similar to those used across northern China and known in the West by their Chinese name, *kang*. These are typically low structures of brick or compacted earth with a fire chamber that can be stoked with fuel through an opening into the side; the fire not only warms the entire platform in the winter but provides heat for a convenient cooking area. Low tables and low storage cabinets were made for use on these platforms. This living arrangement is neat and com-

pact, and makes efficient use of fuel for both warmth and cooking in the cold winter months (fig. 19).

Seating arrangements similar to those used in domestic homes are also used in temples and monastic living quarters, with some variations. In the temples the monks sit in long rows on low wooden platforms with cushions or carpets on top. A row of twenty or thirty Tibetan monks seated cross-legged on these platforms, chanting from religious texts or blowing long trumpets, is a familiar sight in Tibetan temples. In some temples the novice monks also sleep on these platforms at night, wrapped in heavy cloaks to keep out the cold. These low, carpeted platforms (*denkya* or *dentie*) are surviving examples of a mode of living on mats and platforms that has largely passed out of use in the regions surrounding Tibet.

LOW TABLES

In both homes and monasteries low tables are used in front of sitting platforms. The general Tibetan word for table is *choktse*, probably derived from the Chinese word for table, *zhuozi*. These low tables have a variety of uses, including supporting bowls of tea and food. Anyone who has been invited into a Tibetan home knows that within moments of sitting down a bowl of butter tea (steaming black tea churned with salt and butter) usually appears in front of you on a low table, sometimes accompanied by dried yak meat or pastries. Monks in temples also use their low tables in a similar way. Lengthy religious ceremonies are sustained with frequent bowls of tea and it is common in the larger ceremonies to see a pair of monks carrying a huge kettle up and down the rows of monks and refilling tea bowls placed in front of them on countless low tables.

Low tables are also used to support religious texts while they are being read or studied. Tibetan sutras consist of long strips of printed paper sandwiched between loose wooden covers. During ceremonies monks read or chant from these texts, placing the bundle of sutras on a table and turning the leaves one by one. In some monasteries a special tray with a high back is used for this purpose, placed on a low table. This allows the top wooden cover to be removed and propped up while the text is read. Formerly Tibetan monks used a unique reading desk for reading sutras called a *pegam* (fig. 20); these are rarely seen in use today.

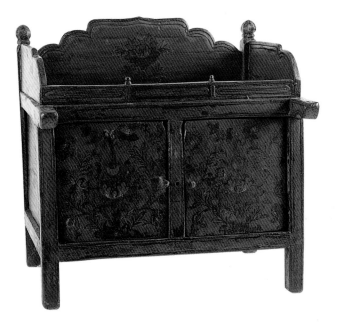

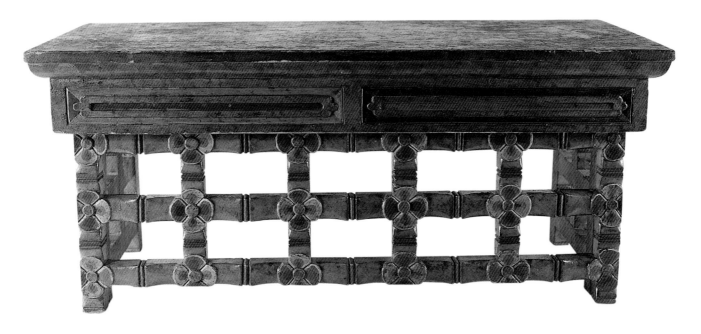

21. The classic low, three-sided folding table, one of a matching pair. 19th century.

The classic Tibetan low table (fig. 21) is the three-sided folding type (*tepchok*); it consists of a solid top and three hinged sides, which allow the table to be picked up and folded flat for carrying or for storage. Generally these tables are between 20 and 50 centimeters (8 to 20 in.) high; it is rare to see examples that are much taller. The top is usually plain but the sides are decorated with carving or painting. Larger monasteries may have hundreds of folding tables, which can be quickly set up for a ceremony outside in the temple courtyard then just as quickly cleared away when it is over. Monks open and close these tables with a practiced flick of the wrist. The folding table seems to be a form that is unique to the Tibetan plateau; it is not seen in the surrounding regions to my knowledge.

Another characteristic type of small table has fixed legs, usually of the curved, or cabriole, variety (figs. 22, 24), and usually joined by stretchers or panels to give them rigidity. This type of table seems to be a very ancient one that is closely related to larger tables with the same basic form that were used as altar tables in central and northern China. In this region there is a tradition of making tables and other furniture with cabriole legs stretching back at least nine hundred years, based

on the evidence of items recovered from Chinese tombs. The cabriole-leg table was probably originally imported from central China and subsequently adopted by Tibetan carpenters. The Chinese-style construction and decorative features typically found on Tibetan versions of cabriole-leg tables are further evidence of this, for example, the small decorative openwork panels, a characteristic feature of Chinese table aprons and of other furniture such as screens.

Modern Tibetan homes have tea tables (*gyachok*) that are the same height as the preceding types of tables but with a bigger, square top (fig. 23). The legs of this type of table are sometimes of the cabriole style. The top of the table has a boxlike construction and incorporates a drawer or cupboard. This type of table has become more popular as seating heights have increased in modern homes, which makes it easier to use a larger table effectively. Because it seems to be a relatively recent innovation there are very few truly antique examples of this type and most that I have seen date from the early twentieth century or later. The tops of these tables offer considerable scope for painted decoration and some examples are painted with designs similar to those found on chests.

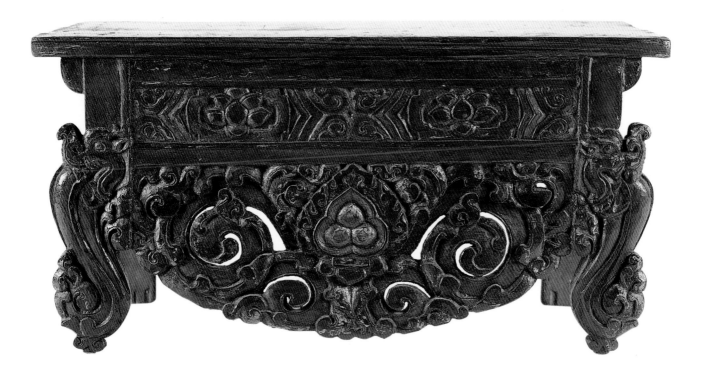

22. Low table with fixed legs of the cabriole style. Circa 18th century.

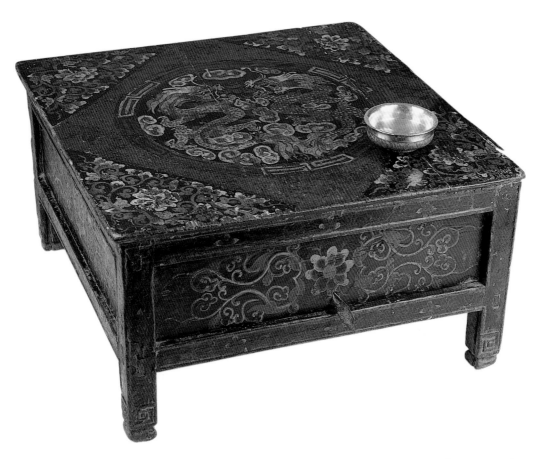

23. Tea table with square top and straight legs, with tea bowl of burr wood bound with silver. 19th or early 20th century.

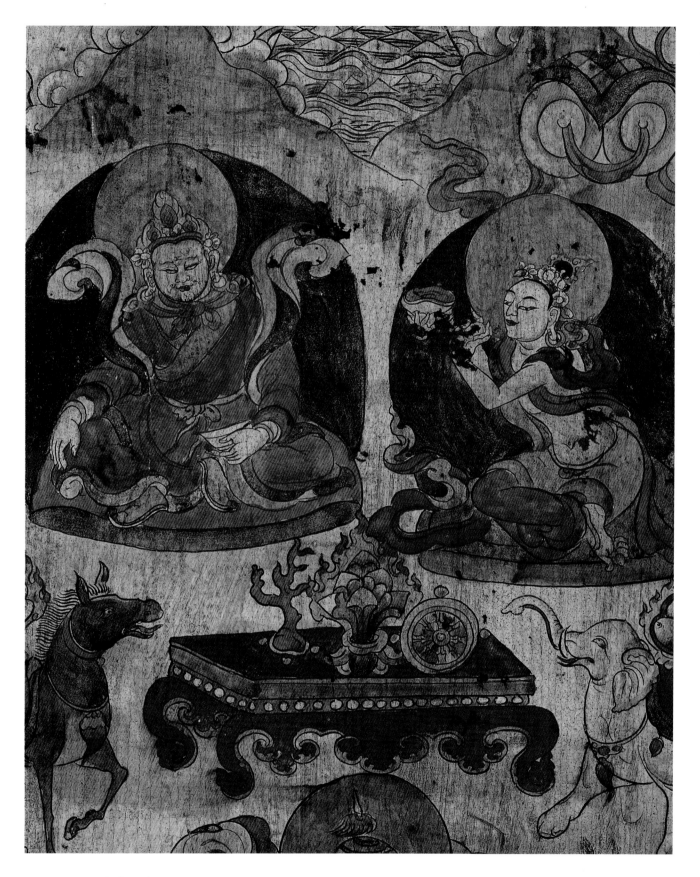

24 (ABOVE). PAINTING ON CABINET SHOWING CHINESE-STYLE LACQUERED TABLE WITH CABRIOLE LEGS SUPPORTING OFFERINGS.
25 (FACING). LEATHER CHEST WITH APPLIQUÉ LEATHER ROUNDELS AND PAINTED DECORATION. 15TH OR 16TH CENTURY.

CHESTS

The second major furniture type characteristic of Tibetan homes and monasteries is the chest. The general term for chests and boxes is *gam*, and both chests and cabinets are sometimes referred to by the general term *chagam*. Many cultures use some kind of wooden chest for storage, but the Tibetans developed a version uniquely their own. As chests were considered receptacles for precious items, it was believed that their finish and appearance should reflect the importance of their contents. Tibetan furniture makers created pieces that are marvels of intricate and lavish decoration. Generally, the layouts of the painted designs on chests followed standardized formats, but within these traditional forms individual craftspeople found great scope for artistic expression.

PORTABLE LEATHER CHESTS

Nomads and other Tibetans use small leather chests (fig. 25) for storing and transporting household goods and precious items, a tradition that seems to have a long history. These are made of heavyweight yak hide stitched together with strips of leather. The outside is usually reinforced on all sides with iron or brass straps, riveted in place. Two or more lugs are normally added on the sides or front of the chest so that carrying straps can be passed around it. This method of construction makes a light and portable box. Sometimes these are even made using a lightweight wicker frame, which lends support to the supple leather while adding very little weight.

An interesting mural in the circumambulatory passage of Shalu monastery in central Tibet (fig. 26) shows a foreign trader on the Silk Roads leading a camel laden with a small leather chest with a characteristic scalloped lid, showing that this form was well known at least as far back as the early fourteenth century, when this mural was painted. Some particularly old examples, such as that of figure 25, are decorated with appliqué leather roundels that resemble fabric designs current during the tenth to fourteenth centuries.

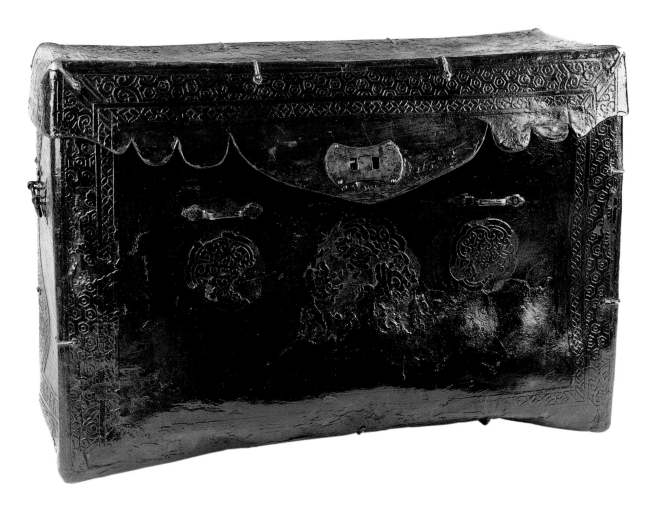

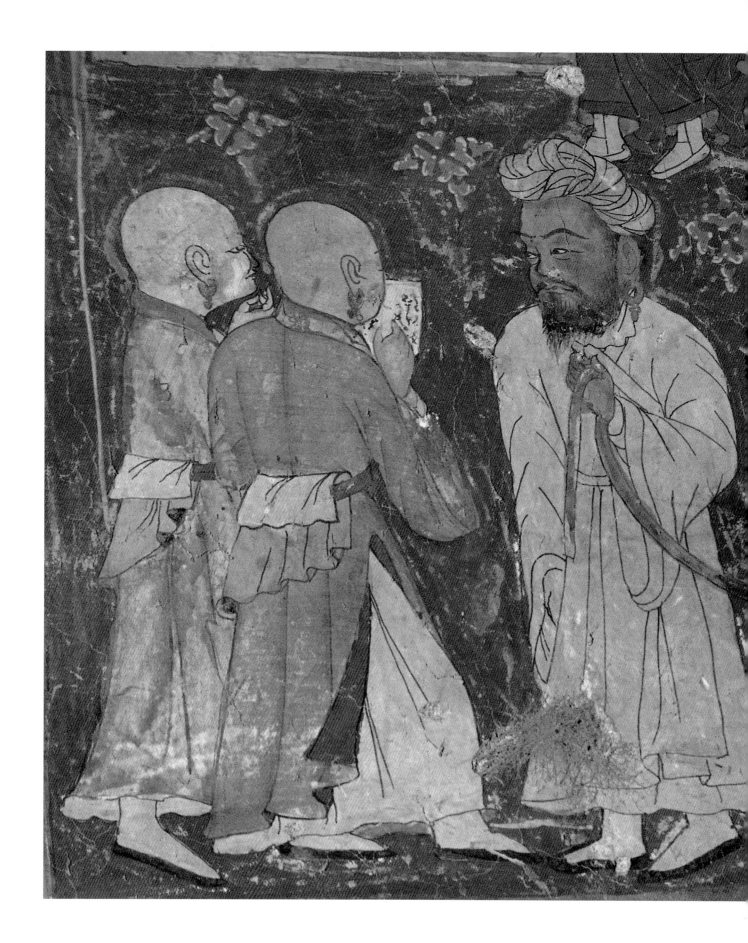

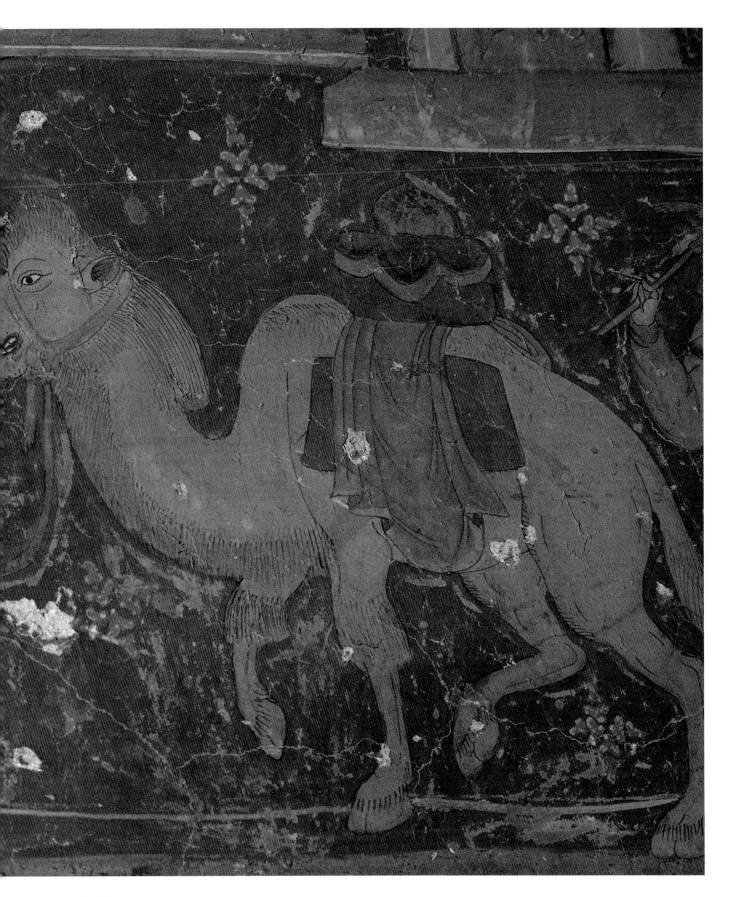

26. Detail of a 14th century mural at Shalu monastery showing a trader leading a camel bearing a leather chest with a scalloped top.

Portable Leather Chests

31

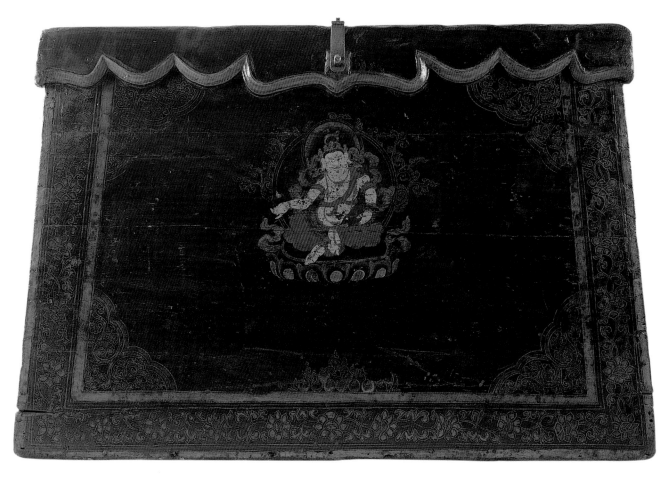

27. SLOPING-SIDED WOODEN CHEST WITH OVERLAPPING LID WITH SCALLOPED EDGE. 15TH OR 16TH CENTURY.

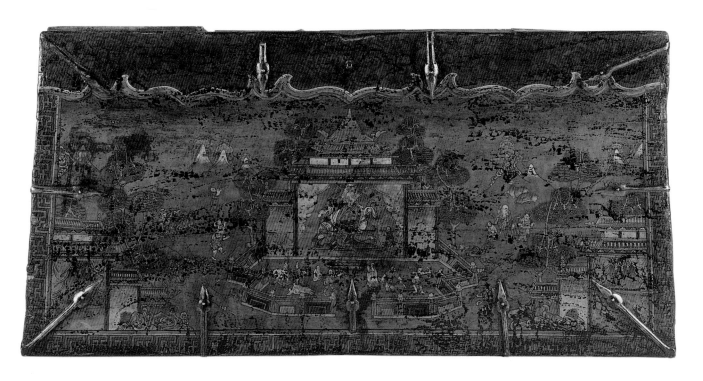

28. STRAIGHT-SIDED WOODEN CHEST WITH SCALLOPED DECORATION AT THE TOP IMITATING THE LID OF THE CHEST ABOVE. 19TH CENTURY OR EARLIER.

Leather-covered chests of a different type are also commonly found in Tibetan monasteries and households. These chests look superficially similar to the portable kind but are constructed quite differently. They are essentially wooden chests that have leather coverings stretched over them. They are constructed on a straight-sided wooden box and their lids do not overlap but sit on top. This kind of chest is much heavier and only rarely used for transport, though they are popular for storage (see fig. 32).

SLOPING-SIDED WOODEN CHESTS

The forms of some wooden chests echo features of leather chest design. Portable leather chests were made with sides that slope inward slightly, especially near the top, so that the lid could overlap. Scalloped decoration was often added along the edge of the lid of the chest by cutting away the leather. The same features also occur in a few wooden chests with overlapping lids (fig. 27). A larger group of wooden chests looks superficially similar to this type, but in these chests what appears to be a scalloped, overlapping rim is false (fig. 28). The true lid of the chest is a flat, hinged panel on the top surface of the chest, either extending the full width of the top or a small hatch set into a rigid top. The scalloped strip is merely a decorative fixture attached to or carved into the front and sides of the chest.

Large wooden chests with sloping-sides and scalloped decoration form a definite group with distinctly different features and decoration than other kinds of chests. As a group they have the following characteristics:

• Sides that slope inward to some degree
• A scalloped lid or a decorative trim resembling a scalloped lid
• An overlapping lid or a flat lid resting on top of the chest
• Heavy decorative ironwork, typically with three or more large decorative straps on the front stretching nearly to the top, with smaller straps reinforcing the edges and corners
• Relatively plain painted decoration, usually consisting of a few scrolls at the corners with a central design on a plain, color background.

Not all of these features are present in all the chests in this group; the degree of inward slope of the sides in particular varies greatly from chest to chest. In most cases, however, it is usually possible to clearly distinguish this type of chest from other types.

Judging from the decoration on these chests, which is discussed in the next chapter, this group includes some very old chests. The oldest may date from the fourteenth century (fig. 29), though it is difficult to be precise because of their relative lack of decoration; others, such as that in figure 27, may date from the fifteenth or sixteenth century.

STRAIGHT-SIDED CHESTS

The other major class of Tibetan chests has straight, parallel sides, with a lid the same width as the chest and that does not overlap. The lid of this type of chest is constructed like a tray, in contrast to the simple, flat board found on most sloping-sided chests. This allows the painted border decoration on the front and sides of the chest to be continued onto the lid, disguising the join. The front of this type of chest is rectangular (fig. 30) rather than trapezoidal as found in sloping-sided chests. Some of these chests were covered in fabric or leather before painting, features which are rare in the sloping-sided variety.

The rectangular format allows a wider range of designs to be used on the front surface of the chest; in particular it allows symmetrical designs and geometric designs similar to those used in woven textiles to be used since these designs fit well within the rectangular proportions. Straight-sided chests also form a distinct group, identifiable by the following features:

• Sides that are parallel and square
• A lid which is flush with the body of the chest and does not overlap
• Hinges consisting of a pair of iron rings attaching the lid to the back of the chest
• All-over decoration with a symmetrical, centered design
• Lightweight ironwork, usually consisting of iron straps of uniform size reinforcing the edges and corners.

As with the sloping-sided variety, not all chests of this type share all of these features; however, the distinction is clear enough in most cases. There is no firm evidence that either style predates the other since early and late painted designs are known on both types, including examples dating to the fifteenth century or earlier.

Together with low tables, chests appear to be one of the most enduring of all Tibetan furniture types, a view supported by the range of designs they show and the apparent evolution of these designs over time. This chronology is discussed in more detail in the following chapter. A fair number of chests seem to have survived from the seventeenth century and even earlier times, probably due to a combination of factors, including Tibet's dry climate and the stability and continuity of the monastic institutions that housed them.

HOW CHESTS ARE USED

Chests are still found today in many different settings including homes and monasteries, though the main users of the largest chests seem to have been the monasteries. In some places they can still be seen in situ (fig. 31), used for storing garments, butter lamps, and other implements, or for storing domestic items in living quarters. A special long, low type of chest (see fig. 121) is sometimes used for storing rolled-up *thangka*.

A typical large assembly hall in a monastic complex might have had twenty or more storage chests; old chests can sometimes still be seen in monasteries which have been using them continuously for two hundred years or more. Some were placed along the sides of the temple or along the walls at the back; others were placed on either side of the central aisle, near the front of the temple and the central altar. Senior lamas, who sit near the front of the temple during religious ceremonies, often sat with their backs to large decorated chests.

A number of Tibetan homes have antique chests and I have occasionally seen fine examples in well-to-do homes in Lhasa and the surrounding area. Some of these elaborately decorated chests seem to have originated

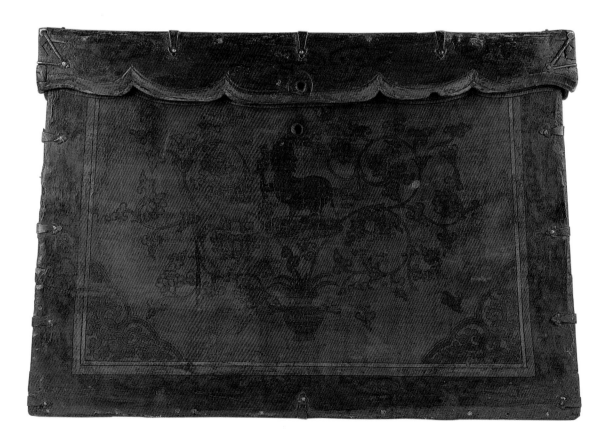

29. SLOPING-SIDED WOODEN CHEST WITH OVERLAPPING LID AND PAINTED DESIGN OF A VASE WITH TENDRILS OF FOLIAGE SUGGESTING A DATE OF 14TH OR 15TH CENTURY.

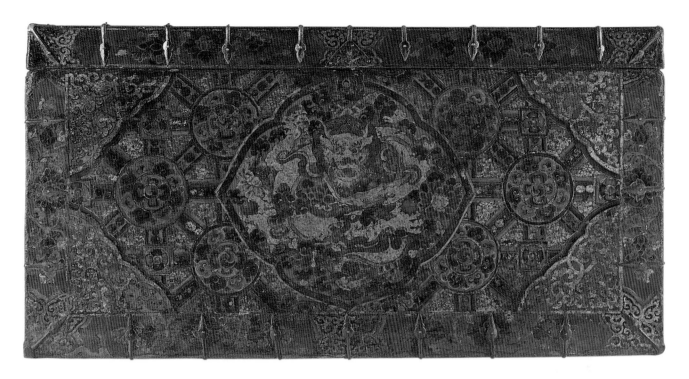

30. Typical straight-sided wooden chest from central Tibet. 17th century.

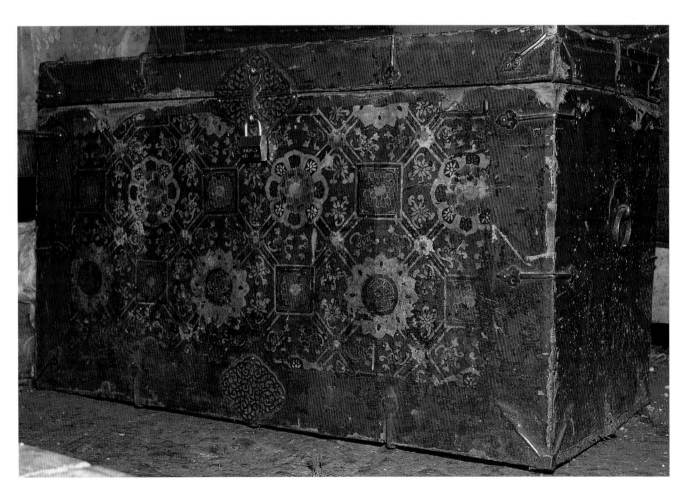

31. Straight-sided wooden chest photographed in situ, probably in continuous use at this monastery in central southern Tibet since it was made. 16th or 17th century.

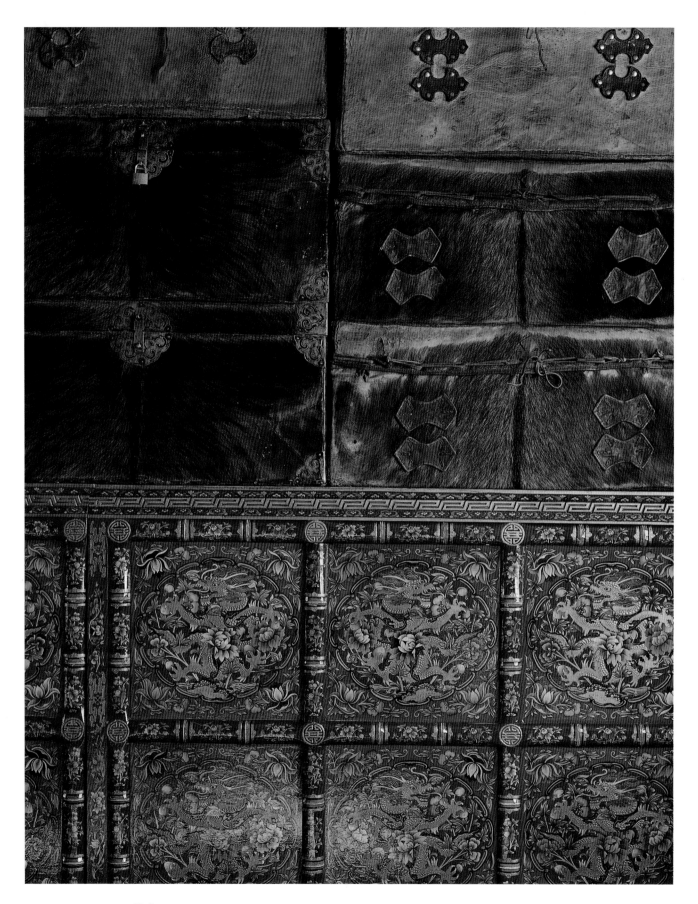

32. Storage chests covered in yak hide, stacked atop a painted cabinet in a home in Lhasa. Modern.

from nearby monasteries. Many ordinary homes also have small or midsize storage chests, although the types most often seen in homes are simply decorated chests covered with yak hide (fig. 32). Some have metal fittings at the corners, while others are entirely undecorated. Many such leather-covered chests, dating from the late nineteenth century or the first half of the twentieth century, can still be seen in homes in central Tibet.

The manufacture of large and opulent wooden chests seems to have declined during the nineteenth century, and chests of this type which are identifiably from the nineteenth century or early twentieth century are correspondingly somewhat scarcer than such chests dating from the eighteenth century. The reason for this decline seems to have been that chests were eclipsed during this period by more sophisticated and fashionable cabinets. When a large and showy set of furniture was required (perhaps as a gift) up until the eighteenth century a pair of large painted chests was an obvious choice. After that time sets of sumptuously painted cabinets seem to have usurped that position.

Chest production never entirely ceased, however, and a fair number of plain and functional chests continued to be made throughout the nineteenth and twentieth centuries. For monasteries in particular they were the most convenient way of storing large quantities of items such as butter lamps, often numbering hundreds or even thousands in the bigger institutions. Today monasteries continue to use chests and to install new ones during restorations, though in recent times these have tended to be large metal chests with padlocks rather than painted wooden ones. Chests are still made for domestic use as well, although plain leather-covered chests or painted metal chests are favored.

CABINETS

Cabinets have a much shorter history in Tibet than low tables or chests. They were made in large numbers only from the eighteenth century onwards. This is apparent from their decorative styles and themes, which cover a narrower range than those that appear on Tibetan chests and low tables. Why cabinets were not more widely used before the eighteenth century is not known for certain. It is unlikely to be because the form was unknown in Tibet since Tibetans had been trading with China for hundreds

of years and would certainly have seen Chinese cabinets, which have been commonplace at least since the twelfth century. Increasing wealth in Tibet during the eighteenth and nineteenth centuries, particularly in private homes, may have played a part in the adoption of the cabinet form since constructing cabinets generally requires more timber and joinery, hence more expense, than constructing chests. The cabinet is also a feature of a settled lifestyle, since most are too bulky and heavy to transport on the back of a horse or yak.

The classic Tibetan cabinet has four square-shaped doors of equal size and a shelf in the middle (fig. 33). Cabinets of this type continue to be used in some monasteries and in nearly all of the wealthier homes, where they are placed against walls and used for general storage. In monasteries and in some homes rows of cabinets support shrine cases that contain statues, *thangka*, and images of lamas. The level surfaces on the tops of the cabinets are also used to support offerings of butter lamps, butter sculptures, and bowls filled with water or the barley beer called *chang*.

In addition to the classic cabinet, many variations on this style of furniture were constructed, including some very large cabinets. Small cabinets, which combined the functions of a storage cupboard and a stand, were also made (see fig. 9).

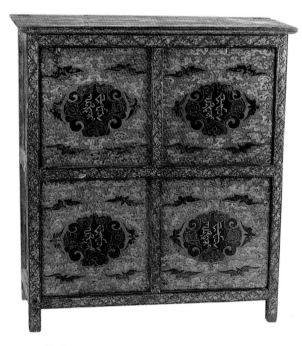

33. CLASSIC CABINET DESIGN WITH FOUR SQUARE DOORS. 18TH OR 19TH CENTURY.

FURNITURE WITH SPECIALIZED USES

There are several types of furniture with special functions that are unique to the Himalayan region: these include reading desks, prayer wheels, offering cabinets, shrine cabinets, and butter lamp stands. Each of these forms was developed to meet a particular need, and all of them are associated with religious activities.

These specialized types of furniture have long histories in Tibet. Examples are sometimes found which appear to be 500 years old or even older. Tibetans probably developed their forms, though it is also possible that some may have been inspired by earlier types in use in former Buddhist regions such as northern India or Kashmir. Few records exist of everyday Buddhist religious life in these regions, however, so their origins are difficult to establish.

READING DESKS

Tibetans call this kind of small desk a *pegam*, which literally translates as "book box." In fact, *pegam* were used mainly as reading desks, designed for studying Tibetan religious texts and used during religious ceremonies for supporting ritual objects such as the *dorje* and bell. We have noted earlier one example (see fig. 20) of such a specially designed piece.

The *pegam* was probably developed soon after Buddhist religious texts were first transcribed and manufactured in Tibet. The original Indian sutras were compact documents, consisting of two thin wooden covers with the texts, written on palm leaf or birch bark, sandwiched in between. They were small enough to be held in the hand while they were being read. When Tibetans translated the Indian texts from Sanskrit into Tibetan and produced their own versions, they copied the basic format of Indian sutras but in many cases they made them larger, and transcribed them on paper rather than palm leaf. A typical Tibetan religious text consists of a bundle of pages around ten centimeters (4 in.) thick between two heavy wooden covers that measure about 25 by 65 centimeters (10 by 25.5 in.). This is about twice the length and many times heavier than the Indian originals, making the bundle too large to easily hold in the hand or in the lap. This meant that they needed to be placed on some kind of support while in use.

In order to make reading sutras more comfortable several types of furniture were developed, of which the *pegam* seems to have been the most successful and most widely used. Most *pegam* consist of a low two-door cabinet with a reading surface above. The cabinet space below is usually used for storing small items rather than the religious texts that are read atop them; those are carefully stored separately in a library. The reading surface has a back to it so that the upper sutra cover can be propped up against it during use. Smaller *pegam* also have two projections at the front to ensure that there is enough room to support the bundle of sutras when they are opened.

There is a variant type of *pegam* which is sometimes still seen in use that merely consists of a frame for supporting the sutra, lacking an enclosed cabinet below. This version might well be the original form of this furniture, developed to provide a support for sutras during use. Enclosing the frame and turning it into a cabinet probably occurred later.

Pegam seem to have gradually fallen out of favor in the nineteenth and twentieth centuries. A more popular solution to handling sutras in monasteries today is a kind of purpose-made tray. This duplicates the shape of the top part of a *pegam*, with a high back so that a sutra cover can be leaned against it, but it lacks the cabinet below and it can be placed on any table or flat surface. Presumably it is cheaper and easier to make than the more elaborate *pegam* form.

Pegam are occasionally found which are around twice the height of the standard form, in other words too tall to be used by a monk seated on a standard low platform. This kind generally has more ornate carving and more elaborate painted decoration than the standard variety (see fig. 165). They were made for use by senior lamas during religious ceremonies and they are relatively rare since they were made in smaller numbers. During ceremonies the monks sit in rows with the more senior members sitting at the front near the altar. A senior lama or a particularly elderly individual has a higher seat than the other monks to signify his status. Normally he sits either on a throne or on a taller pile of cushions than the other monks. To complement his elevated position he needs a taller *pegam*, hence the higher variety.

SHRINE CABINETS

Tibetan temples and domestic shrines are often crowded with statues of different sizes, which are housed in shrine cabinets. These cabinets, along with butter lamp stands and other supports, are lumped together by Lhasa Tibetans, who refer to them as *chösum*, meaning "altars." They may be simple glass-fronted wooden cabinets with little decoration or they may be elaborately carved and gilded creations. In some temples, particularly in places where there was a tradition of donating small statues as offerings, these cabinets may line the walls and stretch up to the ceiling. There is a thriving industry in Lhasa today carving and gilding this type of shrine cabinet (figs. 34, 35), for use in monasteries and in homes. Modern examples tend to be glass-fronted with carved frames.

PRAYER WHEELS

Prayer wheels are such a universal feature of Tibetan life that they have become a symbol of the country. Tibetans believe that the spinning of the wheel is equivalent to the recitation of the prayers that are written on a strip of paper, wound tightly and packed inside

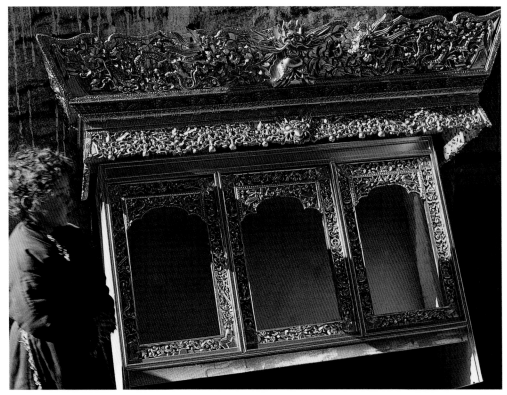

34 (ABOVE). A MODERN GLASS-FRONTED SHRINE CABINET IN A LHASA HOME IS FILLED WITH STATUES OF DEITIES AND PICTURES OF RELIGIOUS TEACHERS.
35 (LEFT). A NEWLY CARVED AND GILDED SHRINE CABINET IN A LHASA STREET.

each wheel. Prayer wheels come in many different forms, from the hand-held wheels (fig. 36) of pilgrims to huge wheels which have their own chapels to house them and which can be pushed simultaneously by several worshippers.

There are other ways of sending prayers up to the heavens besides prayer wheels. Small pieces of paper printed with a design of a horse with precious jewels on its back, known as a "windhorse," are flung into the warm air rising from incense burners (fig. 37). These paper pieces are also thrown from the windows of buses on mountain passes and at auspicious places. From hilltops and shrines long lines of prayer flags flutter in the breeze, so much so that the hills and towns in Tibet are constantly alive with prayer.

The functions of the two uniquely Tibetan items of the reading desk and the prayer wheel reflect different paths for gaining merit in the Buddhist religion: for the studious there is the path of meditation on religious texts, a severe and demanding course, while for the ordinary lay worshipper there is the path of simple faith,

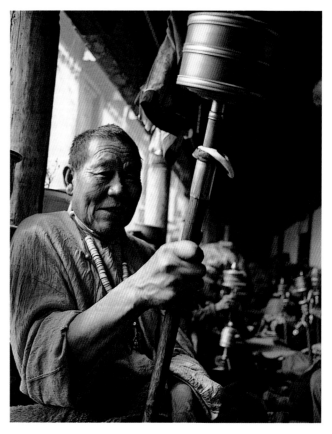

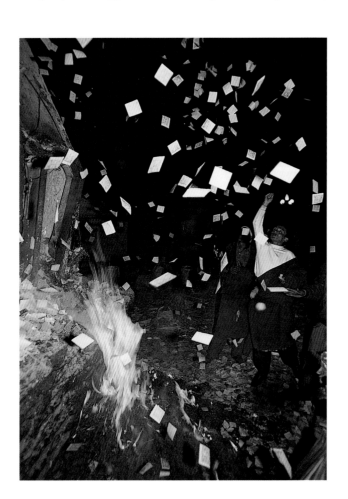

36 (ABOVE). PILGRIM WITH A HAND-HELD PRAYER WHEEL, LHASA.
37 (LEFT). LHASA RESIDENT THROWING PAPER SLIPS WITH PRINTED PRAYERS ON THEM INTO THE WARM AIR RISING FROM AN INCENSE BURNER.
38 (BELOW). LARGE, FIXED METAL PRAYER WHEEL, ONE IN A ROW OUTSIDE A LHASA TEMPLE.

demonstrated through pilgrimage and the recitation of mantras and prayers. Prayer wheels facilitate the second path and ensure that it is open to all, even to those who lack the education to follow the details of the teachings.

Most Tibetan temples have rows of fixed prayer wheels (fig. 38), which pilgrims turn as they perambulate around the pilgrim's route, or *khora*. Aside from using the hands, a variety of ingenious ways have been figured out for turning prayer wheels: in some areas water-powered and wind-powered wheels are found. In Tibetan homes you can sometimes see a type of compact prayer wheel that is powered by the hot air rising from a butter lamp.

Larger prayer wheels are fixed into walls or have

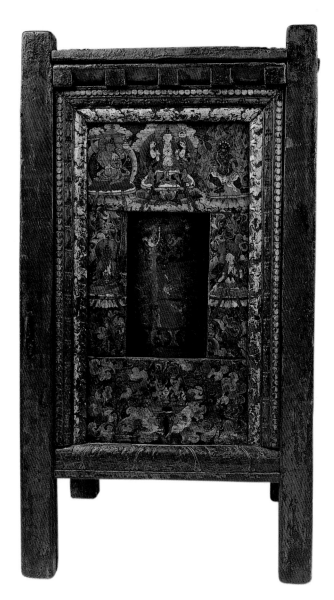

39. PRAYER WHEEL MOUNTED IN FREE-STANDING WOODEN CABINET.

their own chapels. Most are very basic in form and have little decoration around them. A few prayer wheels were made individually in free-standing wooden frames (fig. 39). Beautifully painted, most of these were made for use by wealthy families, important lamas or given as gifts to monasteries. Their decoration often includes a variety of deities that are usually specific to the order or temple that the prayer wheel was associated with. The famous group of three protectors consisting of Manjushri, Avalokiteshvara, and Vajrapani (*Rigsum Gonpo*) is often found on decorated prayer wheel surrounds, in association with other deities, lamas, and historical figures.

OFFERING CABINETS

A third kind of furniture that is unique to Tibet is a cabinet called *torgam*, which is used for housing ritual offerings and found in places where fierce protector deities are worshipped. The cabinets generally have two doors and are quite wide but usually no more than 20 or 30 centimeters (8 to 12 in.) deep, being designed to hold and display butter sculpture offerings and other objects. Most monasteries and some wealthy homes have shrines devoted to fierce deities, who protect the building and its inhabitants. Offerings of butter sculptures were made to these deities, especially during Losar celebrations at Tibetan New Year, and the cabinets were specially designed to receive and store the butter offerings that would generally be kept for a year before being renewed (fig. 40).

The distinguishing feature of offering cabinets is the unique and often macabre imagery of the painted doors. These paintings have specific ritual functions, unlike the paintings found on the majority of Tibetan furniture, which are essentially decorative. The purpose and decoration of these special cabinets is the subject of a separate chapter, Furniture for the Wrathful Gods.

BUTTER LAMP AND OFFERING STANDS

Rows of butter lamps ranged in front of altars are a familiar sight in Tibetan temples. Many butter lamps burn throughout the year, but especially during New Year celebrations the temples seem ablaze with lamps (fig. 41). Butter lamps come in all sizes, though the commonest type by far is a small brass lamp burning yak butter or

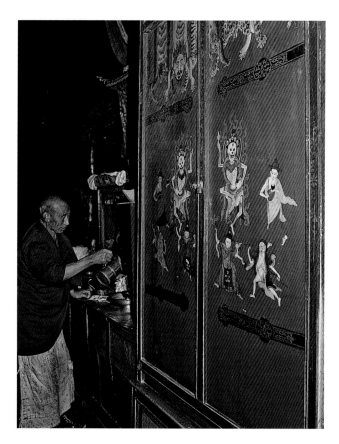

imported Indian ghee. During festivals and pilgrimages Tibetans will follow a ritual circuit through the temples, adding butter to the lamps in the shrines or lighting new lamps along the way.

Butter lamps are usually placed on tabletops or any available surface; however, stands are made especially for holding them (see fig. 172). This particularly ancient example shows the classic form for this type of furniture, a carved wooden stand with three tiers for lamps. This type of furniture is comparatively rare; most Tibetan stands that are still in use today consist merely of beaten metal shelves or some other makeshift arrangement. Most antique examples have the same shape as this example, but lack the intricate carved decoration.

In addition to supporting butter lamp offerings, stands of this kind are also used for supporting another characteristic Tibetan offering that consists of a row of brass or silver bowls, placed close to each other but not quite touching and filled almost to the brim with clean water. Generally these are made in sets of seven, though larger sets are also found. These bowls are often set out together with butter lamps and are renewed daily.

Lhasa furniture makers and dealers sometimes call these open stands *chösum*, using the same word that is used for covered shrine cabinets housing statues of deities. The three-tier butter lamp stand seems to be a distinct type, however, with its own unique form and history.

REGIONAL FURNITURE STYLES

Undoubtedly a great many regional variations in style of furniture construction and decoration existed within Tibet; however, presently only some of the broadest stylistic differences are known. Although there is a great deal of furniture dealer folklore about regional designs, some of this is contradictory, so I have confined myself to describing the variations which I have been able to verify directly from furniture still in situ. A certain amount of furniture can still be seen in its original locations, particularly in larger monasteries in central Tibet such as Drepung, Sera, Tsurphu, Shigatse, and Sakya, and this verification provides the most useful method of determining regional style.

From the point of view of furniture styles we can divide Tibet into three regions, which include areas of Tibetan culture beyond what is today considered politi-

40 (ABOVE). A LARGE OFFERING CABINET IN A PROTECTOR DEITY CHAPEL AT DREPUNG MONASTERY NEAR LHASA. 18TH OR 19TH CENTURY.
41 (BELOW). LIGHTING BUTTER LAMPS AT THE JOKHANG TEMPLE IN LHASA.

cal Tibet. Eastern Tibet includes Kham and Amdo in Tibet "proper," as well as parts of present-day Sichuan, Yunnan, Gansu, and Qinghai provinces. Central Tibet is centered on Lhasa and includes the regions to the south and to the west as far as Shigatse. Far western Tibet encompasses the sparsely populated regions to the west of Shigatse, as far west as Ladakh.

The most clearly discerned variations in style are those between chests and other furniture from eastern Tibet and those from the central region, while only a limited amount is known at present about furniture styles from the far west.

EASTERN TIBET

Chests from eastern Tibet have a distinctive style. Most eastern Tibetan chests are variations on the straight-sided type, though a few sloping-sided chests are known from this region. Eastern Tibetan chests tend to be made of heavier timbers than those from central regions and they are often finished to a higher standard in terms of joinery and precision. Correspondingly they usually have less ironwork than chests from the central regions, with some examples having very few iron straps or even none at all.

The proportions of eastern Tibetan chests are more variable than those from central Tibet and they include a fair number of chests that are taller in relation to their width than typical examples from the central regions. The painting on eastern Tibetan furniture tends to be applied directly to the wood surface, without the intervening fabric covering sometimes found on central Tibetan furniture. Occasionally, painted chests are found with yak-hide coverings.

The designs on eastern Tibetan chests (see figs. 121, 130, 133, and 137) tend to be somewhat different in style and themes compared with designs from the central regions. Characteristic designs from eastern Tibet include tigers and tiger-skin variations, the mythical *zeeba*, and "Chinese" auspicious designs. Borders with a square meander (key-fret) pattern are also a characteristic feature. In places where Tibetan people live side by side with Han Chinese and other ethnic groups on the far eastern borders of Tibet (now in Qinghai, Gansu, Sichuan, and Yunnan provinces) Tibetan furniture styles overlap with mainland Chinese styles. Tibetan-style

folding tables can be found in temples in Yunnan province, for example, alongside lacquered tables that clearly reflect Chinese styles.

CENTRAL TIBET

The styles from this area have come to be regarded as those of "classic" Tibetan furniture. Within this region, which includes Lhasa and surrounding areas, there may be further regional variations; however, these are difficult to discern, probably because furniture has been traded and transported widely within this region.

A typical inventory of old chests and other furniture from the central region can be seen in the large monastic complex at Drepung near Lhasa. This monastery was both wealthy and powerful in former times and has retained a fair amount of its furniture. Recently I surveyed the chests on display in some of the areas open to the public, finding a total of forty-eight chests. This represents only part of the total inventory of this site and it changes each time I visit, but it provides a good idea of the range of styles that can be found at a single location. I was able to assign the pieces I saw to the following categories:

- Straight-sided chests covered with undecorated leather, mostly small 20
- Straight-sided chests with gold-on-red decoration 11
- Other straight-sided chests with various painted designs 5
- Sloping-sided, scalloped-lid chests, plain or with simple decoration 3
- Uncategorized chests 9

The interesting feature of this list is that it includes examples of most of the major types of chests that are associated with central Tibet. It probably documents changing fashions in this region: for example the gold-on-red decorative style is associated with later chests and other furniture that mainly date from the eighteenth century onwards. This style of decoration seems to be characteristic of the central Tibetan region around Lhasa, at least as far west as Shigatse and as far north as the Kagyupa monastery at Tsurphu, since I have seen chests of this type in all these locations. There are probably more of the gold-on-red type in Drepung simply because they were made more recently and are more

likely to have survived to the present than chests from earlier periods. The sloping-sided chests and some of the other straight-sided chests at this site seem to be older, dating from the seventeenth century or earlier, and are correspondingly fewer in number.

The large sloping-sided chests with scalloped decoration and heavy iron straps seem to be a particular feature of the central region; I have not seen this type in the regions to the west of Lhasa, for example. Dealer folklore says that this type originates from the Tsang region to the south of Lhasa. However, I have not been able to verify this personally. On the contrary, I have seen several chests of this type in monasteries in the central region near Lhasa, and Tsurphu monastery, which lies well to the north of Lhasa, has at least one example of a sloping-sided chest with scalloped decoration. Monasteries in the regions to the south, for example in the area around Tsedang, contain few chests these days, and the ones that I have seen so far that seem to be in their original locations are all of the straight-sided type.

FAR WESTERN TIBET

The furniture styles of this region are not as well-known at present as those from the eastern and central regions. Western Tibet was home to the prosperous Guge kingdom until the early seventeenth century, after which it fell into decline, in part because of a gradual drying of the climate that made agriculture and settlement harder to sustain. The great monastic centers at Tholing, Tsaparang, and Piyang probably had large collections of furniture at one time, but these must have been dispersed and lost as these centers declined in influence.

Recently a few furniture items have been emerging from the western regions. One chest that seems to be of relatively early date (see fig. 132) is painted in a distinctive style with two lions in roundels with pearl borders. The decorative style of this chest has close links with the wall paintings at Tholing, which suggests that it may have been made nearby.

A number of other items have also come to light, mainly chests and reading desks. The most distinctive

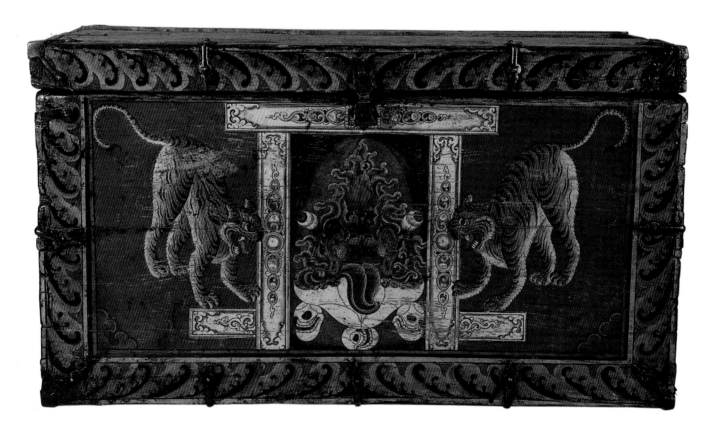

42 (ABOVE). PAINTED WOODEN CHEST SHOWING ELEMENTS OF WESTERN TIBETAN DECORATIVE STYLE. PAINTING LATE 19TH CENTURY, ALTHOUGH THE CHEST MAY BE OLDER.
43 (FACING). TOP-QUALITY MODERN PAINTING AND GESSO WORK ON A CABINET IN A LHASA HOME.

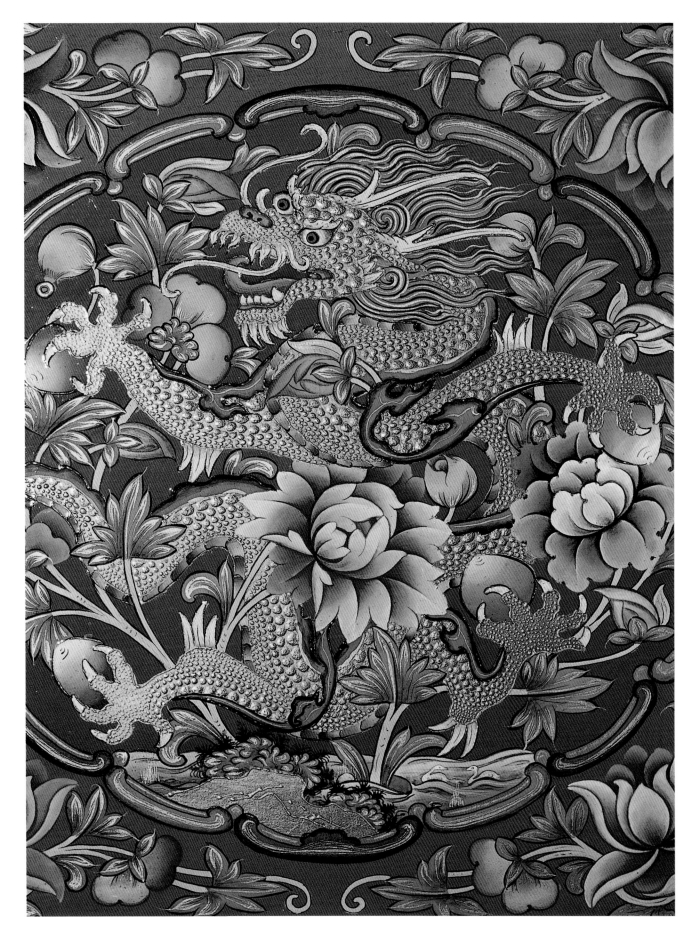

feature of their designs seems to be roundels with symmetrical motifs including stylized animals in groups of two, four, or eight. These designs also have links with various styles of ancient mural paintings from western Tibet. Another constant feature of western Tibetan decorative style seems to be the inclusion of areas of painting which consist of black outlining on a single-color, usually white, background, such as the decorative panels framing the central offering on a nineteenth-century chest (fig. 42). This feature can also be traced back to mural paintings from the same region from the sixteenth century and earlier, and it may have its origins in Nepalese styles, which influenced the art of this region to a greater degree than other areas. The subject of this particular painting is a rather unusual one for a chest: it depicts a fierce offering of human sense organs in an upturned skull, flanked by two tigers. A chest with such a specific type of decoration would have been used in a shrine to a protector deity (*gonkhang*), perhaps to house ritual implements or clothing.

Furniture from the late nineteenth and twentieth century still in situ in temples in western Tibet and in Ladakh, including low tables, folding tables, and chests, mostly resembles furniture from central Tibet. It may be that the earlier style has largely died out in most parts of western Tibet and been replaced by furniture either imported from the central regions or else made locally and copying this "universal" style. More investigation is needed in order to understand what the western Tibetan furniture style consisted of and how long it persisted.

MODERN CLASSICAL FURNITURE

Tibetan furniture making is fortunately still a living tradition. Recent years have seen an expansion of this industry, which is now centered on Lhasa. Small workshops have sprung up, producing cabinets, shrine cabinets, and tea tables. On any fine sunny day one can see furniture painters at work in the back streets in the old town. Their business is mainly in making the uniquely Tibetan items that are not mass-produced in China, such as tea tables and carved shrine cabinets. The quality of work varies, as it always has, from the rough-and-ready to the exquisite (fig. 43). Certain painters are particularly respected and sought after: a complete set of cabinets painted by one lama in Shigatse is rumored to cost the equivalent of several thousand dollars. Routine painted decoration is left to local artisans, but when special painting with religious significance is required a skilled artist is drafted. Nechung monastery recently acquired a fine new set of offering cabinets for a protector deity chapel with marvelous paintings of the Host of Ornaments type. For this work an artist from Gyantse was brought in, from some distance and no doubt at some expense. As noted, possessing the finest quality painted furniture is a sign of taste and discernment.

Large storage chests are rarely produced these days, though smaller chests are still used by merchants and nomads. Today the emphasis is on strength and lightness so modern traveling chests are made from zinc-plated steel. These inexpensive chests (fig. 44), painted with colorful designs, can be seen piled up in the markets in Lhasa.

44 (FACING). STACK OF MODERN PAINTED CHESTS AT A LHASA SHOP, FABRICATED FROM ZINC-PLATED STEEL.

THEMES AND DECORATION

In Tibetan furniture, decoration is what chiefly attracts our attention and determines aesthetic value. As described in the previous chapter, the materials and construction of Tibetan furniture have their own individual character, but for the most part Tibetan furniture is not particularly noteworthy for its wood or its joinery. Decoration, on the other hand, adds beauty and meaning to Tibetan furniture and is what makes it special. This chapter is again divided into two parts. The first part deals with the origins and history of Tibetan furniture designs, while the second introduces various patterns and symbols, including universal designs such as the dragon and snow lion.

ORIGINS AND MEANING

A love of color and texture is the most obvious feature of Tibetan painted furniture. Tibetan artists often filled every available space on their furniture with paint, gesso, and gilding. Some of the decorative patterns they used are based on native Tibetan motifs, others are designs that were absorbed by Tibetan culture long ago or made popular in more recent times as a result of trade with China. The richness and variety of the Tibetan tradition seems to be partly the result of these contacts and exchanges, extending back more than a thousand years. We can roughly divide Tibetan decorative motifs into three classes on the basis of their origins.

Religious symbols. Symbols such as the endless knot, lotus, *vajra,* Dharma wheel, and flaming jewel (fig. 46) are often explained in terms of religious significance. In fact, their meanings have evolved over time; most are ancient shapes that have taken on new meanings within the Buddhist and Bon religions. The wheel symbol, for example, was present in pre-Buddhist India, but for Buddhists it came to represent the Buddha and his teachings. Some of these symbols have been part of Tibetan culture for thousands of years; others were introduced along with Buddhist teachings between the seventh and the twelfth centuries. During this time a great many artists from India, Nepal, and Kashmir worked in Tibet, commissioned by Tibetan patrons to create artworks such as temple murals and paintings, and they brought their motifs and symbols with them.

Decorative designs. In addition to symbols with specific meanings Tibetan artists also used a great many purely decorative designs. Tracing the origins of these designs is difficult since many have almost universal currency. Scrolls of stylized vegetation, for example, are found in many cultures across Asia and Europe, and a border that consists of flowers on an undulating vine is found in decoration all across Asia. In some cases, however, the shapes of the elements on a particular piece of furniture may suggest a specific prototype.

Tibetan artists were most obviously inspired by the patterns they saw in precious imported objects such as

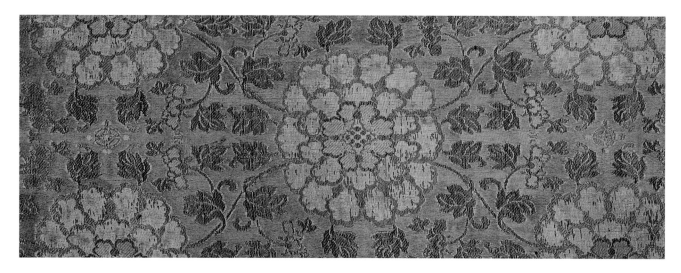

45. TIBETAN RUNNER MADE OF IMPORTED CHINESE SILK WITH FLORAL VINE DESIGN. 16TH OR 17TH CENTURY.

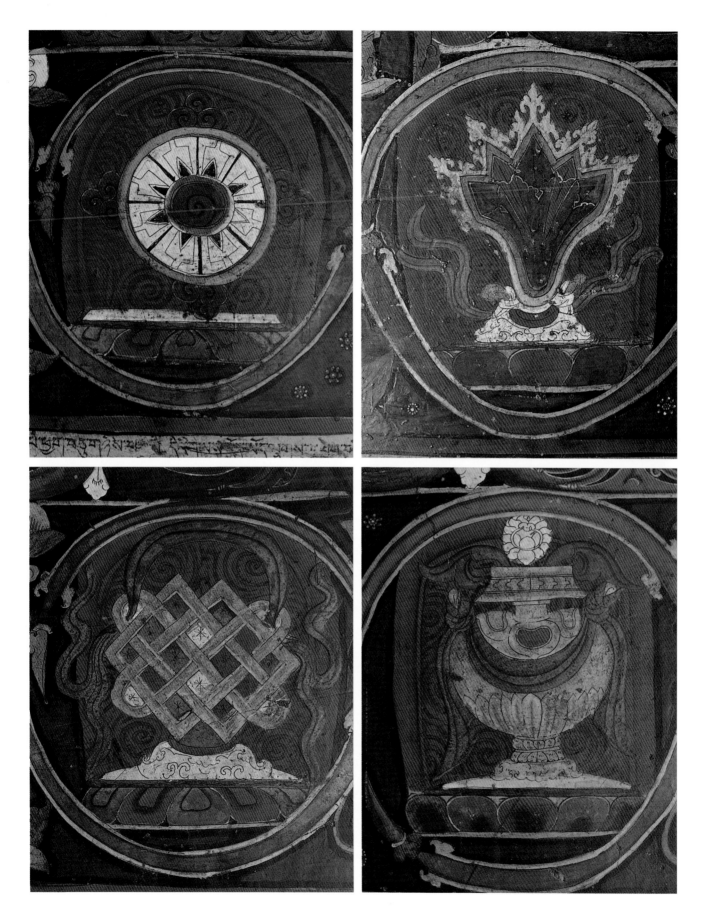

46. CLOCKWISE FROM TOP LEFT: DHARMA WHEEL, FLAMING JEWEL, VASE OF PLENTY, AND ENDLESS KNOT. GYANTSE KUMBUM, C. 1425.

Origins and Meaning

silks (fig. 45) and porcelain. In addition to the contributions of Indian and Kashmiri artists already mentioned, Tibetans living in the period between the seventh and twelfth centuries were also familiar with objects from the Sassanian culture to the west, from an area corresponding with present-day Iran, from the cultures of the Uighurs and others along the Silk Roads oases to the north, from the Xixia kingdom just to the east, from the Qidan culture in present-day Inner Mongolia, and from the Chinese dynasties to the east. Many items from these cultures have been found in Tibetan temples in recent years, though wooden furniture from this early period is rare. Many decorative motifs were absorbed and adapted during this period, however, as can be seen from surviving murals, scroll paintings, and metalwork.

From the fourteenth century onwards, the period from which most of the furniture in this book dates, the politics of the region changed substantially. The Buddhist cultures that formerly surrounded Tibet went into decline, for reasons as varied as the Muslim conquests and climate change. The dominating artistic, political, and cultural force in Asia from the fourteenth century onward was the Chinese empire to the east of Tibet. The Mongols, who conquered most of the Han Chinese people during the late thirteenth century and set themselves up as the Yuan dynasty (1279–1353) with their capital in Beijing, first defined this grouping in its modern form. Their hold on power was relatively short but the empire they created was continued by the Ming dynasty and endures, with modifications, up to the present day. As well as being politically strong the Ming dynasty also produced outstanding decorative arts, which reached new heights of sophistication and quality, so it was natural for Tibetan artists to seek inspiration from Chinese decorative styles during this period. As a result, many Tibetan designs can be seen as age-old motifs that have been reinterpreted in the light of Ming-dynasty Chinese decorative styles.

Auspicious symbols. In this category are the motifs that represent desires for long life, wealth, and happiness, as distinct from religious meanings specific to Buddhism or Bon. They include symbols such as the Chinese character *shou*, meaning longevity (fig. 47), and groups of five bats, symbols of good fortune. In Chinese the word for bat, *bian fu*, is a homophone for an expression meaning "to acquire wealth"; five is an auspicious, *yang* (odd) number, corresponding to the five cardinal directions, five elements, etc. These designs were

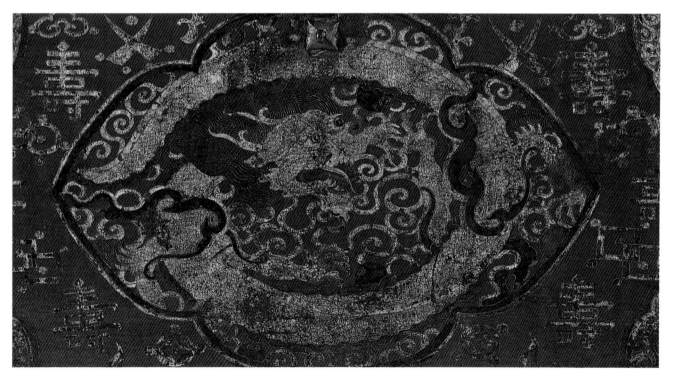

47. Auspicious symbols swirling about the central dragon on a chest include crossed rhinocerous horns, Chinese characters for longevity, *ruyi* (scepter) cloudlike shapes, and interlocking coin and rhombus shapes. 18th century.

Themes and Decoration

absorbed from Chinese art over a considerable period, although there seems to have been a surge in the popularity of Chinese-inspired auspicious symbolism in Tibetan furniture during the eighteenth and nineteenth centuries, mainly as a result of fashion trends amongst urban Tibetans. In the Chinese tradition these symbols have widely understood meanings, often related, as in the case of *bian fu*, to puns on the pronunciation of the names of the objects and to myths or folk beliefs. In the Tibetan language and culture these meanings and relationships are largely lost, the symbols being used as conventional decorative motifs rather than for any specific meaning they evoke.

FUNCTION OF FURNITURE DESIGNS

It is important to emphasize that the majority of furniture designs, even those that embody a religious component, did not make the item they were applied to an object of veneration in the same way that an important statue or painting was venerated. Most furniture designs form part of the familiar backdrop of Tibetan life and pass unregarded in daily life. The visual symbols and motifs themselves turn out to be far more durable than the meanings which are conventionally attached to them. The exceptions to this are certain paintings on objects with a specific religious function, particularly offering cabinets and prayer wheels.

DECORATIVE LAYOUT ON CHESTS

In most cases the overall layout of the design on the front panel of a painted chest follows a standard pattern, as, for example, that of figure 30. At the center of the design there is usually a decorative medallion containing an auspicious design, often surrounded by floral scrolls. The corners are usually filled with intertwining scrolls resembling the stems of plants. Later Tibetan chests from the seventeenth century onwards have particularly elaborate versions of these corner scrolls. The space in between may be filled with a textile-derived design or with other motifs, or left plain. Textile-inspired designs often form the background on straight-sided chests. They are not often used on sloping-sided chests, presumably because the parallel lines of a textile design would look awkward on a chest with sides that slope inwards.

At the outer edge of most of these decorative schemes is a border. This may be plain, but is more commonly filled with flowering vines, clouds, or some other repeating pattern. This general format is used across Asia for filling rectangular spaces with decoration and can be seen in such diverse examples as Persian rugs and the carved decoration on the inner walls in northern Chinese courtyard houses. Probably the most exact parallel is found in carved stone slabs and wall treatments (fig. 48) in Chinese temples. These rectangular panels often depict a mythical animal such as a *qilin* (a mix of stag, wolf, and horse, with a single horn) or dragon in a medallion shape, as on this wall. They often have the same characteristic corner scrolls and borders filled with a floral vine motif, showing that Chinese and Tibetan artists shared many common elements in their decorative vocabularies.

Tibetan chests from the sixteenth century and earlier are generally painted on the sides and sometimes on the top as well as the front face. Chests later in date (seventeenth century onward) are more often decorated on the front face only, sometimes with plain-colored side panels, most often red against a green background. Some chests (see fig. 149) are painted with pictorial scenes. In such cases the artist simply treated the face of the chest as a canvas, usually adding a plain border to the design.

In most cases the ironwork on chests and other Tibetan furniture seems to have been added after the painted design was completed, so that the painter was able to take advantage of the whole surface unhindered, though there are occasional exceptions. In some cases the ironwork covers up part of the painted design, sometimes even covering an important part such as the face of a figure or a decorative detail. It is thus fair to assume that in most workshops the person who added the ironwork was not the same as the one who painted the chest.

The relationship between painted decoration and ironwork is often a useful guide to establishing whether painted decoration on a piece of Tibetan furniture is contemporary with the item or added later. Most original painting is continuous underneath ironwork. Restorers or forgers of old furniture in Tibet rarely bother to remove ironwork before restoration, so their work can be spotted because the painting ends at the

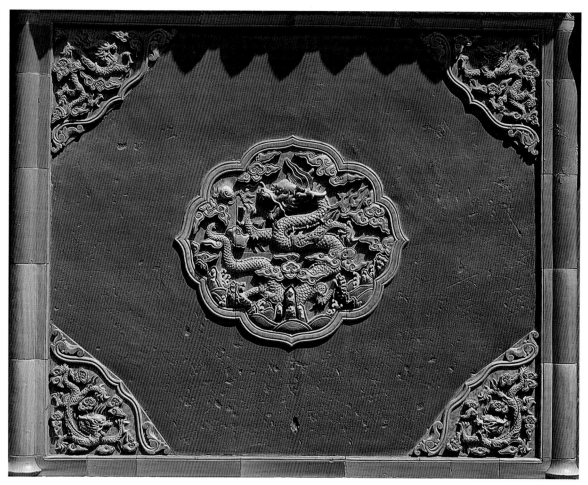

48. Glazed tile wall in the Forbidden City, Beijing, showing central medallion with corner scrollwork, a typical design layout on Tibetan chests.

edge of the ironwork. In some cases paint splashes on the ironwork itself give the game away. New painting is a particular problem with old portable leather chests; since painted chests are a great deal more valuable than the unpainted variety the temptation to add painting to an aged plain chest is strong.

DECORATIVE LAYOUT ON TABLES

The layout of decoration on the front and side panels of small folding tables usually differs from the format used for chests, even though the basic rectangular shape is similar. On small tables there is usually little or no border around the design. The central area is sometimes decorated with carved and painted openwork rather than painting. In a common variation it is divided vertically into two panels, occupied by a symmetrical pair of carved or painted animals (fig. 49). This arrangement, when combined with a tabletop that is sculpted into a

lotus-petal design, is reminiscent of the designs for the throne bases for Buddhist deities in paintings and sculptures. This form derives ultimately from Indian throne designs. Tibetans became familiar with this basic form when they acquired Buddhist artworks from India and other neighboring countries from the eighth century onwards. Some small tables were probably made for use as supports for Buddhist images, the format later becoming a standard one for this type of table.

DECORATIVE LAYOUT ON CABINETS

The layout of designs on cabinets usually follows one of two basic formats. In both cases the borders and frame timbers are usually filled with floral or geometric patterns. The cabinet doors, which are often roughly square, are either decorated with space-filling floral or other patterns (fig. 50) or else they are treated as canvases for pictorial illustrations (fig. 51).

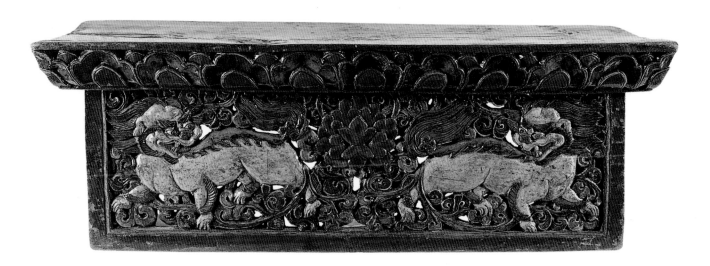

49. SMALL FOLDING TABLE DECORATED WITH OPENWORK DESIGN OF TWO SNOW LIONS. 16TH OR 17TH CENTURY.

50. DETAIL OF SQUARE CABINET DOOR PAINTED WITH ABSTRACT FLORAL DESIGN. 17TH OR 18TH CENTURY.

Decorative Layout on Cabinets

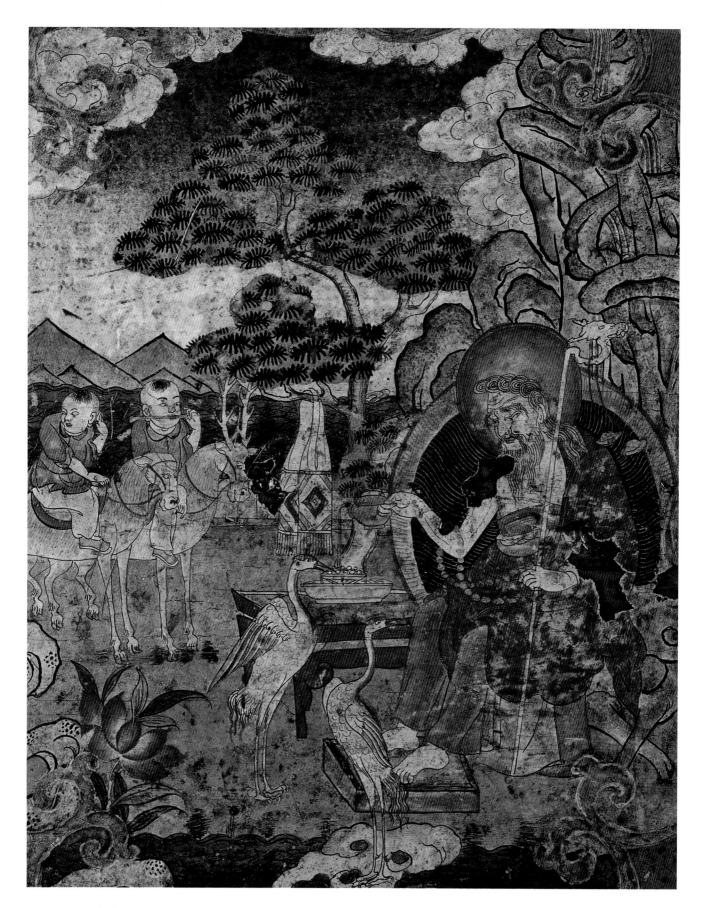

51. Chinese-inspired cabinet door painting showing elderly sage surrounded by symbols of lonegevity. 19th century.

HISTORY AND INFLUENCES

The story of Tibetan furniture designs over the last five centuries is primarily the story of the assimilation of Chinese decorative styles developed at the Ming and Qing courts (fourteenth through nineteenth centuries) and their adaptation by Tibetan artists. In scholarly circles it has become unfashionable to talk about "influence" in art and decorative styles; however, in this case the word is appropriate.

The main reason for this influence is that during this period China excelled above all in the production of luxury goods, particularly silks and porcelain, which were traded around the globe. Another important factor was the continuing interest by successive Chinese emperors in the Tibetan Buddhist religion. They made many donations of luxury goods to Tibetan monasteries and Tibetans came to associate these goods with wealth and taste. This was the association that Tibetans desired for their own furniture, so it was natural to turn to Chinese decorative designs as a source of inspiration. During this period, however, the Chinese influence on Tibetan life and art was limited to decorative fashions; religious beliefs in Tibet remained rooted in Indian and local traditions and were little influenced by those of neighboring China.

Despite the predominance of Chinese decorative styles during this period, the exchange of decorative ideas was not all one way. During the fourteenth and fifteenth centuries many Indian designs entered the Chinese decorative vocabulary via Tibetan and Newari (Nepalese) art. These include the *makara*, a kind of dragon with a nose like an elephant trunk and a foliate tail, the small scepter symbolizing compassion, called in Sanskrit *vajra* (*dorje* in Tibetan), and various designs for gems and precious offerings.

GIFTS FROM THE CHINESE COURT

Sponsorship of Tibetan religion by the Chinese emperor and his court was an important feature of the contacts between China and Tibet. This sponsorship began during the Yuan dynasty and was continued by the Ming and Qing emperors, who created Tibetan-style monasteries in Beijing such as the Yonghegong (popularly known as Lama Temple). This was in spite of the fact that the variety of Buddhist belief prevalent in China was a form of Mahayana quite different from the Tibetan Tantric variety. These contacts seem to have been maintained partly from genuine religious interest and partly to maintain political links with the powerful Tibetan monastic institutions. The exotic nature of Tibetan Buddhism with its intimations of occult knowledge and power also seems to have held a continuing fascination for the Chinese court, just as it does today for many outside Tibet.

The period during the fifteenth through seventeenth centuries was also a period of renewal for Tibetan Buddhism, associated with the expansion of religious institutions and the rise to dominance of the Gelug (Yellow Hat) sect, still the most populous sect in Tibet today. Many monasteries were created or enlarged during this period. The refurbishing of temples created a demand for luxury fabrics and other decorative items. As Tibet lacked native production in many of these areas it was natural to look to China for them.

The Chinese emperors supported large communities of artists and craftspeople in their capital, producing objects for the court. Many spent a compulsory period in Beijing annually, making items for the court as a kind of tax, while others were permanently employed. All excelled in their arts and the objects they created were of exquisite workmanship. As a result, many of the items that were donated to Tibetan monasteries were of outstanding quality, including superb painted porcelain, silk hangings, carpets, printed copies of sutras, woven silk *thangka*, gilded statues, and lacquer furniture.

TRADE WITH CHINA AND CENTRAL ASIA

In addition to items given as gifts even greater quantities of decorative goods entered Tibet via trade with merchants from China. Few records of this trade exist, however from the evidence of objects found in Tibet it is apparent that this has been an almost continuous exchange for at least the last thirteen-hundred years.

As mentioned in the Introduction, the traditional image of Tibet as an isolated region has always been far from the truth. Extensive trade was conducted through the eastern border regions, particularly Kham and Amdo

(modern-day Gansu, Sichuan, and Qinghai provinces). These areas are home to the Kham people, who are the preeminent traders and businesspeople in Tibet today. Tall Kham traders are easily spotted in Tibetan marketplaces, with their distinctive dress style and fondness for fine clothing and jewelry.

Over hundreds of years, traders bought and sold quantities of Chinese and Central Asian silks for making clothing, as well as silverware, jewelry, precious stones, and small porcelain bowls for use as tea bowls. As a result of their activities these materials became distributed throughout Tibet. Many Chinese silk fabrics were bought and incorporated into clothing for ceremonial and special occasions, worn both by lamas and wealthy lay Tibetans. Silk fabrics were also used for making altar cloths, temple banners (fig. 52), *thangka* mounts, aprons, and many other uses.

Many different kinds of textiles entered Tibet; among the most consistently popular with the Tibetan people were textiles with dragon designs. In China, bolts of cloth with dragon designs were produced for the use of the court, which included the vast apparatus of the civil service as well as the imperial family. The size and placement of dragons and other auspicious elements in these garments were precisely laid down by sumptuary regulations and customs, according to the ranks of the wearers. Tibetans liked the designs on these fabrics but had no such strictures about their use. Tibetan cloaks called *chuba*, made using Chinese textiles, look superficially similar to Chinese court robes; however, the fabrics were chosen for their decorative appeal and regal effect rather than to denote rank.

Despite the dominance of Chinese textiles they were not the only types imported into Tibet. Tibetan monasteries also acquired Indian textiles, at least from the Mughal period (mid-sixteenth century) onward, though in smaller quantities than the Chinese goods. Some of these Indian textiles have recently been re-exported from Tibet and are finding their way into museums and collections. Their influence on Tibetan design in recent centuries is harder to discern.

52. Tibetan temple banner made of Chinese silk embroidered with coiling dragon. 17th century.

Themes and Decoration

Patterns and Motifs

Medallion designs

Textile designs from the eleventh through fourteenth centuries seem to have had a significant influence on the basic layout of Tibetan decorative designs, particularly those on chests. A basic format that was current during that period consists of medallions containing an animal such as a dragon, set on a simple geometric or floral background. This type of design was also found in lacquer work, metalwork, and stone carving but Tibetan artists were most likely to have encountered it on imported textiles. Early leather chests found in Tibet sometimes have appliqué roundels of a similar general type (see fig. 25). There is a close similarity between these decorative designs and one of the most common Tibetan chest designs consisting of a roundel with a dragon or other auspicious beast set on a geometric or floral background.

Geometric designs based on textiles

Many characteristic background patterns on Tibetan furniture seem to have been inspired by textile designs. These repeating designs were first developed between the seventh and twelfth centuries, when silk fabrics with geometric designs became popular. Common types include the hexagon design (fig. 53), interlocking-Y designs (fig. 54), a Chinese lattice design called *wanzi*, and coins. The interlocking-Y design may derive from the pattern of interlocking plates on ancient Chinese armor. The Chinese lattice comes in a variety of forms and is based around the auspicious swastika symbol (fig. 55; see also fig. 69). These lattice designs create a lively effect since the swastika lends a twist to the pattern, and many of them occur in right-handed and left-handed (mirror image) forms. They are commonly seen in furniture from China and Tibet and on textiles from most parts of Asia. All of these geometric designs occur in painted form on Tibetan furniture, especially on chests as background fills between other parts of the design.

53. Joined hexagon motif, derived from textile patterns and typical of Tibetan designs from the 18th century and earlier.

54. *Wanzi* lattice (inner part) and coin lattice (outer part) designs from an 18th-century chest.

55. Decorative *WANZI* lattice motif composed of linked swastikas. 18th or 19th century.

BROCADE ROUNDELS AND SQUARES

One of the most enduring types of geometric textile design was a brocade design, called *kedi* in Tibetan, consisting of a geometric arrangement of linked roundels and squares, the intervening spaces usually being filled with other geometric patterns and flowers. This design was produced in various forms from the twelfth century right through the nineteenth century (figs. 56, 57), although the most distinctive and complex designs seem to be those produced between the fourteenth and sixteenth centuries. These textiles were particularly popular in Tibet; many examples can still be seen today in monasteries, in use as ceiling coverings, hangings, in clothing, and in mountings for *thangka*.

The Tibetan fondness for copying textile designs onto chests seems to have been an extension of the habit of covering chests with silk textiles. Leather chests sometimes have decorative panels inset with textiles, for example, a Ming-dynasty brocade (fig. 58). Some furniture designs (fig. 59; see also fig. 123) seem to be direct copies of brocade patterns, designed to give the impression of a sumptuous fabric covering. More commonly, chests were decorated with a simplified version consisting of squares and roundels linked by bars, with no intention to deceive the eye. This design took on a life

of its own in Tibet and was used for decorating furniture, doors, and architectural elements (fig. 60). It is still used today by Tibetan painters, its origins having been forgotten in many cases.

56. A FAVORED BROCADE DESIGN TYPE CONSISTING OF
LINKED ROUNDELS AND SQUARES. 15TH OR 16TH CENTURY.

57. Linked squares-and-roundels motif on Chinese silk. 16th or 17th century.

58. Leather-covered chest inset with Ming-dynasty brocade piece. 16th or 17th century.

59. Painted chest design closely following Chinese silk brocade pattern. 17th century.

60. DOORWAY PAINTED WITH SIMPLIFIED VERSION OF SILK BROCADE DESIGN. SAMYE MONASTERY.

FLORAL MOTIFS

Floral and plant motifs were most often used in the same manner as geometric patterns, for filling in backgrounds and for providing repeating designs for border areas. Border patterns on chests are often stylized flowers and vines, loosely referred to as either peony or lotus with little distinction made between these different species in Tibetan art. In many cases the versions of these found on Tibetan furniture are based on prototypes from Indian and Nepalese art, modified by exposure to Chinese designs from later centuries (figs. 61, 62). The prominent floral borders and background fills on many Tibetan chests (see figs. 123, 124) resemble Chinese designs from the fourteenth and fifteenth centuries, familiar to Tibetan artisans from porcelain, carved stonework, and other decorative arts from this period.

61. CHINESE SILK TEXTILE WITH VINE DESIGN. 17TH OR 18TH CENTURY.

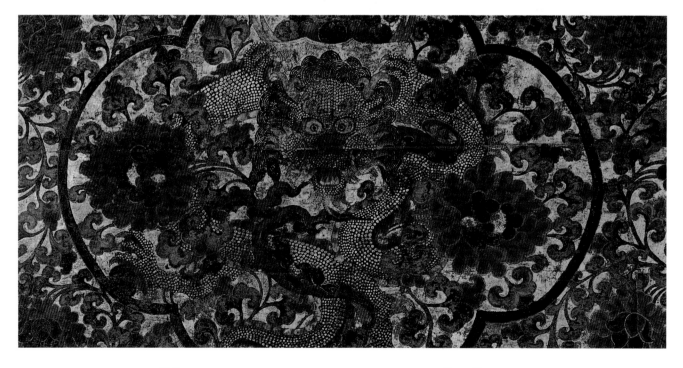

62. DRAGON MEDALLION ENMESHED WITH FLOWERS AND DENSE FOLIAGE. CHEST, 18TH CENTURY.

Themes and Decoration

CLOUD PATTERNS

Stylized cloud designs (figs. 63, 64) are also found as border designs on chests and occasionally on other furniture types. The cloud shapes are usually multicolored and set on a dark blue or green background. Cloud designs underwent subtle changes during their long history and can sometimes be used as guides to dating furniture items. Puffier clouds tend to be characteristic of pre-eighteenth century designs, while narrower, elongated shapes linked together are more characteristic of items dating to the eighteenth century and later.

BORDER MEANDER DESIGNS

The geometric meander known as the key fret (fig. 65) has several variations. The common characteristic they all share is that they are linear and angular in shape. The key-fret design is a very ancient one, but it became especially popular with Tibetan and Chinese furniture makers during the eighteenth and nineteenth centuries. It is a characteristic feature of furniture produced in the eastern part of Tibet, where the influence of Chinese decorative styles was strongest.

63. ROUNDED CLOUD SHAPES CHARACTERISTIC OF EARLY AND MID-MING-PERIOD TEXTILES. 15TH OR 16TH CENTURY.

64. PAINTED CLOUD DESIGN. CHEST, CIRCA 16TH CENTURY.

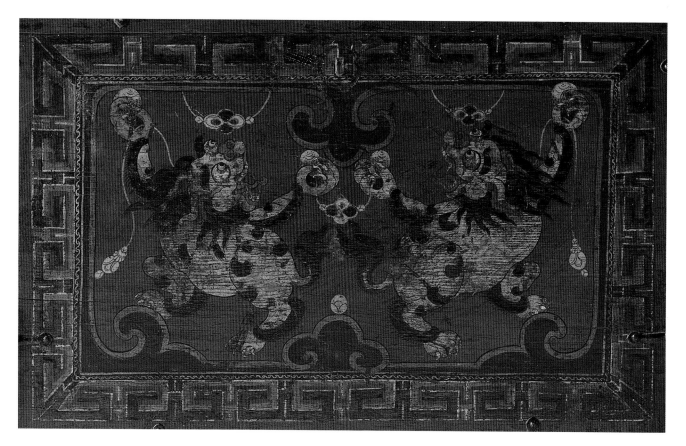

65. KEY-FRET DESIGN FRAMING CENTRAL MOTIF OF TWIN SNOW LIONS. CHEST, 18TH OR 19TH CENTURY.

SYMBOLS

Tibetan decorative arts incorporate a huge range of symbols, many of which have specific meanings in addition to decorative uses. Meanings were not constant, however, and many of the most widespread motifs such as the wheel and the conch have changed in their significance over the centuries and from place to place, though the shapes themselves have changed little. This is a striking testament to the hold on the imagination that these simple forms exert.

PRECIOUS JEWEL

The motif of the jewel, *norbu,* permeates Tibetan art; it has many meanings, the most basic of which is a precious offering. Jewels are painted as multicolored round or oval shapes, sometimes with flames licking up around them to symbolize the fact that these are no ordinary gems. Dragons and other figures on Tibetan furniture frequently hold trays of these kinds of offerings aloft. Piles of jewels represent offerings to deities in both the Buddhist and Bon religions.

Jewels are sometimes found as the main subject in furniture decoration; they are particularly characteristic of chests from the sixteenth century and earlier. When they are the centerpieces of the design they are usually painted as a bundle of elongated flaming gems with rounded ends, or, in a related version of this design (called *norbu membar* in Tibetan), as a single elongated, eight-faceted gem with flames playing all around it (fig. 67).

Another form of jewel decoration found throughout Tibetan art is the triple gem (fig. 66). This is a group of three rounded gems of different colors, sometimes depicted enveloped in flames. In Tibetan Buddhism this group symbolizes the three components of Buddhist society: the Buddha, the Buddhist teachings (Dharma), and the Buddhist community (Sangha).

66. Triple-gem motif, borne by waves in this instance.

67. Medallion with flaming-jewel motif. 15th or 16th century.

Precious Jewel

Vajra

The ritual implement call in Sanskrit *vajra*, or *dorje* in Tibetan (fig. 68), is an important symbol in Tibetan Buddhism. It is used in various ceremonies performed by monks, who hold it in the right hand while wielding a ritual bell called *ghanta* or *drilbu* in the left hand. Together these two objects symbolize the union of wisdom and compassion and also of female and male principles. This idea of union is a central concept in Buddhist teachings, representing the state of enlightenment.

The origins of the Tibetan *vajra* probably lie in Vedic (pre-Buddhist) India. The *vajra* is the weapon of the god Indra, analogous to the thunderbolt of Zeus. The shape of the *vajra* has changed since Vedic times, but the normal form in Tibet is a symmetrical double-pointed shaft with a number of prongs at either end. A painted *vajra* may be found on furniture, where it usually signals a link with Tantric Buddhism, such as on an object used in a temple or in connection with religious rites.

Swastika

This ancient symbol, *yungdrung* in Tibetan, is far older than either the Buddhist or Bon religion, although it is associated with these beliefs in Tibet. In other parts of Asia the swastika is sometimes associated with Buddhism and sometimes regarded as more of a general symbol of good fortune and prosperity, such as its use in auspicious lattice designs among the Han Chinese.

The counterclockwise form of the swastika is associated with the Bon faith in Tibet, while the clockwise form is usually associated with Buddhist belief. Bon paintings that feature swastikas invariably show the counterclockwise version, however it does not always follow that a counterclockwise rotating swastika indicates a Bon artifact. The reason is that Tibetan Buddhists are less particular about this symbol than their Bon counterparts and commonly use both forms of the swastika, often in the same decorative scheme. I have often seen carpets and other textiles in Tibet in Buddhist temples that incorporate symmetrical pairs of clockwise and counterclockwise swastikas.

Nevertheless, objects that are only decorated with the counter-rotating form are at least fair candidates for having come from Bon temples or households. A design

68. The ritual object called *dorje*, a symbol of wisdom and enlightenment. Gyantse Kumbum, early 15th century.

of swastikas mingled with auspicious Chinese characters, typically *shou*, meaning long life (fig. 69), is perhaps the most common use of the swastika symbol on Tibetan furniture. I have seen chests decorated with clockwise and with counterclockwise varieties of this design.

Four-color disc

This symbol consists of what appear to be four elongated commas of different colors swirling around a disc (fig. 70). It looks superficially similar to the Chinese *taiji* symbol that has two colored sections, but the Tibetan version, called *norbu gakyil* (jewel disc) has a different meaning. The four sections, usually red, yellow, green, and blue, are regarded as representing the four elements: fire, earth, air or space, and water respectively. In a Buddhist context the four colors can also symbolize the Four Noble Truths communicated by the Buddha, which give insight into the nature of suffering and how to obtain liberation from it.

69. Chest with a counterclockwise rotating swastika indicating Bon faith, surrounded by Chinese characters meaning long life.

The four-color disc occurs quite often in furniture decoration, for example, on the lids or sides of some chests (see fig. 119). Two- and three-color versions of the disc are also seen.

THE EIGHT PRECIOUS OBJECTS

These are a group of auspicious objects that are often found together in Tibetan art. They were included in the furniture designs as well as in daily-use objects as varied as tea bowls, temple hangings (fig. 71), and tents. The set of Eight Precious Objects (*Tashi Dargye* in Tibetan) is widely used in modern Tibet and can be seen painted on the walls inside homes and on hangings in doorways in Lhasa, where they represent wishes for good fortune. They are usually found as subsidiary motifs in furniture designs. The exceptions are the lotus and the wheel; these two symbols sometimes form the main subjects of furniture designs because of their special significance.

Various explanations of the significance of the Eight Precious Objects are circulated. One version holds that they represent offerings from the gods to the Buddha after he succeeded in obtaining enlightenment. Other

70. Four-color disc motif, representing the four elements: earth, fire, air, and water. Chest, 17th or 18th century.

The Eight Precious Objects

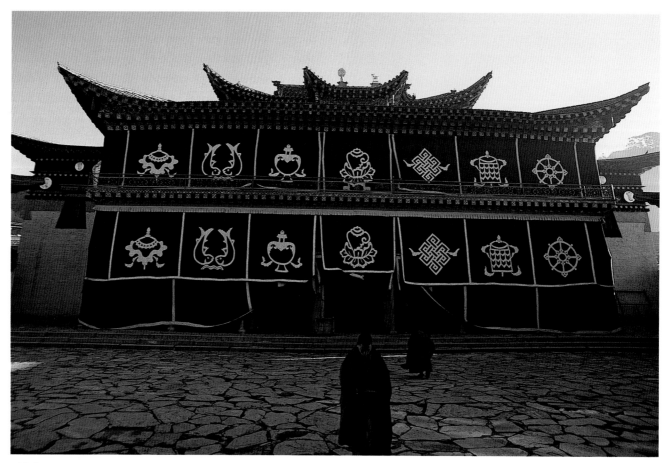

71. ROWS OF TEMPLE HANGINGS DEPICTING THE EIGHT PRECIOUS OBJECTS (LEFT TO RIGHT): PARASOL, PAIR OF FISH, VASE OF PLENTY, CONCH AND LOTUS (CENTER), ENDLESS KNOT, VICTORY BANNER, DHARMA WHEEL. LANGMUSI TEMPLE, MODERN.

explanations include that they represent marks on the Buddha's feet or symbolize his vital organs.

TIBETAN SET OF PRECIOUS OBJECTS

Lotus flower (pema). The lotus (fig. 73) is a symbol of purity and of enlightenment. The blossoming of a lotus flower from the mud symbolizes the possibility of enlightenment arising from mundane existence.

Wheel (khorlo). The wheel (fig. 72) was adopted by Buddhists to symbolize the Buddha and his teachings (Dharma). It is also commonly found as an attribute of certain deities in Bon art. The eight spokes of the wheel can symbolize the Eightfold Path, a list of activities undertaken to attain enlightenment. The wheel symbol can be seen on the roofs of Buddhist temples in Tibet, between a pair of seated deer, symbolizing the Buddha's first sermon in the Deer Park at Sarnath in India. The wheel carries the additional meaning of authority, both the authority to teach and the authority to rule.

Endless knot. This is a popular decorative symbol throughout Tibet, often seen on door hangings in Lhasa as well as in other contexts. The knot is said to symbolize endless and indivisible wisdom and compassion.

Conch. The conch is an ancient symbol that started out as a war trumpet used by early Indian tribes. Shell trumpets are commonly used during ceremonies in Tibetan temples. The conch symbolizes the promulgation of teachings.

Parasol. The parasol symbolizes protection and royal status.

Pair of fish. The pair of fish is an ancient symbol known across most of Asia in Hindu, Buddhist, and other traditions. They have a variety of meanings but most commonly symbolize good fortune and abundance.

Victory banner. This symbol is thought to be derived from the banners that were hoisted on ancient Indian war chariots. It became a symbol of victory in battle over one's foes; in Tibetan belief it was adopted as a symbol of

the victory of religious teachings over evil or competing belief systems.

Vase of plenty (tergyi bumpa). The vase of plenty, or treasure vase, has several meanings, including good fortune and abundance. It can hold the elixir of immortality and hence it also represents a wish for long life.

This set of Eight Precious Objects is occasionally augmented or replaced by other symbols, such as gems and trays of precious jewels, which are discussed separately.

CHINESE SETS OF PRECIOUS OBJECTS

Some Tibetan furniture is decorated with a different set of precious objects derived from Chinese tradition (see fig. 78). In a similar manner to the Tibetan set, the Chinese set of Eight Precious Objects evolved over time: earlier examples tend to be more variable than later ones in terms of the objects included and their total number.

72. WHEEL SYMBOLIZING THE DHARMA, WITH SWIRLING DISC IN CENTER. CHEST, 16TH CENTURY OR EARLIER.

73. MEDALLION PAINTED WITH LOTUS-FLOWER DESIGN. CHEST, 18TH CENTURY.

These changes as well as drawing styles can sometimes be useful as a guide to dating furniture. Figures 118 and 156 show examples of earlier furniture pieces that include Chinese precious objects in their decoration.

Earlier Chinese sets, dating from the thirteenth to fifteenth centuries, known from blue and white porcelain from this period for example, typically include selections of between six and ten objects from the following list: gold ingots, coins, a pair of rhino horn cups, books bound with ribbons, coral, a lozenge shape, *ruyi* (a kind of scepter, which appears as a curling cloud shape), three flaming jewels, a conch, a flaming pearl, and an artemisia leaf. Later sets are more likely to have exactly eight members. The flaming jewel and conch are common to both Tibetan and Chinese sets.

DRAGON

The dragon, *druk* in Tibetan, is ubiquitous in Asian art, typically representing power and authority, particularly that of kings and emperors. Unlike in the West, the Asian dragon is generally a benign creature, and associated with water rather than fire. In the hands of Tibetan artists the dragon became the centerpiece of a variety of decorative designs, while at the same time acquiring some playful and individual characteristics.

The origins of this mythical animal are debatable, but it is likely that it has had indigenous beginnings in many different cultures across Asia. The dragon we imagine today represents a synthesis of these types. Some of the earliest dragonlike animals seem to have been aquatic serpents; a tradition of this type of wingless dragon exists across Asian and Southeast Asian cultures and stretches back to prehistoric times. In Southeast Asia and India these water serpents are called *naga* and and figure in many myths and legends. The *naga* is recognized as a separate animal in Tibetan art and is sometimes painted or sculpted on the sides of elaborately decorated thrones for deities, but rarely encountered in furniture designs. In central China, where the dragon symbol has been most thoroughly researched, the dragon seems to have evolved from its aquatic ancestors into an animal with the power of flight, traditionally considered to live in the space between heaven and earth. The Chinese dragon had

acquired all the basic features it still possesses today by the Han dynasty (206 BC–AD 221).

From the time it was first imagined, the Chinese dragon seems to have been a hybrid of different animals: Chinese artists during the Ming and Qing dynasties (fourteenth through nineteenth centuries) were guided by a traditional formula that describes the beast as having "the head of a camel, the horns of a deer, the eyes of a demon, the body of a snake, the scales of a fish, the belly of a frog, the ears of a cow, the legs of a tiger, and the claws of an eagle," attributes called the "nine likenesses." Aside from the anatomical difficulties posed by fitting this list of animal parts together, the resemblances can often be seen in the dragons from these periods that are depicted on Chinese textiles and Tibetan furniture.

EARLY DEPICTIONS OF DRAGONS IN TIBET

In Tibet the dragon dates back at least to the early royal period, from the seventh to ninth centuries. The *druk* lived in the sky and produced thunder. A second kind of dragon, called *lu*, lived in water. The *lu* is closely related to other water dragons, such as the *naga*. The forms of these early Tibetan dragons have been less well researched than their Chinese counterparts and relatively few examples are known. Some of the earliest surviving depictions in central Tibet are on the capitals of columns in Karchu (Kechu) temple, built in the eighth century. Two of the carvings show lithe, dragonlike creatures (fig. 74) that seem to reflect a local Tibetan style. Interestingly, both these dragons have upturned elephant-trunk snouts, a feature that is also present in many Tibetan dragons from much later periods.

The dragon designs seen on furniture from more recent centuries are distinctively Tibetan, but have close links with Han Chinese art. For this reason comparison of Tibetan dragon designs with the better-studied field of Chinese and other Asian textiles is a useful way to establish a chronology and to estimate the dates of many Tibetan designs. As with other motifs, however, Tibetans imported ideas and adapted them to their own tastes and uses, developing new variations that are not seen in Chinese art and sometimes preserving archaic forms long after they had fallen out of favor in other regions.

A superb pair of dragons (fig. 75) was painted on the wall of a chapel in Shalu monastery in central Tibet during the fourteenth century. These dragons are good examples of the painting styles of this period and show many of the features that can also be seen in dragons on the very oldest Tibetan furniture. These creatures have elongated and sinewy forms that make them seem full of motion and energy, and they are depicted flying over a background of clouds or waves. Their heads are small in relation to their bodies and are long and narrow rather

74. Carved dragon at an eighth-century temple in central Tibet.

75. Dragons painted on a wall at Shalu monastery in central Tibet. 14th century.

Early Depictions of Dragons

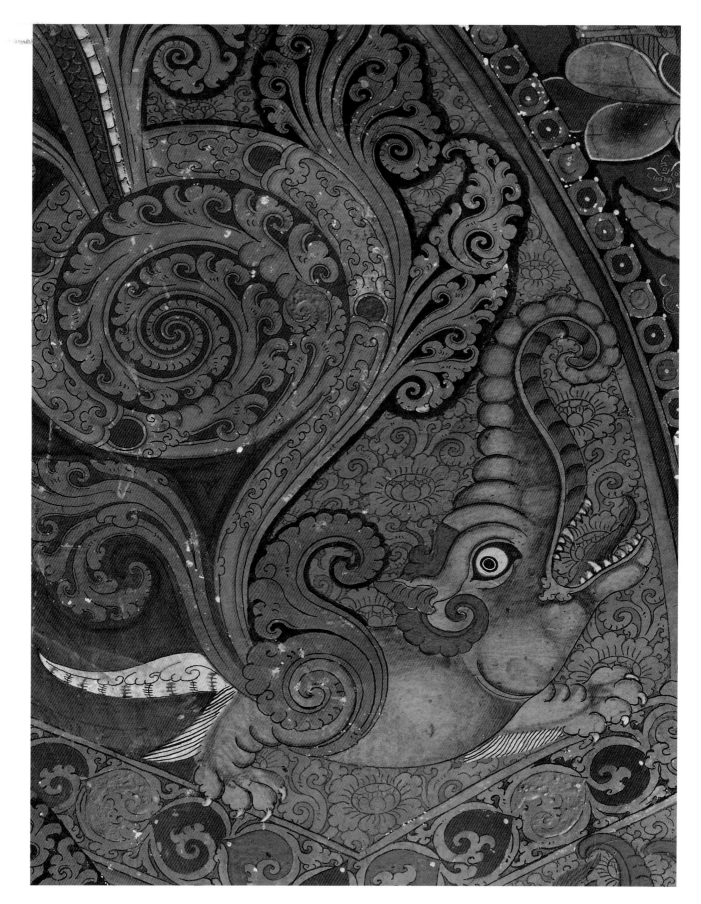

76. THE MYTHICAL *MAKARA* HAS A NOSE LIKE AN ELEPHANT TRUNK AND FISHLIKE TAIL. GYANTSE KUMBUM, EARLY 15TH CENTURY.

Themes and Decoration

than wide. They have long red tongues that protrude from their fierce, open jaws, and they sport goatee-like beards underneath their chins.

The Shalu dragons also have the curious noses that resemble elephant trunks turned upward, which are similar to those seen on another mythical animal called *makara*, which is often seen decorating throne backs of Buddhas and other deities in India and Tibet. The *makara* (fig. 76) resembles a short, stubby dragon with a fishlike tail. The upturned trunk may have crossed over from the *makara* to the dragon and is a common, though not universal, feature of Tibetan designs. This feature is also occasionally seen on dragons on imperial Chinese porcelain from the Ming dynasty, and it may have been picked up from Tibetan styles.

EARLY TIBETAN DRAGON DEPICTIONS ON FURNITURE

It is interesting to compare the Shalu dragons with those depicted in murals at the Kumbum, popularly known as the Great Stupa, at Gyantse that were painted slightly later (fig. 77) and with a dragon on an early Tibetan chest (fig. 78). On the chest design a similarly thin and sinewy dragon with a *makara*-like trunk coils amid a background of multicolored clouds, his mouth open and a long red tongue flicking out. His mane is orange rather than green as in the Shalu versions, but he has a similar red crest extending down his back. With long, sinewy fingers and claws he clutches a red object that is probably intended to be a precious gem. This chest and its painting are closest in spirit to the Gyantse dragon and

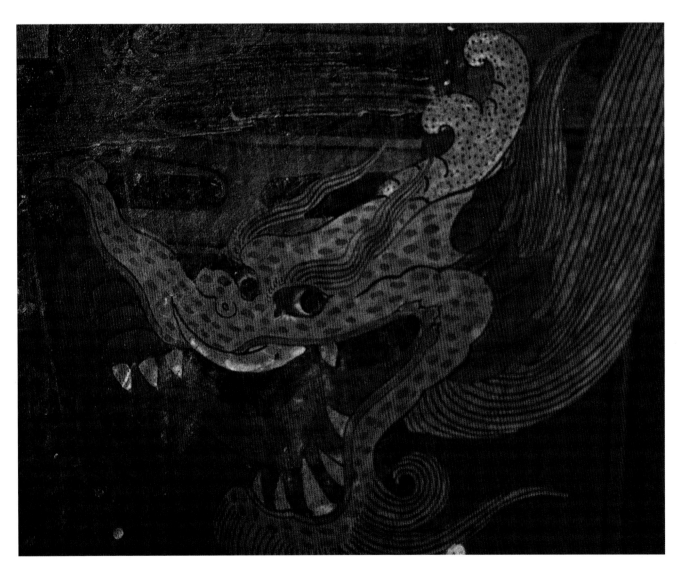

77. DRAGON, FROM PAINTING OF A THRONE BACK. GYANTSE KUMBUM, EARLY 15TH CENTURY.

Early Tibetan Dragon Depictions

78. Medallion featuring a dragon surrounded by precious objects on an early Tibetan chest. 14th or 15th century.

may date from approximately the same period, the late fourteenth or early fifteenth century.

The arrangement of the dragon within the roundel, with its head at the bottom and its body curling up above, follows the pattern which was current across China and Asia during the eleventh through fourteenth centuries and can be seen in textiles, stone carving in temples, and on porcelain decoration from this period. This particular arrangement is not often seen after the fifteenth century.

A characteristic of these early designs is the relative freedom enjoyed by the artists in the manner in which the coiling dragons were arranged, such that no two depictions are exactly alike. In later centuries, particularly from the seventeenth century onward, this artistic license appears to gradually diminish in Chinese designs

as dragon motifs become more formalized, although Tibetan artists were generally less constrained than their Chinese counterparts.

TIBETAN ELABORATIONS

Tibetan artists took Chinese decoration as their inspiration but adapted the designs to suit their own tastes. Dense floral backgrounds were added. Tibetan dragons were given trays of gems (*zhongpa rinpoche*) to hold rather than chasing flaming jewels. On occasion Tibetan artists also preserved features in their designs that had long before gone out of fashion in China, for example, curling, winglike features at the elbows and knees of dragons, resembling features on Chinese dragons from the Yuan dynasty (fourteeth century) and earlier, even though the Tibetan designs are clearly centuries later in date.

During the sixteenth, seventeenth, and eighteenth centuries a great many Tibetan chests seem to have been produced with dragon designs. Dragons from the sixteenth and seventeenth centuries (figs. 79, 126) often have larger, more rounded heads than those of earlier centuries, with flowing green manes and tight, close curls. They have clawlike eyebrows and green or red crenellated crests running down their backs, and look generally fatter and better fed than earlier examples.

Some of these dragons face squarely forwards, in contrast with the side-facing style of earlier examples. This form appears in Chinese textiles for the first time around 1500 in court rank badges. From the sixteenth century onwards both side-facing and front facing dragons are found on Tibetan furniture and on Chinese fabrics in roughly equal proportions.

The dragons in figures 79 and 80 show features that made their appearance in some Chinese designs during the late sixteenth and early seventeenth centuries, particularly the short white spikes around the mouths of the dragons and the sharper spikes in the crest along the backs of the dragons. Some dragons on chests of the seventeenth and eighteenth centuries reflect this "spiky" style. These features are not a definitive guide to separating earlier designs from later designs, however, since a range of styles was produced during this period.

From the eighteenth century onwards the dragon designs on Chinese textiles continued to evolve, becoming steadily more formalized and uniform under the influence of the tastes of the Qing court, which favored the revival of archaic decorative designs harking back to the Tang dynasty and earlier periods. The side facing and front facing designs on Chinese textiles during the eighteenth and nineteenth centuries all follow a nearly identical basic form (fig. 81). These developments do not seem to have impressed Tibetan artists greatly, however. Tibetan dragon designs that are closely modeled on Qing-dynasty forms are uncommon, though examples do occasionally occur. Perhaps the rather formal Chinese dragons of the later Qing dynasty had less appeal to Tibetan tastes, which are closer to the playful artistic spirit of the Ming than to the formal style of the Qing court.

Although modern Tibetan dragon designs on furniture (see fig. 43) have continued to evolve and change,

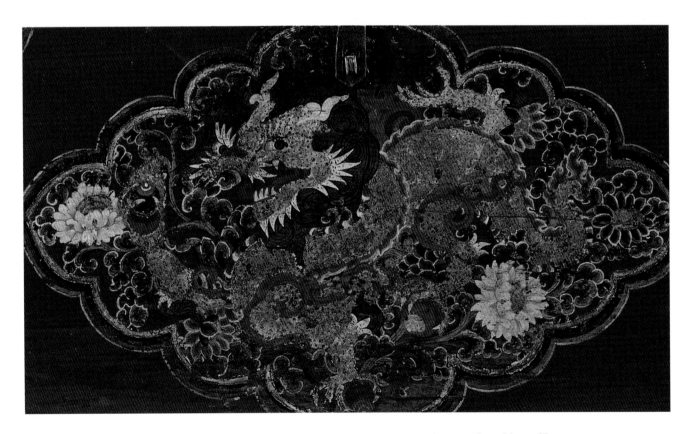

79. Chinese-inspired dragons with spike-like protruberances around mouths and eyes. Chest, 16th or 17th century.

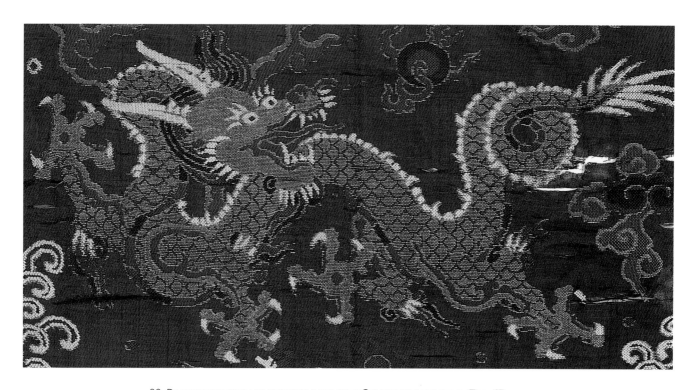

80. DRAGON WITH SPIKE-LIKE PROTRUBERANCES FROM CHINESE TEXTILE FOUND IN TIBET. 17TH CENTURY.

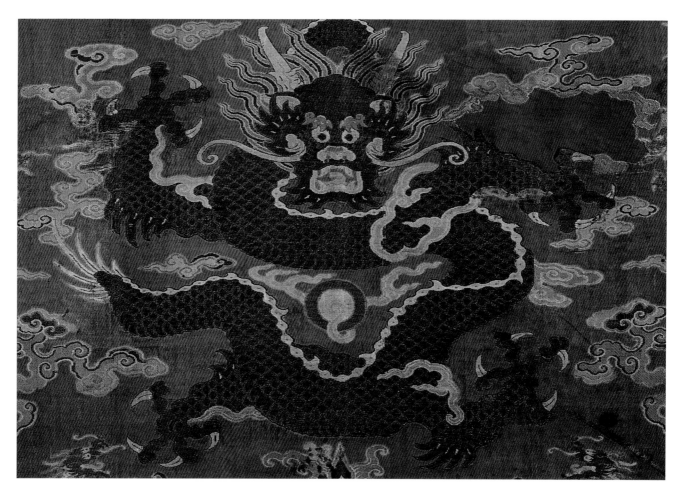

81. DRAGON FROM CHINESE SILK TEXTILE USED AS ALTAR HANGING IN TIBET. 18TH CENTURY.

Themes and Decoration

these contemporary designs still show a strong sense of continuity with the artistic tradition.

SNOW LION

The mythical snow lion, in Tibetan *senge*, is one of the most loved and most often depicted creatures in Tibetan art (figs. 82, 83). Snow lions are painted on furniture and can be seen in many other places besides, such as in paintings playing at the feet of sages, in the form of stone sculptures of pairs of lions outside palaces, and even on the paper currency formerly used in Tibet. The Tibetan snow lion is a fantastical creature with a white body and a bright blue or green mane.

The snow lion has a formal role as a guardian figure for some Tibetan deities and as a vehicle for others. In this role pairs of snow lions were incorporated into the bases of thrones supporting Buddhas and Bon deities. Pairs are also sometimes found in the bases of small tables (figs. 151, 152). This is equivalent to throne-base decoration since these tables were also used as supports for images or important offerings. The snow lion is also the vehicle for the popular deity Vaishravana, a god of wealth, and is occasionally seen on Tibetan chests (fig. 144), straining under his corpulent form.

Depictions of Tibetan snow lions from the fifteenth through seventeenth centuries tend to be lively, muscular, and ferocious animals, as depicted in figure 82, while examples from the eighteenth century onward tend to have rather puglike faces, as in figure 83. These later snow lions are close cousins of the strange "lion-dogs" (*shizi* in Chinese) which became increasingly popular as a decorative motif in China from the seventeenth century onward. This creature is often closer in appearance to a dog than a lion. Tibetan snow lions from the eighteenth and nineteenth centuries are also sometimes found playing with balls with ribbons attached, behavior that seems rather out of keeping with their fierce ancestry.

Small wooden storage chests similar to Tibetan chests occur all across northern China. The most common design on these chests is the Chinese lion-dog playing with a ribbon ball. Despite the similarities in design they are different in decorative style and detail compared with Tibetan chests. They tend to be smaller than most Tibetan chests and they lack ornamental ironwork.

TIGER

The tiger, *tak* in Tibetan, formerly roamed wild across much of Asia, including China and India and the forests

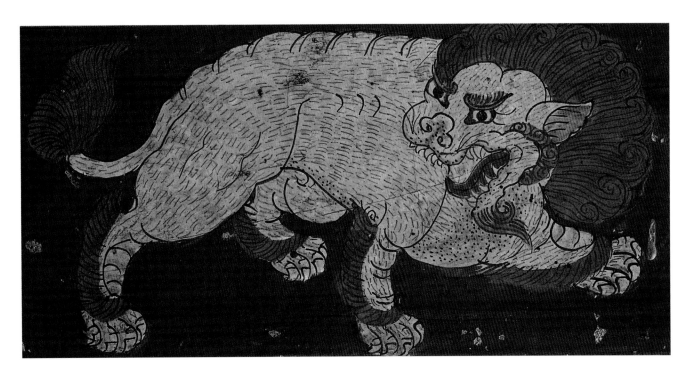

82. SNOW LION FROM MURAL AT GYANTSE KUMBUM. EARLY 15TH CENTURY.

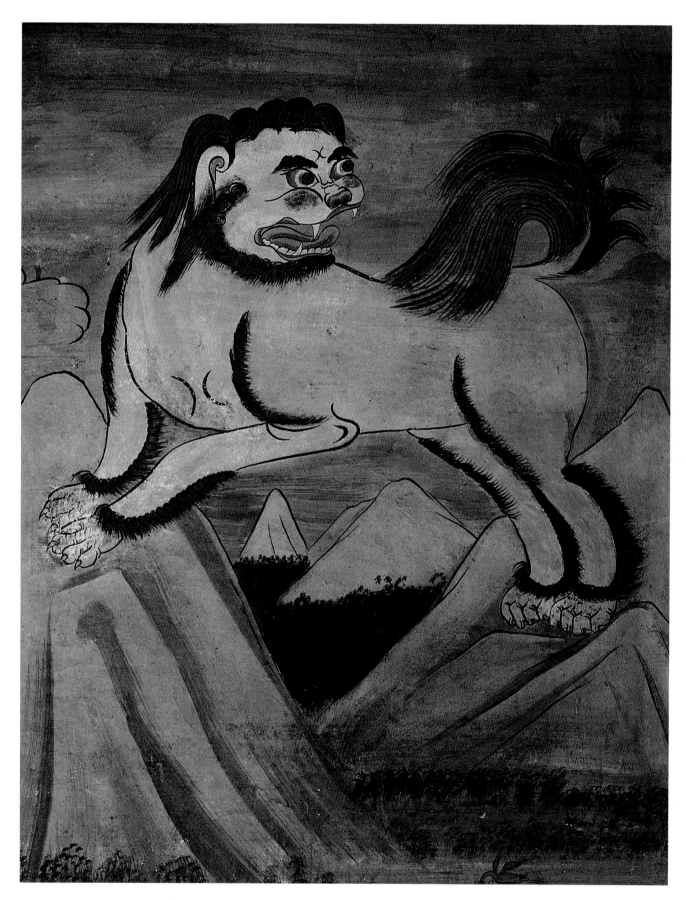

83. Painting of snow lion from Gonlung monastery. 19th or early 20th century.

of eastern Tibet. Feared and respected, the tiger was until recently a real presence in people's lives and it is still an integral part of the region's mythology. The tiger's associations with strength and power are obvious; in central China it was believed that tigers have the Chinese character for king (*wang*) emblazoned in the stripes on their foreheads. Across Asia a tiger skin or tiger-skin rug is considered a suitable covering for a throne for a king or other important official, or as a covering for a chest containing precious items.

In Tibet this association with strength and power runs parallel with more subtle meanings. Tantric sages in India and Tibet used tiger skins as meditation seats. Woven rugs with tiger motifs are still favored for meditation in Tibet today. In Tantric Buddhism the tiger skin represents the transmutation of anger into wisdom and insight, and also protects the person meditating from outside harm or interference. Tiger skins can also be seen in the form of loincloths on the majority of fierce protector deities painted or sculpted in Tibetan temples, where the symbolism is closely related to this belief. Some furniture with tiger designs was used in chapels devoted to these fierce deities.

Genuine tiger skins were greatly prized in Tibet and a few monasteries still have examples, particularly in the chapels devoted to protector deities (fig. 84). Tiger skins

84. A TIGER SKIN AND ITS "KEEPER." PROTECTOR DEITY CHAPEL OF NECHUNG MONASTERY.

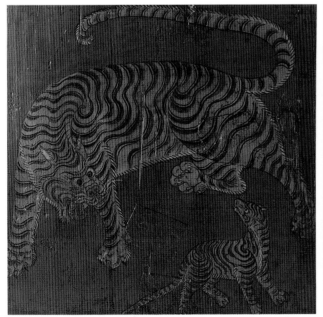 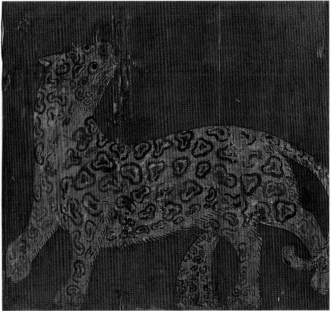

85. PAIR OF DOOR PANELS DEPICTING A TIGER (LEFT) AND SNOW LEOPARD (RIGHT), WITH CUBS. 18TH OR 19TH CENTURY.

were never easy to obtain, however, and became harder still as the animal was hunted to near extinction over most of Asia. Occasionally, leather chests are found which have genuine tiger-skin panels set into them. Partly as a consequence of the scarcity of the real thing Tibetans have been weaving carpets with tiger stripes as a substitute for at least the last two hundred years, and also painting tiger-skin designs on furniture, particularly chests. These tiger designs take three basic forms. In one version the entire skin is represented, complete with head and claws. Chests are sometimes painted to look as if they are draped with tiger skins (fig. 135), in a kind of trompe l'oeil effect. A second version commonly painted on furniture is a near-abstract design consisting of a stylized tiger stripe on a red, yellow, or brown ground. This is often found on chests, in rectangular panels on the front or sides, and it is by far the commonest type of tiger motif. A third type consists of portraits of the live animal.

The largest group of Tibetan furniture with tiger or tiger-skin designs seems to have come from the eastern part of Tibet, especially the parts bordering the provinces of Sichuan and Yunnan. Some very lively paintings of tigers come from these regions, with stripes rendered as stylized swirls that seem charged with energy (fig. 85).

SNOW LEOPARD

The snow leopard, *kang seng* in Tibetan, is native to the Himalayan region (fig. 85) and is still found in the wild, though in greatly reduced numbers because of hunting. Snow leopard skins, with their dappled and spotted patterns, are occasionally seen in Tibetan markets, especially in the eastern provinces such as Kham, where they are used as a trim on the local version of the long Tibetan cloak (*chuba*). Leopard-skin panels also occur as inset panels in leather-covered chests.

The tiger and snow leopard are often depicted together in Tibetan art, where they symbolize male and female principles respectively. Fierce female deities sometimes have leopard-skin loincloths similar to the tiger-skin ones worn by male deities. This distinction is found both in Buddhist and Bon deities. The leopard-skin pattern is often found in combination with tiger-stripe designs (see fig. 136), representing the symbolic

union of male and female, compassion and wisdom, a constant theme in Tantric Buddhism.

As an aside, in order to protect remaining wild populations of animals, trade and cross-border shipments of furniture items with tiger or leopard fur, whether antique or modern, are illegal under international law. Customs officials routinely impound and destroy items of this type, regardless of their age or origin.

ZEEBA

The *zeeba* is a fierce and striking face, recognizable from the two tendrils of foliage or strings of gems that come out of its mouth, grasped by disembodied hands on either side. The *zeeba* has been a feature of Asian art for at least fifteen-hundred years. In India there are several legends describing its origin: one says that the *zeeba* was a demon created by the Hindu god Shiva, which was deprived of its prey and devoured itself instead, leaving only the head and hands behind. Shiva assigned the *zeeba* to stand guard over doorways, where it is still found today in many parts of the Himalayan region. The *zeeba* can also be seen surmounting the archways (*torana*) over the statues of deities from India, Tibet, and China.

Zeeba faces are sometimes painted on chests or carved into small folding tables. An example from a chest (fig. 86) displays most of the standard features of *zeeba* designs painted on furniture. These include the spotted skin and fierce grimace, consistent with its function as the protector of the precious contents of these chests. These *zeeba* faces show many features in common with Tibetan dragon designs, such as the curling horns and the tight hair curls on top of their heads. The hair curls are particularly characteristic of designs from the sixteenth and seventeenth centuries and the shapes of their faces with their pronounced cheeks and spiky tufts also resemble dragon designs from the same period.

A feature that is often present in *zeeba* designs is a small sun and moon symbol (*nyma dawa*) resting on top of the head of the *zeeba*. There is an interesting connection here between *zeeba* designs and masks used for rituals and dances from cultures across the Himalayan regions, both Buddhist and non-Buddhist. These masks often include the same sun and moon symbol, carved on the forehead of the mask or resting on top of it. This suggests a link between the *zeeba* face and the ancient tra-

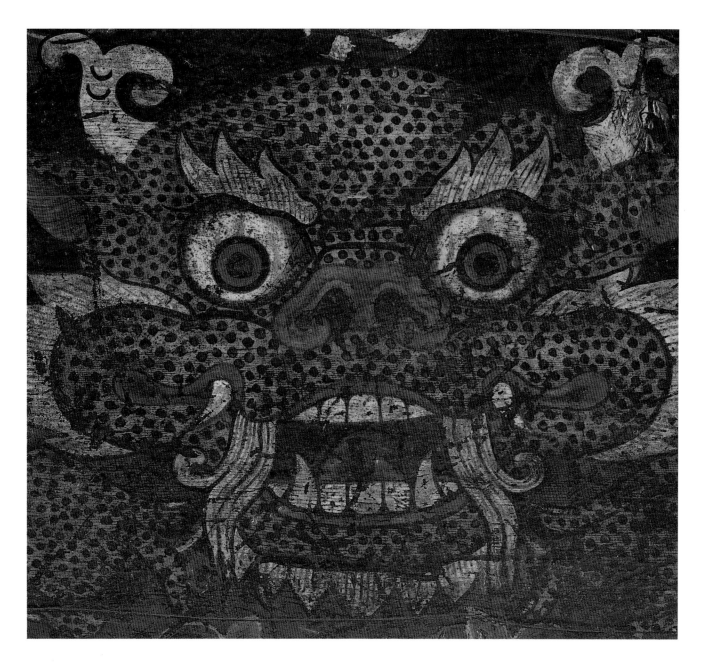

86. The disembodied head of a *zeeba* stands guard throughout Asia. Chest, 17th century.

ditions of mask-making in the region. The sun and moon symbol is nowadays considered a Buddhist motif and is found, for example, on the tops of many stupas in Tibet and Nepal, but the same symbol is also found in other religious traditions in the Himalayas and it undoubtedly predates the arrival of Buddhism in Tibet. It is also used as a protective symbol in its own right on doorways and entrances in central Tibet.

Lhasa folklore says that the *zeeba* design is exclusively reserved for use in monasteries and for items intended for use by persons of rank or importance,

although I have not been able to verify this in the case of furniture with the *zeeba* face. The design is more common on chests from the eastern regions than those from central Tibet.

ELEPHANT

The elephant is an important symbol in Tibetan art, in spite of the fact that it is not native to Tibet. Tibetan depictions of elephants (fig. 87) are quite distinctive, if not particularly naturalistic. Most Tibetan artists have never had the opportunity to study a live elephant and

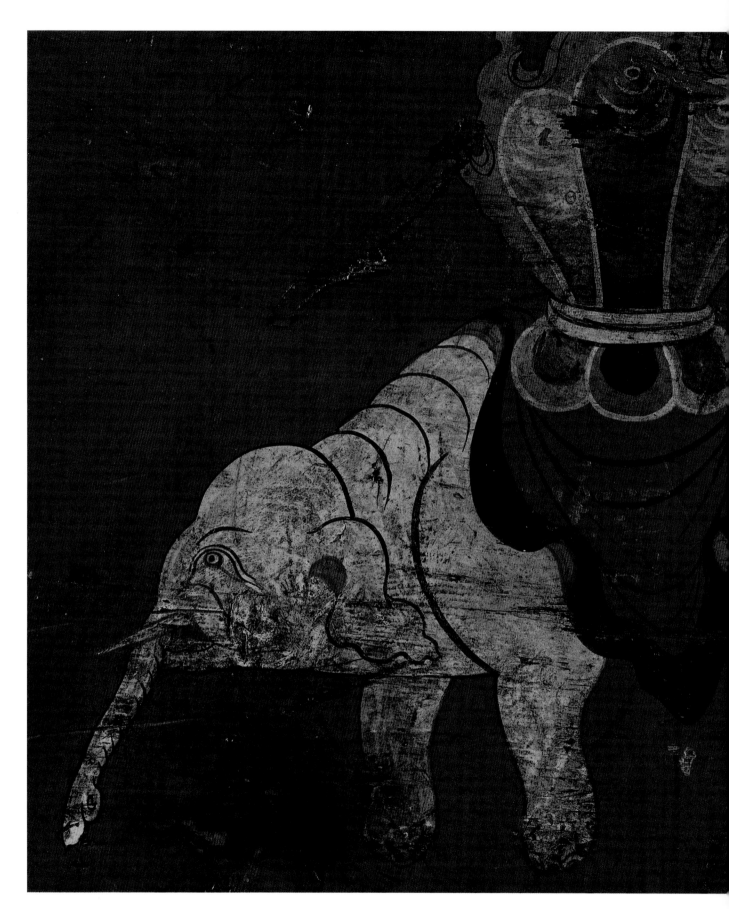

87. A white elephant, symbol of royal authority, bearing precious jewels. Chest, 18th or 19th century.

so their paintings owe as much to imagination and convention as they do to nature.

This particular creature is a white elephant, a type sometimes regarded as the special preserve of royalty. In India and Nepal elephants were the seat of kings and maharajas and are symbols of royal power. These associations probably entered Tibet from India and Nepal along with Buddhist teachings. In Tibetan art, elephants were regarded as appropriate vehicles for offerings such as precious jewels and for some Buddhist deities.

For Buddhists, elephants have religious and symbolic significance on several levels. One association is with an episode in the Buddha's early life, when he demonstrated his power by subjugating a wild runaway elephant that no one else had been able to tame. On a more subtle level, the elephant can symbolize the delusions and desires that followers of Buddhism struggle to overcome on their journey to enlightenment. Paintings are seen of fierce protector deities with elephant skins covering their backs, and friezes of flayed animal skins decorate the walls of shrines to these deities, as well as furniture items used in these chapels, such as offering cabinets. In this context elephants also represent the conquest of ignorance by Buddhist teachings. These specialized types of furniture and decoration are discussed in the following chapter.

Deer

Statues of deer can be seen on the roofs of nearly all temples in Tibet, in the form of a pair carved from wood or sculpted in gilded brass with a wheel in between them. This grouping is recognizable to all Buddhists as a symbol of the Buddha's first sermon, which took place in a deer park at Sarnath in India.

The wheel motif derives from the earliest Indian Buddhist art and symbolizes both the Buddha's teachings (Dharma) and also stands for the Buddha himself. For the first few centuries after the Buddha's death the figure of the Buddha does not seem to have been rendered in painting or sculpture. Instead, the wheel symbol was used as a stand-in for Shakyamuni. Today the figure of the historical Buddha is freely represented in painting and sculpture, but an echo of the earlier tradition persists in the symbol of the pair of deer and the wheel.

An animal pair with the Dharma wheel is relatively rare on furniture because it has a very specific religious connotation. Examples are occasionally found, however, such as a chest (fig. 89) showing a pair of Tibetan antelope sitting on either side of a Dharma wheel.

A pair of deer is more commonly seen on furniture in a different context, in association with a meditating ascetic, or with Shou Lao, the Chinese god of longevity (fig. 88). The ascetic or Shou Lao figure is typically shown seated in a peaceful landscape setting with a pair of deer sitting on the grass in front of him. In Chinese mythology the deer is said to be able to find the sacred *lingzhi*, a fungus that can confer immortality. Deer are also associated with health and vitality, and deer horn is taken as medicine. Most furniture items with these designs date from the nineteenth and early twentieth century, when Chinese-influenced designs of this type were popular in Tibet.

PHEASANT, PHOENIX, AND CRANE

Colorful birds are sometimes found on Tibetan furniture, most commonly in the central medallions of chests. The birds are sometimes shown naturalistically, as in a painting of a pair of golden pheasants (fig. 90), birds that are recognizably similar to the pheasants that can be seen wild in Tibet to this day.

Sometimes the birds are stylized rather than lifelike, in which case they are usually shown in a heraldic form with widely splayed feathers (fig. 91). This type is somewhat similar to the phoenix, which is a common decorative design on Chinese porcelain and textiles and which symbolizes wealth. They were sometimes painted on Tibetan chests as symmetrical pairs surrounded by brightly colored flowers. Pairs of cranes are sometimes present in the retinue of Shou Lao, the god of longevity. Cranes, which are believed to mate for life, have associations with long life and marital fidelity.

PARROT

Parrots have been an occasional feature of Central Asian art for at least a thousand years and are present on some very early textiles from this region. They crop up quite commonly in Tibetan furniture painting, usually as a pair of Indian green parrots (fig. 141). Like cranes they

88. Deer kneeling in front of Shou Lao, the Chinese god of longevity, shown with cranes and peaches, symbols of long life. Chest, 19th century.

Parrot

89. PAIR OF TIBETAN ANTELOPES FLANKING A WHEEL SYMBOLIZING THE DHARMA, THE TEACHINGS OF BUDDHA. CHEST, 17TH CENTURY.

90. CENTRAL MEDALLION DEPICTING A PAIR OF GOLDEN PHEASANTS, WITH CHINESE CHARACTERS FOR LONGEVITY IN THE FOUR CORNERS. CHEST, 18TH CENTURY.

are believed to pair for life and are associated with marital fidelity.

BAT AND BUTTERFLY

The bat is another symbol of good fortune that became common as a decorative motif in Chinese and Tibetan art in the eighteenth century. It symbolizes wealth and good fortune to the Chinese, as we have noted, because its Chinese pronunciation, *bian fu*, sounds similar to the words for "becoming fortunate." The bat motif takes a very stylized form in China and is normally rendered in groups of five, which is considered an auspicious number. During the eighteenth and nineteenth centuries this design was applied to a great many decorative Chinese objects such as porcelain and carved woodwork and became immensely popular. Many of these objects found their way to Tibet, where the design was picked up and incorporated into furniture designs, albeit modified to suit Tibetan tastes.

91. CRANE DEPICTED ON A CHEST IN A HERALDIC POSTURE SIMILAR TO THAT ON CHINESE COURT RANK BADGES OF THE 17TH AND 18TH CENTURIES.

Bat and Butterfly

The bat, as depicted in Chinese art, was already stylized to the point where it bore only an approximate resemblance to the living creature. In Tibetan art there is little distinction between depictions of bats and those of butterflies, another common design in both Chinese and Tibetan art. Many Tibetan designs contain animals which resemble bats but which possess butterfly-like antennae (fig. 92). In Tibetan hands they seem to be purely decorative, lacking any specific meaning.

The presence of bat designs on furniture can be a useful guide to the period of manufacture, since the design was not common before the seventeenth century in Tibet or China, thus its presence usually indicates that an item dates from the eighteenth century or later.

TIBETAN DEITIES

Two particular types of deities occur repeatedly on Tibetan furniture: wealth-creating deities and longevity deities. These figures have some religious significance but also represent down-to-earth concerns appropriate

92. BATLIKE CREATURE WITH BUTTERFLY-LIKE ANTENNAE IN GILDED GESSO. CHEST, 18TH CENTURY.

for furniture with everyday functions. Other deities with more profound religious significance occur occasionally on furniture with more specialized functions, such as offering cabinets, will be described in the next chapter.

WEALTH-CREATING DEITIES

Vaishravana and Jambhala (sometimes called Kubera) are gods of wealth who were originally part of Indian mythology. Both are sometimes found painted on chests, though Jambhala is the more often encountered of the two. They are closely related gods and they are easily recognized since they cradle a small animal, said to be a mongoose but normally resembling a rather plump rat. Vaishravana and Jambhala keep a tight grip on this animal, which is understandable since it spits out a stream of precious gems that often pile up into a heap in front of the god. The origins of this mongoose are not clear, though some have speculated that it derives from an ancient Indian practice of making purses out of mongoose skins. Aside from this similarity, the two types of wealth deity can be distinguished by their appearances and by their attributes.

Vaishravana is dressed like a warrior in chain mail armor, usually with a tunic with large shoulder pads and flowing sleeves (fig. 93). He holds a victory banner and is usually seated on a snow lion. Vaishravana is also one of the Four Guardian Kings, a group that is almost always present at the entrance of temples, generally as huge painted figures in regal dress.

Perhaps because of his dual function as a guardian figure and as a bestower of wealth, Vaishravana is a popular figure in Tibet. He is one of the most commonly painted of all Tibetan deities and can often be seen painted individually on *thangka* as well as in temples and occasionally on furniture (fig. 144). He is revered by all the Tibetan sects, but particularly in temples belonging to the Gelug sect.

Jambhala is less often seen in *thangka* painting than Vaishravana, but he is more often found in paintings on Tibetan chests. He is normally seated on a lotus throne rather than a snow lion and is dressed as an Indian king. He holds a lemon or jewel in his right hand and the jewel-spitting mongoose in his left (fig. 94).

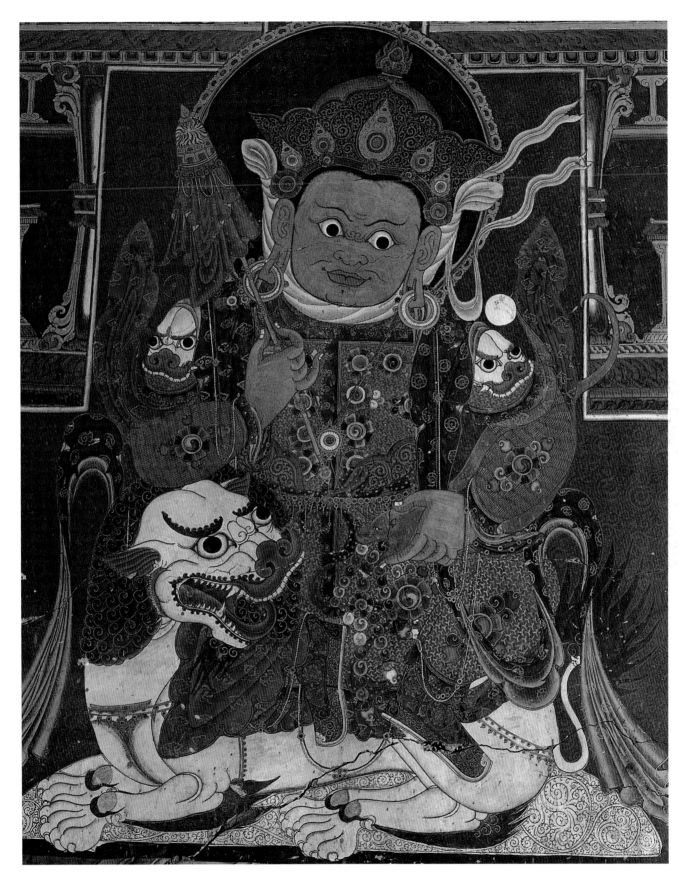

93. The popular wealth-creating deity Vaishravana, also king of the northern direction. Tholing monastery, 16th century,

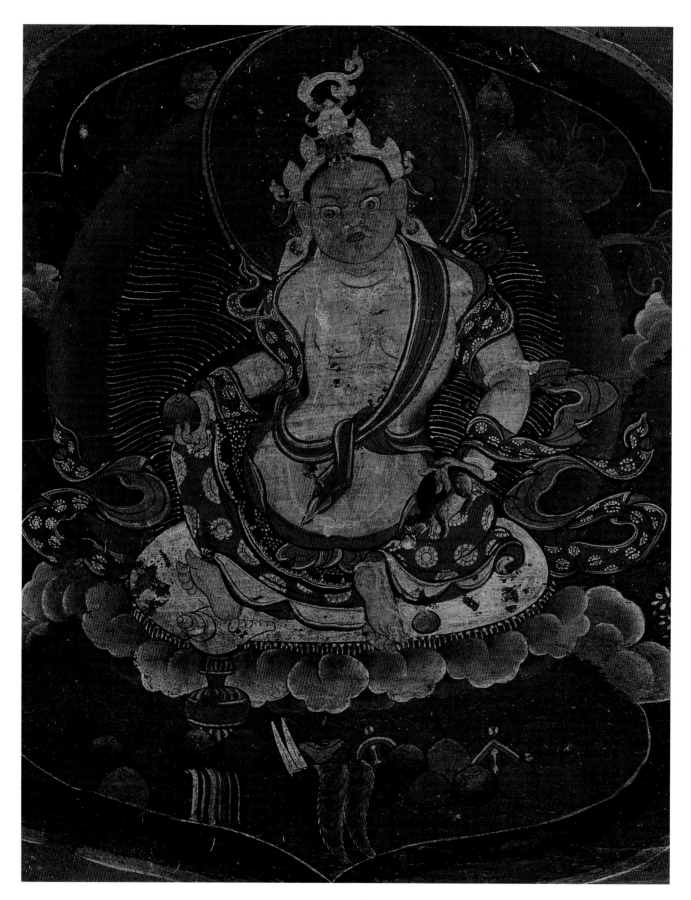

94. The wealth-creating deity Jambhala, holding a jewel-spitting mongoose. 18th century.

GODS OF LONGEVITY

Scenes containing figures resembling elderly men in white robes are sometimes found on Tibetan furniture. These are usually depictions of Shou Lao, the Chinese god of longevity. Depictions of ascetics also occur. They are generally shown as elderly men meditating in caves or in mountainous settings. For Tibetans these ascetics also have associations with long life.

SHOU LAO

Depictions of Shou Lao represent a wish for a long and healthy life. Shou Lao is an elderly man with a high forehead, usually seated under a pine tree and holding a staff. With him are various other symbols of longevity, which usually include deer, cranes, the fungus *lingzhi*, and peaches (see fig. 88). Considered divine fruit from trees owned by the gods, these peaches confer immortality when eaten. The *lingzhi*, a curiously shaped mushroom, is also said to confer immortality when eaten. Several Chinese emperors devoted considerable amounts of time and money to tracking down the sacred fungus that they believed would allow them to live forever, though their efforts would seem to have been in vain.

The symbolism related to Shou Lao derives from Chinese sources and is found most commonly on Tibetan furniture painted in the eighteenth and nineteenth centuries. During this period, corresponding to the second half of the Qing dynasty, these symbols were frequently carved and painted on Chinese artworks of all kinds. This fashion seems to have influenced the aesthetics of the wealthier urban Tibetans in Lhasa and other centers, who developed a taste for furniture, particularly cabinets, decorated with versions of these designs.

MEDITATING ASCETICS

These meditating figures of hermits in remote mountain settings are similar in many ways to the depictions of Shou Lao, though they derive from Tibetan and Indian rather than Chinese sources. The representations of Shou Lao and Tibetan ascetics seem to have merged over time, the distinction between the two becoming blurred. Tibetan ascetics are portrayed as elderly men sitting cross-legged, usually in a rugged and isolated setting. They relate to the ancient Indian tradition of the mystic who retreats from society in order to reach enlightenment through concentrated meditation. They were thought to be able to live to a great age, a fact that eventually led to their depiction in connection with wishes for long life. A reading desk (fig. 165) includes a painting of a meditating ascetic.

KINGS AND PERFECT WORLDS

The idea of a perfect world or paradise has an important place in Tibetan artistic imagination. Tibetan cosmology contains countless paradises ruled over by different deities. Some of these paradises, such as the mythical kingdom of Shambhala, are often represented in Tibetan painting. Closely linked to this idea is the concept of the ideal monarch, or *chakravartin*, ruling over a perfect and peaceful world, and paintings of monarchs in idealized landscapes are sometimes found on Tibetan chests and cabinets (fig. 148).

The king is normally shown reposing on a throne in a palace, in the midst of a landscape with trees bearing fruit and flowers, green pastures and forests, and a backdrop of green hills with snow caps. The inspiration for these scenes seems to have come from artists in the eastern parts of Tibet, where such green and lush landscapes are found. Painters in these areas were also influenced by traditions of landscape depiction in Chinese art. The style these eastern Tibetan painters developed during the seventeenth and eighteenth centuries eventually became the standard for depiction of idealized landscapes in all regions of Tibet. The landscape backgrounds in paintings on furniture as well as many modern *thangka* and mural paintings can be traced back to this tradition.

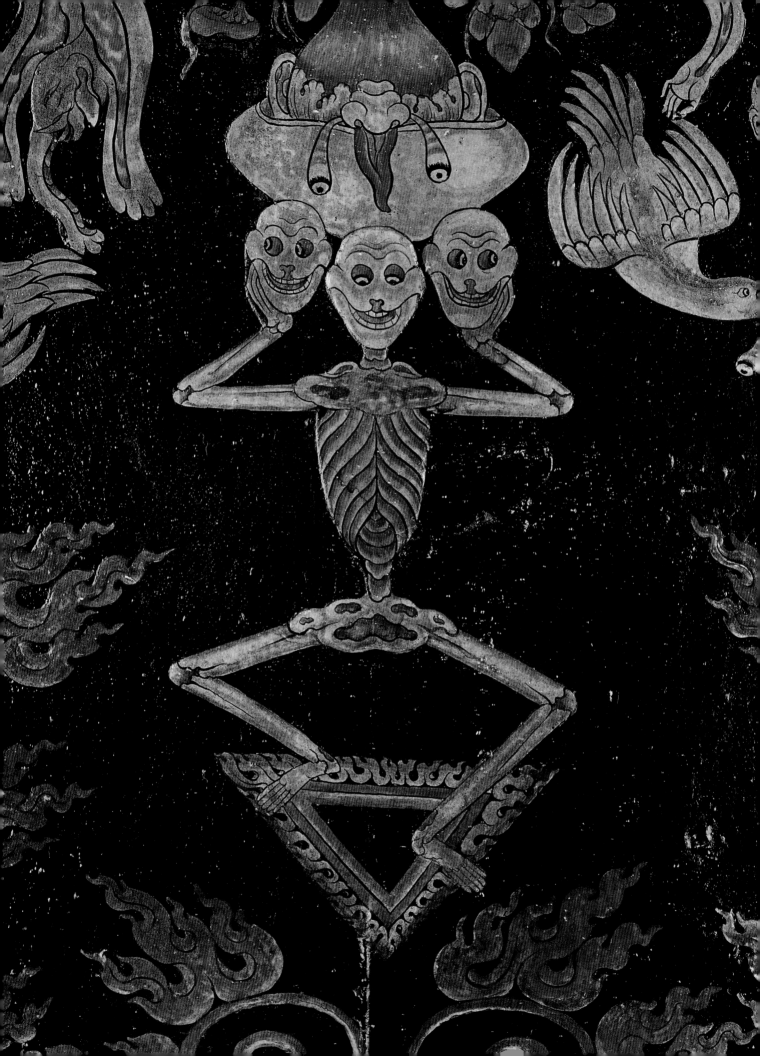

FURNITURE FOR THE WRATHFUL GODS

Cabinets and other items painted with wrathful faces with wide eyes and tangled hair, or macabre decoration such as flayed skins, skulls, and dismembered body parts are a distinctive and unique feature of Tibetan furniture (figs. 95, 96). The objects decorated in this way clearly have some specific symbolism, sometimes labeled with the catchall term Tantric, although this explains little since that could equally well be applied to much of Tibetan religious belief and art.

A clue as to the purpose of these designs comes from the context in which they were used. Some Tibetan cabinets with this type of macabre painting were placed in special shrines to the fierce gods who protect temples and homes in Tibet. Their function was to house offerings, mainly butter sculpture offerings (*torma* in Tibetan) to these gods, hence their name *torgam*, literally "offering cabinets." Other objects with macabre imagery, such as paintings and masks, are often kept in the same shrines.

To understand the designs on these specialized pieces of furniture and other objects it is necessary to delve a little more deeply into Tibetan beliefs and to set aside some preconceptions about this kind of imagery. To those unfamiliar with Tibetan beliefs, a face with fangs, blue skin, and wild hair would appear to be a demon of some kind. Similarly, a skullcap bowl filled with blood conjures up impressions of witchcraft, or of primitive or folk beliefs. These impressions are quite different from the way these images are viewed by Tibetan eyes.

FIERCE DEITIES IN TIBETAN RELIGION

The concept of a fierce or wrathful deity originated in India along with Tantric Buddhism. However it was in Tibet where this idea was developed to its fullest extent, where wrathful deities seem to have found a fertile ground for their development in Tibetan religious and artistic imagination. The Tibetan fierce deities came from a variety of different sources. Some are wrathful forms of Indian bodhisattvas, benign beings who help lead Buddhists along the path to enlightenment. Others are indigenous pre-Buddhist gods who were won over centuries ago to the cause of Buddhism.

Like most aspects of Tibetan religion, fierce deities can be viewed on several levels. At the most basic level they are powerful protectors (*dharmapala*), both of the religion and of ordinary people. By reciting mantras dedicated to the protectors and making appropriate offerings to them it is possible to obtain protection from a variety of dangers. At more advanced levels some of the fierce deities, such as Mahakala, may assist in the meditative path to enlightenment by helping practitioners overcome spiritual obstacles and negative emotions.

To lay worshippers from the towns and villages these protector deities are real presences who are fearsome to their enemies but are recognized as friends by the faithful. They can be persuaded, propitiated, and cajoled into providing protection and benefits by making offerings to them, for example, by presenting butter sculptures to them or by adding tallow to butter lamps on their altars. One Tibetan New Year festival (Losar) we watched the townspeople of Lhasa filing past a huge image of Yama, the Lord of Death in the Buddhist tradition, bowing their heads and adding butter to a huge lamp in front of the deity. The statue of Yama is a fearsome thing, with the head of a snarling bull, riding on a bull that grinds

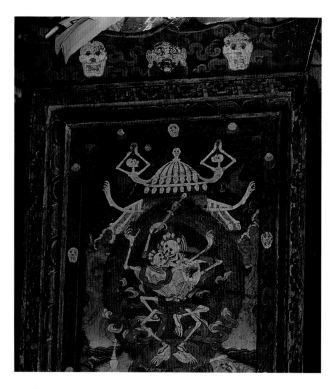

95. A PAINTING OF A BONE PALACE, THE RESIDENCE OF A FIERCE DEITY, HERE CITIPATI AND HIS CONSORT, WHO ARE PART OF THE RETINUE OF MAHAKALA. OFFERING CABINET, 19TH CENTURY.

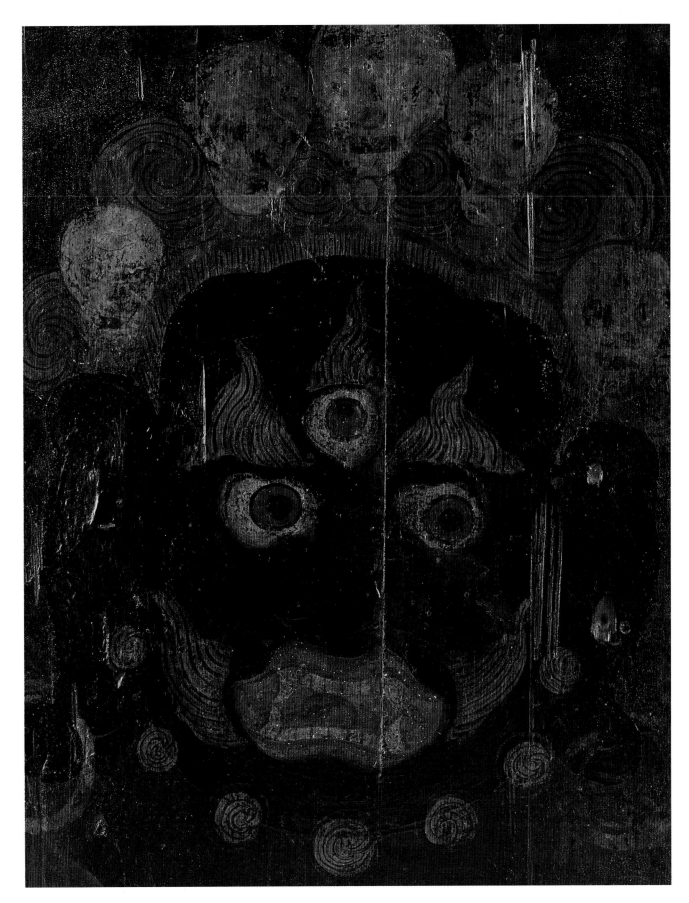

96. Face of the fierce protector, possibly Mahakala, from an offering cabinet. 18th century.

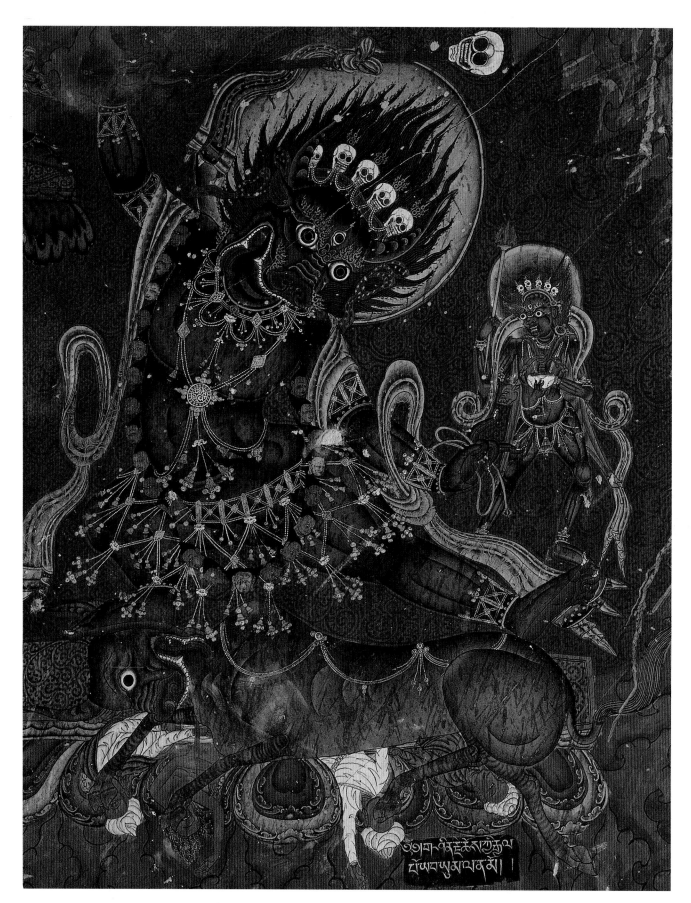

97. YAMA, LORD OF DEATH AS WELL AS A PROTECTOR DEITY, FROM MURALS AT TSAPARANG, WESTERN TIBET. 16TH CENTURY.

an unfortunate victim beneath it. Though the imagery is disturbing, the act of paying homage to Yama is not the worship of death, but quite the opposite, witnessing the defeat of death by Buddhist teachings. The image of Yama (fig. 97) has its roots in Hinduism, absorbed and adapted by Tibetan Buddhism. The tiny *vajra* placed on Yama's forehead represents the taming of the Hindu god of death by a greater power. In Tibetan Buddhism, Yama has become a protector of the faith, to be looked upon with awe but understood as a benign presence.

MAHAKALA AND PALDEN LHAMO

There are many Tibetan protector deities, some of which are popular across all parts of Tibet and some of which are local gods who are popular only in certain areas. The two most commonly encountered protector deities, revered in all parts of Tibet, are a form of Mahakala known as Gurgyi Gonpo in Tibetan, and Sri Devi, who is more commonly known by her Tibetan name Palden (or Penden) Lhamo. Many offering cabinets were made for rituals associated with the propitiation of these deities.

Mahakala is a fearsome figure with several forms. His two-armed form (fig. 98) squats foursquare and cradles a staff called a *gandi* in his arms. This is the same type of staff carried on ceremonial occasions by the lama who enforces discipline in monasteries, and serves as a badge of office. Mahakala also carries a flat-bladed chopper in his right hand and a skullcap bowl in his left. Into this bowl he shreds the bodies of demons representing material desires, transforming them into an elixir symbolizing enlightenment. Around his head he has the crown of five skulls that can be seen on many Tibetan wrathful deities. The five skulls symbolize the transmutation of the five afflictions of anger, pride, greed, envy, and ignorance into pure wisdom.

Representations of Mahakala straddle the division between fierce protector deities and the meditational deities that have deeper spiritual significance. Mahakala has his own Buddhist text (the *Mahakala Tantra*), which represents a path to enlightenment in its own right for those prepared to study and meditate on it. For most Tibetans, however, his main function is the protection of temples and homes. He is an important deity, to be propitiated with offerings and ritual in return for practical benefits.

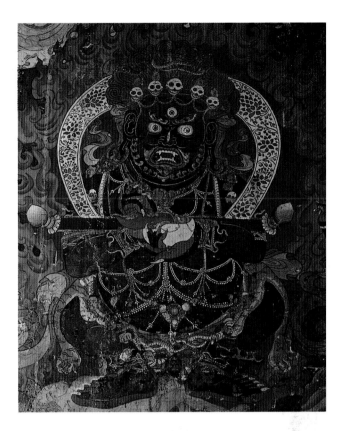

98 (ABOVE). MAHAKALA IN HIS TWO-ARMED FORM, CRADLING HIS CEREMONIAL STAFF, FROM MURALS AT SAKYA MONASTERY, CENTRAL TIBET. 18TH CENTURY.
99 (BELOW). PALDEN LHAMO, FIERCE PROTECTRESS OF LHASA AND TIBET, MERU NYINGBA, LHASA.

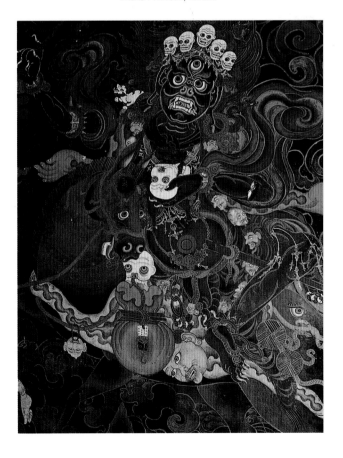

Mahakala and Palden Lhamo

Palden Lhamo (fig. 99) is a goddess with special significance because she is regarded as the protectress of Lhasa. She is a wild and fearsome figure, dark blue in color, riding an ass that glides over a sea of blood. She has a characteristic set of attributes, including a peacock-feather canopy over her head and a sword and a skull bowl. The ass she rides has a pair of dice tied to it, symbolizing her power over fate, together with a bag of poisons and a ball of sacred threads. Like Mahakala she is often painted near the entrance to temples and sometimes has her own dedicated protector chapel, such as the fine example in the Assembly Hall of Drepung monastery, near Lhasa.

In addition to these universally recognized protectors, local protector gods abound in all parts of Tibet. In many cases these gods are associated with local landscape features such as mountain peaks. Many are celebrated on particular days, when their statues or images are taken out of their shrines and paraded around the villages. Their worship and propitiation often straddle the line between organized religion represented by Buddhist and Bon temples and local folk beliefs. In some cases the local deity has been co-opted as a protector of the official faith. In other instances their worship lies outside the mainstream; the local Buddhist clergy in some areas keep their distance from the shrines and shun their festivals.

CHAPELS FOR PROTECTOR DEITIES

Most Tibetan temples and some of the largest homes have special shrines or chapels to Mahakala and other protector deities. Some furniture with macabre decoration was made for use in these shrines and chapels.

Called *gonkhang*, these chapels are usually found either just inside the entrance of temples in a side chapel, or else as a separate building beside the temple. Their doorways are easily recognizable because they are generally decorated with a pair of wrathful faces. There is also usually a frieze of skulls around the frame or on a hanging covering the door (fig. 100). Similar decoration can be found on the doors and frames of many offering cabinets, the significance of which will be discussed later in this chapter.

100. DOOR HANGING AND DETAIL (FACING), PAINTED WITH FACES OF MAHAKALA AND TRIMMED WITH SKULLS, GYALWO GONPA, AMDO.

Furniture for the Wrathful Gods

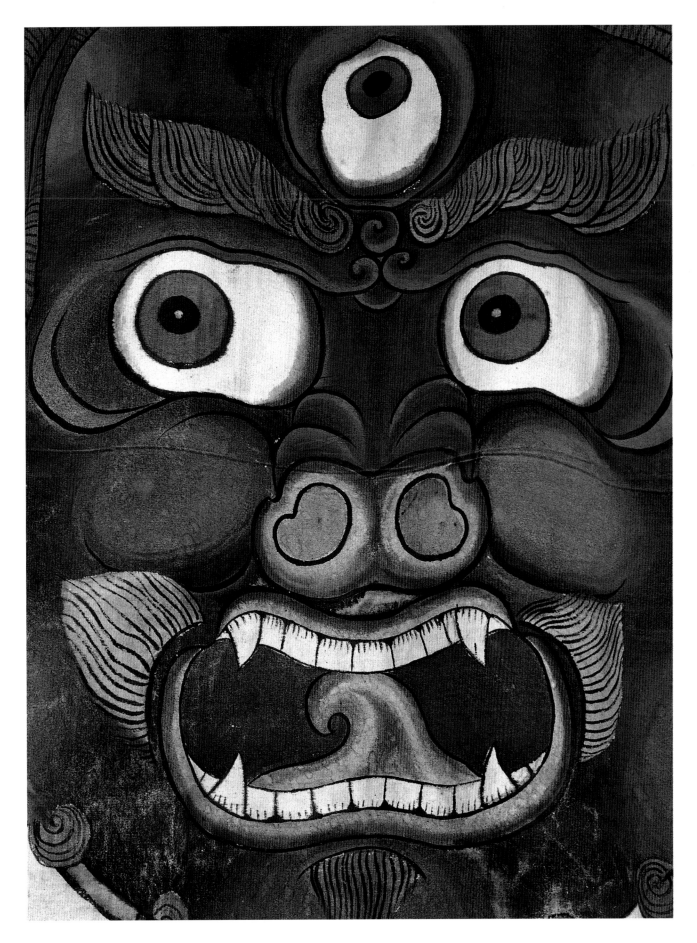

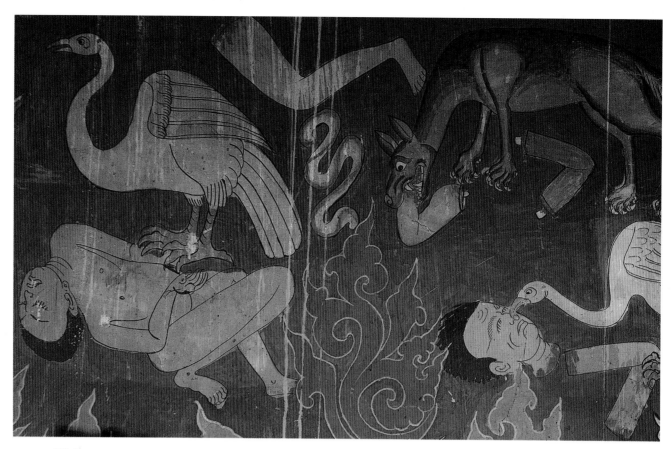

101. Charnel-ground murals at Gyantse Pelkhor Chode depict human remains being devoured by birds and wolves. 15th century.

One of the best surviving examples of a *gonkhang* is off the Assembly Hall at Gyantse in central Tibet. Inside is a huge statue of Mahakala, hung with and almost obscured by scarves (*khata* in Tibetan) in yellow and white given as offerings. The paintings around the wall date from the fifteenth century and consist of lively depictions of Mahakala's retinue of fierce deities, with charnel-ground scenes of human remains being devoured by crows and wolves (fig. 101). Similar scenes occur in the painted designs on the doors of many offering cabinets. The walls of the Gyantse *gonkhang* are also hung with some particularly terrifying masks (fig. 102).

This imagery is a reference to Mahakala's origins in a vision seen by an Indian ascetic while meditating in a cremation ground. Ascetics who meditated in these places wrote many of the Tantric Buddhist texts. The cremation grounds provided a kind of shock therapy where it was possible to grasp the ultimate lack of significance of material experiences and sensations. The imagery of these places, on chapel walls and on the doors of offering cabinets, serves as a constant reminder of this truth.

102. Mask used in dance performances, hung in a 15th-century protector deity chapel in Gyantse.

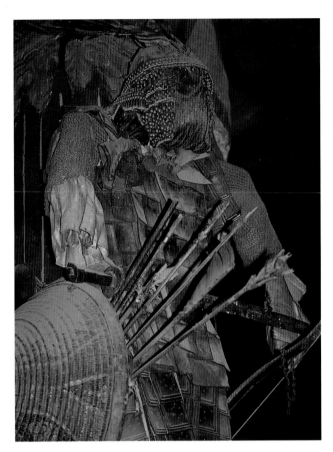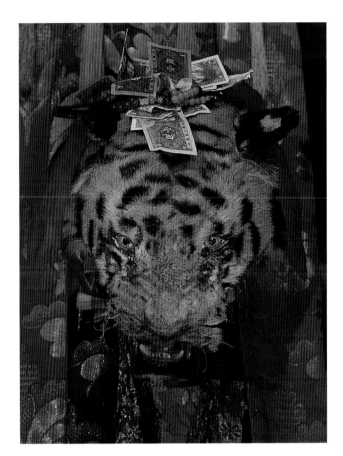

103, 104. Weapons, armor, and the head of a tiger are all suitable offerings to protector deities.

Many protector deity chapels devoted to Mahakala and other local protector deities are closely associated with weaponry and conflict, and at some *gonkhang* women are not allowed to enter because of their fearsome and warlike associations. Many contain piles of weapons that have been donated by believers as offerings to the main deity (fig. 103). In some *gonkhang* in remote areas, weapons can be found dating back hundreds of years, including suits of chain mail and shields. In one such chapel in Mustang we found ancient knives alongside rifles donated in relatively recent times. We were also shown a withered and blackened hand of a vanquished enemy donated some hundreds of years ago and preserved hanging from the ceiling. Body parts and skins of fierce animals such as the tiger and snow lion are also regarded as suitable offerings for the angry gods and are sometimes found in *gonkhang* (fig. 104).

In important *gonkhang,* especially those attached to larger temples, we can usually find one or two monks in attendance, sitting on a low platform and beating a large suspended drum while chanting prayers to the wrathful deities in the shrine. From time to time the faithful file in and make offerings of barley beer, butter lamps, and ceremonial scarves to the wrathful gods, represented by the dark and angry-looking statues that sometimes tower over them. Lit by the light from butter lamps and filled with smoke, incense, and sound, the *gonkhang* inspires awe and terror.

Offering cabinets

Offering cabinets were made to house *torma* (fig. 105), the small sculptures made of *tsampa* (a staple of the Tibetan diet composed of barley powder and yak butter). The simplest of these sculptures consist of triangles of red colored *tsampa,* and can be found on altars in any part of a Tibetan temple. In offerings dedicated to wrathful gods a more complex type of butter sculpture may be offered, known as a Fierce Offering of the Five Senses. This sculpture symbolically offers up the five human senses in the form of a skullcap bowl containing the heart (representing the body and the sense of touch), the eyes (sight), the ears (hearing), the nose (smell), and

the tongue (taste). This type of offering and painted depictions of it (fig. 108) symbolize the conquest of cravings and attachments caused by the senses, which hinder the path to enlightenment. This offering is also sometimes visualized in great detail as part of a meditational practice.

Torma are generally renewed in special ceremonies held once a year, usually around Tibetan New Year. Donations are made to the deity and sometimes the deity's vows to protect the local people are symbolically renewed. Offering cabinets of all sizes and shapes for housing *torma* are found in protector deity chapels, with large cabinets tending to predominate because of the sheer number and variety of offerings they need to accommodate (see fig. 40). Large glass-fronted cabinets of relatively recent manufacture are used extensively for housing offerings in protector deity chapels (as well as in other parts of temples), although this type of furniture is rarely found in collections outside of Tibet.

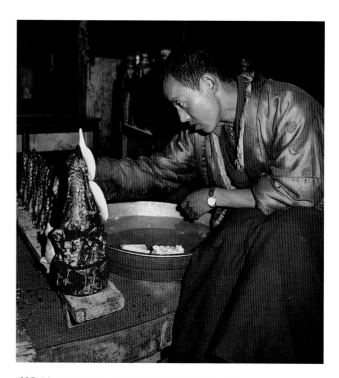

105. MAKING *TORMA*, OFFERING SCULPTURES OF BUTTER AND BARLEY FLOUR, SAMYE MONASTERY, CENTRAL TIBET.

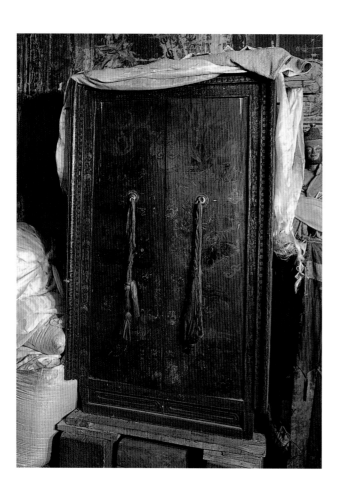

106. OFFERING CABINET (*TORGAM*) DEDICATED TO THE WRATHFUL PROTECTOR DORJE RABTENMA (A FORM OF PALDEN LHAMO). SHALU MONASTERY, CENTRAL TIBET.

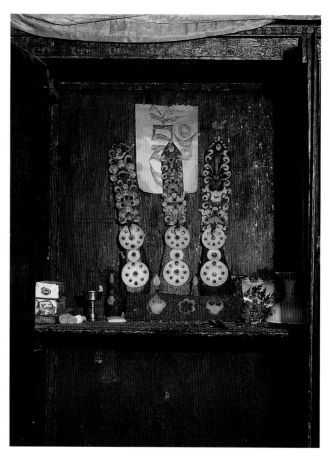

107. THE INTERIOR OF THE OFFERING CABINET SHOWN AT LEFT HOUSES BUTTER OFFERINGS, WHICH ARE RENEWED ANNUALLY IN A SPECIAL CEREMONY.

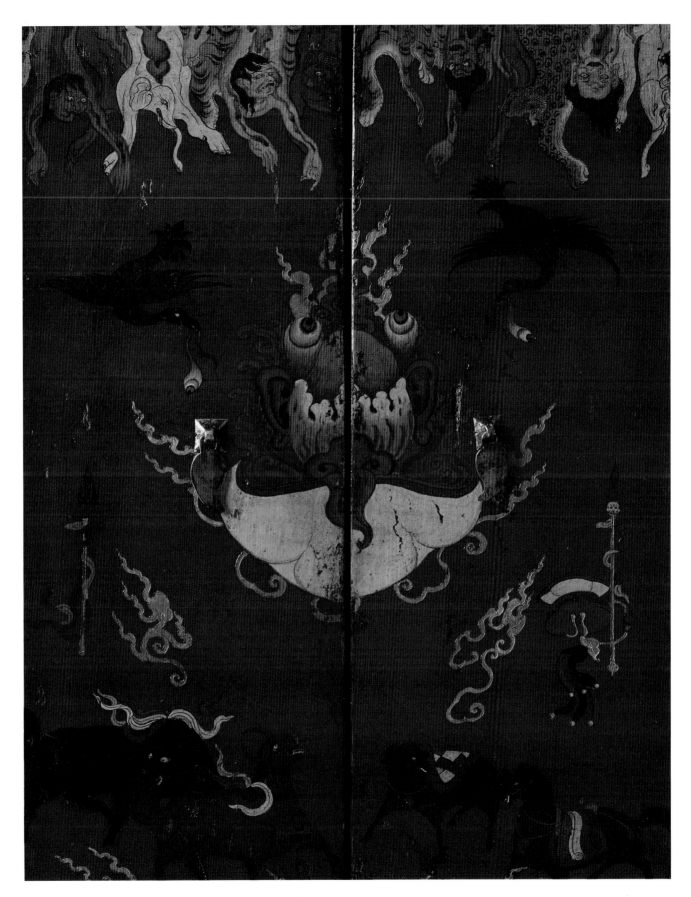

108. Offering cabinet painted with a representation of the Fierce Offering of the Five Senses, human sense organs symbolically presented to a fierce deity in an upturned skullcap bowl. 19th century.

Offering Cabinets

The offering cabinet most commonly seen in collections is a smaller piece with single or double wooden doors (fig 106, 110). It is sometimes said that these cabinets came from *gonkhang* in temples, but they were more likely used in other locations such as small shrines in private homes and subsidiary shrines to protector deities in other parts of temples. In these situations a smaller and more self-contained shrine cabinet was needed, rather than the larger ones more typically found in *gonkhang*.

Aside from their distinctive decoration, offering cabinets differ in shape and construction from the more conventional type of domestic storage cabinet. They are generally tall and wide but shallower than a conventional cabinet. Inside they may be bare or may have one or two shelves for supporting butter sculptures and other ritual offerings, which are placed on the shelves or propped up against the back of the cabinet.

PAINTED DESIGNS ON OFFERING CABINETS

Most offering cabinet paintings fall into one of two types. The first type of decoration consists of large, fierce faces. Some cabinets have a single face covering both sides of a double door; others have a pair of faces, one on each door panel (fig. 109). These faces are similar to those that are often painted on the outside of the doors leading into the *gonkhang*. With their bared fangs and staring eyes they function as protective talismans to ward off enemies, both real and spiritual. In some cases the faces represent a particular deity, such as Mahakala (fig. 110); however, more often their features are generalized and no particular deity is intended. They resemble the masks of fierce *dharmapala*, protectors of the faith, used in Cham dances, which are also stored in protector chapels, hanging on the walls.

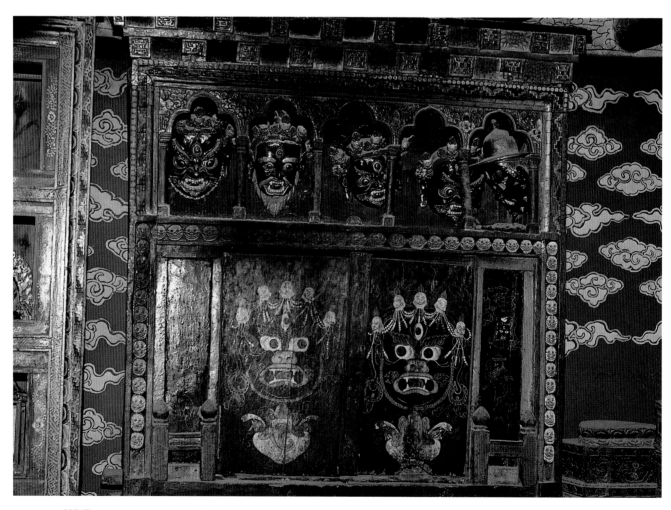

109. THIS OFFERING CABINET FROM LADAKH IS IN THE FORM OF A MINIATURE PALACE FOR A WRATHFUL GOD, WITH OFFERINGS STORED BELOW AND MASKS FOR RITUAL DANCES STORED ABOVE.

Furniture for the Wrathful Gods

The cabinets shown in figures 109 and 110 were seen in a lama's living quarters in Ladakh. The first of these cabinets resembles a miniature palace and shows particularly clearly how the offering cabinet can be more than just a receptacle for offerings, and can in fact be a complete residence-in-miniature for the protector god. Viewed in this way, the significance of the frieze of skulls on the frames of many offering cabinets becomes clear; it represents the bone palace where the fierce deity is supposed to reside (see fig. 95). This is also analogous to the frieze of skulls painted on the doorframes of full size *gonkhang*. Wooden offering cabinets of this type may even have rows of flayed animal skins painted on the inside, analogous to the rows of flayed skins painted around the inside walls of protector chapels. This type of cabinet does not necessarily need to be placed in a *gonkhang,* as it is, in effect, a miniature *gonkhang* in its own right. An example of this is the offering cabinet at Shalu monastery dedicated to the wrathful protector Dorje Rabtenma (see figs.106, 107). This cabinet is not located in a *gonkhang* but rather in an upstairs chapel. It allows Dorje Rabtenma, who is an important protector of the temple, to be worshipped alongside other peaceful deities in the chapel.

The second type of painting found on offering cabinets is more complex. The protector deity to which the offering cabinet is dedicated is not shown directly, but his or her presence is summoned by their specific attributes. This kind of painting is sometimes called a Host of Ornaments (*gyantshog*), the ornaments referring to the attributes of the deity. Offering cabinets of this type from shrines dedicated to Mahakala, for example, show his costume and ornaments together with the cremation-ground imagery he is associated with, typically with flayed skins of humans and animals across the top and birds and animals carrying body parts below. Only the deity himself is missing. In the most elaborate forms of these designs the costume of the deity and his or her attributes float in space, ready to be occupied by their owner. Not all paintings of offerings of this type can be identified as being specific to one particular deity, however; in some cases the offerings are of a simpler and more general type suitable for any fierce deity.

While some of these descriptions sound grim, most offering cabinet painting has a characteristically Tibetan sense of life and humor about it, with grinning skulls and capering animals that seem to mock our obsession with material objects and to undermine our fear of death. Paradoxically, these depictions of cremation grounds on offering cabinets are sometimes amongst the most full of life of all paintings on Tibetan furniture.

The Host of Ornaments painting shown in figure 111 is from an offering cabinet dedicated to Palden Lhamo. The painting includes all her main attributes; the only missing element in this uncanny representation is the deity herself.

OTHER GONKHANG FURNITURE

In addition to offering cabinets, other types of furniture are also occasionally found in the *gonkhang,* including

110. ANOTHER OFFERING CABINET, IN A LAMA'S RESIDENCE IN LADAKH, THIS ONE DEPICTING THE FACES OF THE WRATHFUL PROTECTOR GODS MAHAKALA (LEFT) AND PALDEN LHAMO (RIGHT).

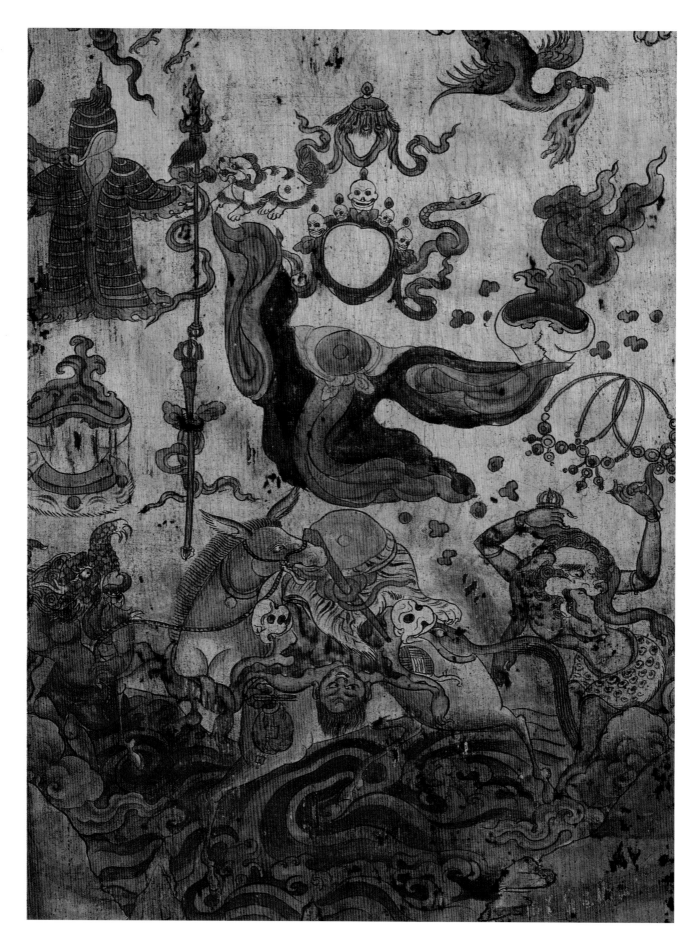

cabinets with two doors or four doors, decorated with skulls and severed heads and sometimes with "fierce offerings." These cabinets are sometimes placed in front of altars (fig. 112) and are used for supporting offerings of various kinds, especially *torma*. This function seems to be more important than storage and some cabinets of this type even lack doors.

Wooden chests are also found in protector chapels, though most are similar in design and decoration to chests found elsewhere. Very rarely chests are found which have distinctive imagery relating to protector deities, such as borders of skulls, fierce offerings, etc. In visits to these chapels in many different areas I have seen relatively few chests in their original locations, one exception being a *gonkhang* in Ladakh where a chest with macabre decoration was used for storing ritual implements associated with ceremonies devoted to Mahakala. I have also seen a chest in a *gonkhang* in central Tibet with a tiger-skin design in the form of a realistic pelt, painted as if it were draped over the chest, used in front of an altar to a fierce deity. Given that tiger skins and tiger body parts are sometimes seen in *gonkhang* as offerings it may be that chests with tiger-skin decoration or inset panels of real tiger skin were often used in this way in former times, though chests of this type can also be found in other rooms of Tibetan temples.

Would-be buyers of Tibetan furniture should take note that substantial amounts of furniture, including offering cabinets, larger two- and four-door cabinets, and chests, have been offered for sale in recent years which have imagery which is described as Tantric, generally with skulls and friezes of animal and human skins. The large majority of such pieces are either entirely modern

or else are old pieces of furniture that have been recently repainted. Any piece of furniture with this type of decoration that is offered for sale should be examined closely with a skeptical eye.

Of all the varieties of furniture, offering cabinets and other *gonkhang* furniture are probably the most uniquely and distinctively Tibetan, having no exact parallel in the furniture of other regions. Their complex decoration and symbolism offer a window into Tibetan esoteric beliefs, as well as a display of some of the liveliest and most original of all Tibetan decorative designs.

112 (ABOVE). ANOTHER TYPE OF GONKHANG CABINET IS DESIGNED MORE TO SUPPORT AND DISPLAY OFFERINGS THAN TO STORE THEM.
111 (FACING). OFFERING CABINET PAINTED WITH THE HOST OF ORNAMENTS MOTIF, INTENDED TO SUMMON AND PRESENT OFFERINGS TO PALDEN LHAMO.
MOST OF HER KEY ATTRIBUTES ARE SHOWN, INCLUDING THE ASS THAT SHE RIDES, HER ROBE AND HEADDRESS,
WITH A PARASOL OF PEACOCK FEATHERS FLOATING ABOVE. 19TH CENTURY.

Other Gonkhang Furniture

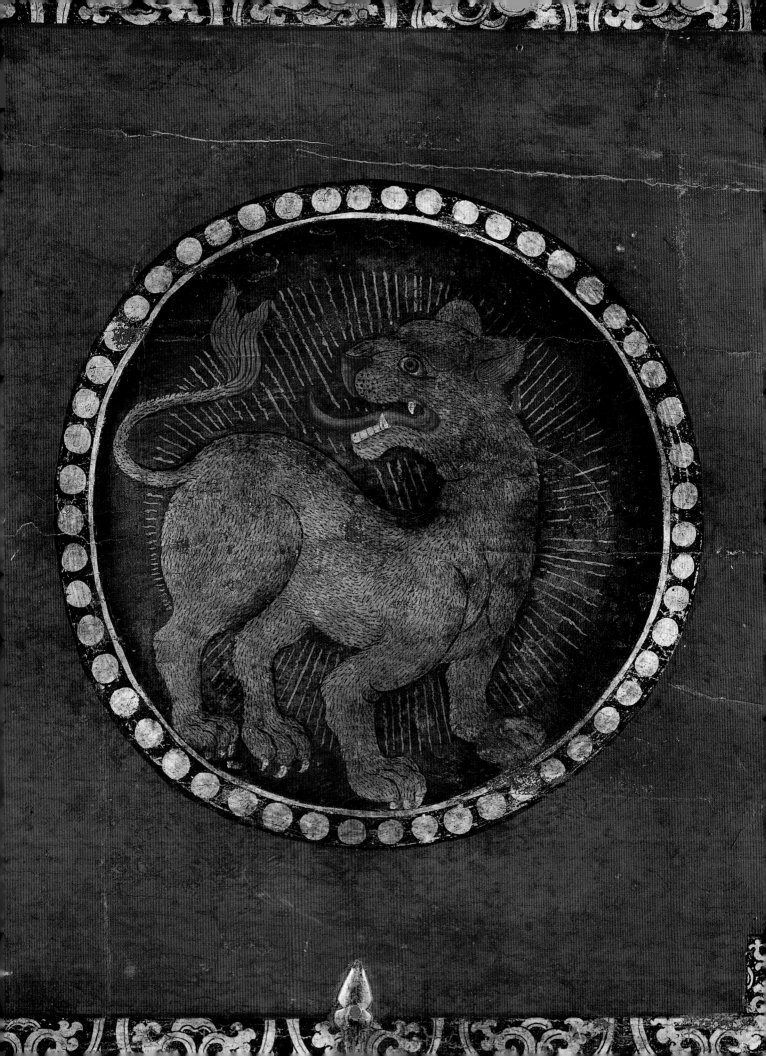

SELECTED PIECES

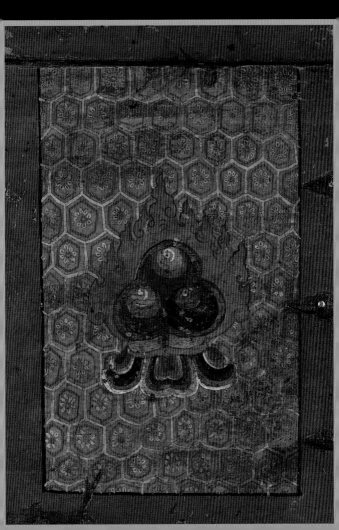

CHESTS

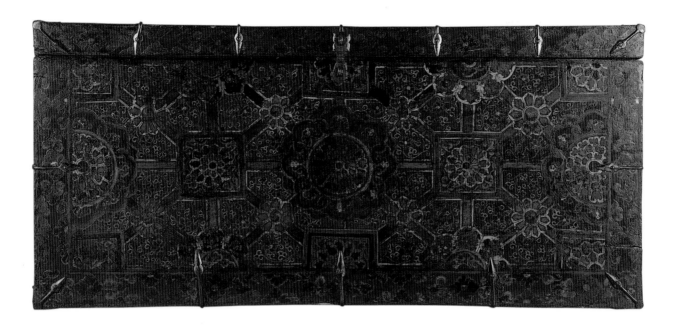

113
Painted wooden chest
102 cm x 45 cm x 40 cm 17th century

A silk textile design inspired the decoration that fills the central part of this chest. The border of the chest has a simple floral motif and the top and sides have been left plain. It is interesting to compare the textile design on this chest with the one on the dragon chest of figure 123. Whereas that chest seems to follow precisely a silk textile design, in this case some variations are apparent. The details of the brocade design, with its square and floral medallions linked by diagonal bars, are followed quite closely and there are flowers in the triangular areas as on many actual textiles; however, some uniquely Tibetan elements have crept in that were not present in Chinese textiles that served as models. These include the tricolor swirling disks in the centers of some of the floral medallions.

A stylized design of squares and floral medallions linked by bars eventually became a standard part of the Tibetan repertoire for decorating chests, in some cases reproducing silk brocade designs precisely, in other cases approximating them to a greater or lesser degree. In later centuries many such designs bore only a passing resemblance to the textiles that originally inspired them.

NOTE: ALL MEASUREMENTS ARE GIVEN AS LENGTH X HEIGHT X WIDTH.

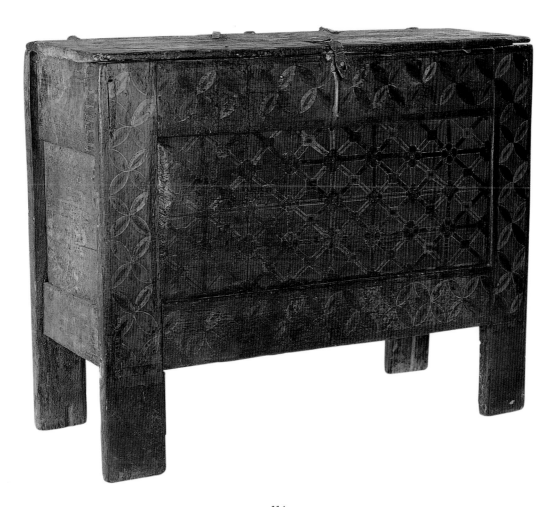

114
Painted wooden chest with legs
86 cm x 88 cm x 33 cm 17th century

Small storage chests standing on legs are found most often in eastern and southern Tibet, probably because the climate is wetter and air circulating under a chest would prevent dampness wicking up into the interior.

The chest is made using the same construction method used for cabinets, with panels set in frames, rather than the plank-style construction that is more usual for wooden boxes. A framework has been constructed using timbers held together with mortise-and-tenon joints, with panels inserted to form the front and sides of the chest. The lid is a simple board with a hinge.

The front panel is decorated with a stylized textile design of squares and floral rosettes linked by diagonal bars, with a delicate background of *wanzi* lattice pattern in between. The border around the central panel is decorated with a design that appears at first to be a floral pattern; in fact, it is a variation of a design called the coin pattern, created by drawing overlapping circles. What appear to be flower petals are actually the overlapping parts of adjacent circles. The ground between these petals is filled with another textile-inspired pattern of green hexagons.

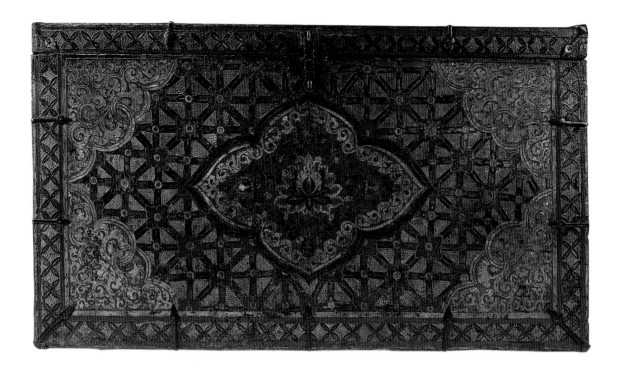

115
Painted wooden chest
116 cm x 66 cm x 48 cm 18th century

Centered on the front of this chest is a lotus flower that springs from a bud at the base. Flames issue from the center of the flower, emphasizing that this is no ordinary bloom but a symbol of Buddhist belief. Around the flower are several smaller blossoms and buds. Surrounding the central quatrefoil shape there is a geometric design loosely based on a silk textile pattern. Part of the design is filled with stipples of gilded gesso, giving it a three-dimensional texture. The corners of the design are filled with an intricate version of the corner scrolls seen on many Tibetan chests.

Around the edge of the chest is a design that is based on a coin pattern, produced by drawing overlapping circles. The circles, or coins, define a flowerlike pattern of petals where they overlap. The effect also approximately resembles the shape of an ancient Chinese bronze coin, hence its name.

Gesso is used quite extensively to outline the designs, prior to coloring in. A fair amount of gold leaf has been used, in addition to paint. The techniques used, the rich colors, and the well-elaborated designs suggest that this chest was made during the eighteenth century.

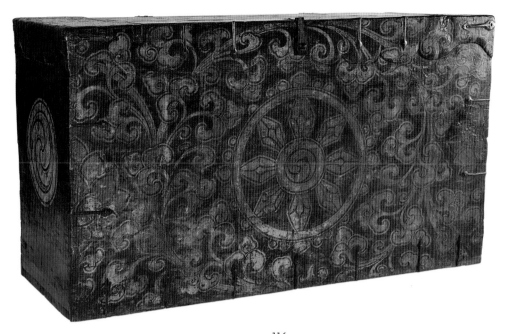

116
Painted wooden chest
123 cm x 78 cm x 48 cm 16th century or earlier

The front panel of this chest is filled with an exuberant floral pattern, with a pair of lotus flowers at the left- and right-hand edges and scrolling vegetation in between. In the middle of the design is a Dharma wheel with eight gemlike faceted points, with a swirling disc symbol (*norbu gakyil*) in the center. A variant of this symbol, with three sectors, appears on the sides of the chest, one side of which is visible in the illustration.

The chest has scalloped decoration lightly carved into the front and sides, near the top. The lid of the chest is a flat board, hinged at the back, which is recessed into the top of the chest. The lid stretches about two-thirds of the width of the top of the chest.

The decoration of this chest is unusual, which makes it difficult to assign a date to it with confidence. Decoration that extends over the whole surface of the item without clear borders is sometimes associated with earlier dates. This kind of decoration was superseded by more sophisticated styles during the fifteenth and sixteenth centuries. The shape of the foliage elements, which are roughly triangular and divided into three parts, a little like the fleur-de-lis motif, recalls decorative foliage designs that were popular during the fourteenth through sixteenth centuries. Based on these aspects it seems likely that the chest was made no later than the sixteenth century and may be earlier in date.

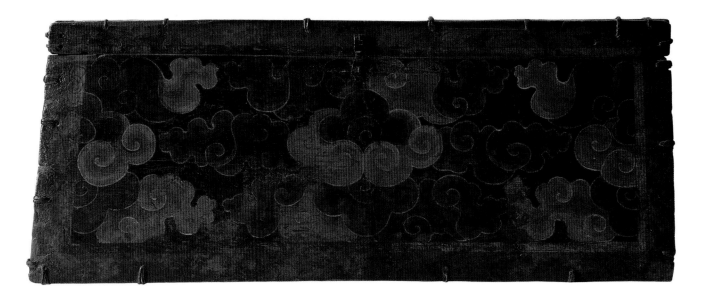

117
Painted wooden chest
130 cm x 54 cm x 38 cm circa 16th century

A bold design of stylized clouds covers the entire central panel of this long chest. The border design consists of a yellow band and a green band, with faint cloud-design markings. The sides slope inward slightly, in this case combined with a conventional tray-shaped lid rather than the flat lid that is more usual with sloping-sided chests. The joinery is reinforced with leather ties binding the edges instead of the more usual iron straps.

Cloud patterns are quite commonly used in Tibetan furniture decoration but they are rarely used as the main subject of a design. These clouds seem to have been inspired by Chinese textiles or paintings. Judging by the rounded shapes and the cruciform-shaped cloud in the center of the chest, the works that provided the inspiration for this design dated from the early or mid-Ming period (fourteenth or fifteenth century). The borders of the chest with designs delineated in fine, dark lines were probably also inspired by silk textiles. They were likely intended to imitate damask, a type of fabric in which the design is apprehended through areas with different textures catching the light differently.

The overall design of this chest, the decoration, the colors used, and the condition of the paint with its fine crackle are consistent with a date of manufacture during or slightly after this period, perhaps during the fifteenth or sixteenth century.

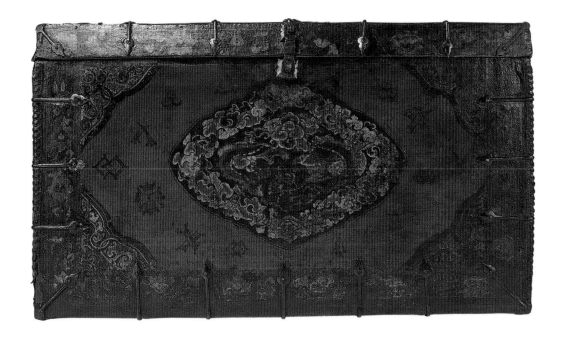

118

82 cm x 43 cm x 43 cm 15th century or earlier

The painted decoration on this small chest indicates that it is of great age, perhaps dating to the fifteenth century or even a little earlier. At the center of the design is a lithe and sinewy dragon clutching a single gem. The dragon, with its small head, open mouth, and long, protruding tongue resembles Chinese prototypes from the Song and Yuan dynasties (tenth to fourteenth centuries). By the sixteenth century fashions in dragon designs in both Tibet and China had changed, evolving into fuller and rounder forms, as described earlier.

Surrounding the central design is a deep, red border containing ten different auspicious symbols drawn in black. They include precious coral, the triple gem, the pair of books, rhino horns, coins, ingot, conch, crossed ingots, pair of rhombuses, and crossed rhino horns, with some symbols appearing more than once. Symbols such as the conch and triple gem are associated with Buddhism, while others have no specific religious

meaning but are associated with good fortune. This particular list of auspicious objects is characteristic of the fourteenth century, and similar groupings can be found, for example, on Chinese blue-and-white ceramics from the same period. Later lists of auspicious objects from both Tibet and China show some differences from this group, evolving as time passed to become more consistent both in number and type of objects.

The sides of the chest are also painted, with a design consisting of precious gems superimposed on a hexagon-pattern background. This type of decoration on side panels is characteristic of small chests made during this period.

The chest was covered in cloth before paint was applied. The corners are bound with leather to provide extra protection, in addition to the more usual iron staples. There is some repainting along the lower right-hand edge of the chest and around the metal clasp.

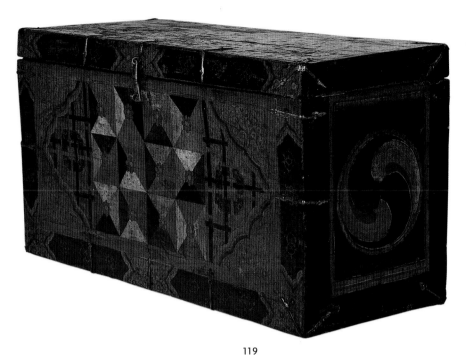

119
Painted wooden chest
100 cm x 45 cm x 43 cm circa 16th century

The painted design on this chest is unusual. In the center of the front is a colorful square of geometric patterns, surrounded by ribbons with two suspended disk shapes. The owner of this chest told us that it was originally one of an identical pair, but that the other chest was in relatively poor condition when he found it.

The geometric central part, with its design of squares and flowers (left), was probably inspired by a characteristically Tibetan type of patchwork textile, made up of triangles of salvaged silk fabrics. These cloths are sometimes used to drape altars and as coverings for precious objects. The painting on the front of the chest is reminiscent of an altar draped with one of these cloths and this may be the effect that was intended.

The surrounding design is more puzzling. A series of interlacing ribbons hold two captive disks resembling Chinese jade *bi* disks in gold mountings. The effect looks rather like a simulation of gift-wrapping. At the edges of the chest is a border design containing precious objects, including interlocking jewels, interlocking rhombuses, and endless knots. This particular group of precious objects, when considered together with other features of the design, suggest that this piece dates from the fifteenth or sixteenth century.

The chest has decorative painting on the top and sides as well as on the front. The painting on the top has mostly worn away, but the painting on the sides is still clear and shows two Tibetan swirling disc symbols (*norbu gakyil*). The four colors of these symbols represent the four elements.

The painting on this chest has been applied on top of a covering of fabric that has been thickly coated with a ground material, probably a size made from a mixture of clay and gum. The paint shows a fine crackled texture, a feature that is characteristic of many earlier pieces of Tibetan furniture.

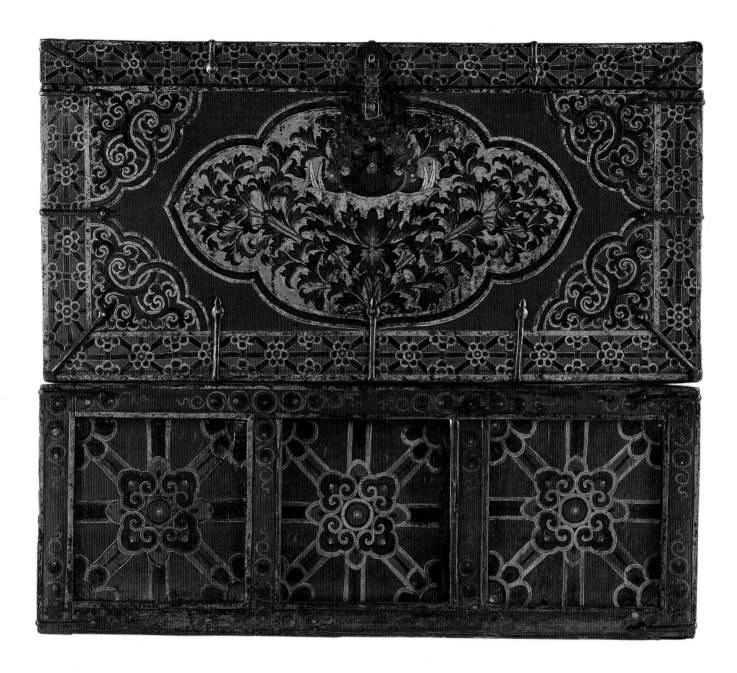

120
Pair of chests with stands
Each chest: 89 cm x 44 cm x 39 cm
Each stand: 89 cm x 33 cm x 39 cm
18th century

Both chests in this pair are decorated with the same design. In the central medallion is a bowl filled with precious jewels, surrounded by flames and a pair of rhino horns, symbolizing wealth. The corners are filled with scrolling plant designs and the borders are filled with a stylized textile pattern. The sides have been left plain.

The stands for the chests are constructed using a frame-and-panel type construction similar to that used for cabinets. The central panels (see left) are decorated with an enlarged version of the stylized textile pattern used on the borders of the chests. The frames of the stands are painted with precious jewels linked with scrolling designs.

It is rare to find intact pairs of chests in Tibet and it is even more unusual to find an intact pair with their original stands. We have no way of knowing how many chests were made in pairs, nor how many were made with stands like these. However, it is likely that a great many more were made this way than survive today. Such beautifully decorated sets of chests and stands were probably given as gifts or offerings to individuals or to monasteries. In Tibet and China pairs of objects are regarded as more auspicious than single items and therefore particularly suitable for gift-giving.

The painting style and bold colors of these chests suggest that they were made in the eighteenth century. The condition of the chests is excellent, due in part at least to their having been placed on stands and therefore out of reach of dirt and knocks.

121
Painted wooden chest
165 cm x 55 cm x 45 cm 19th century or earlier

This long, low chest is made of unusually heavy boards and it lacks the metalwork straps seen on many Tibetan chests. These features, together with the decoration, point to an origin in eastern Tibet, where an abundant supply of timber allowed furniture makers to be more generous in their joinery than their central Tibetan counterparts.

The design of the chest, which has a muscular and provincial feel about it, consists of two wheel motifs resembling *taiji* (yin-yang) symbols, and divided into four sectors of red, yellow, blue, and green, representing the four elements. Surrounding them is a stylized tiger-skin design. The painter has solved the problem of how to decorate a long, narrow chest by duplicating the same design, a solution that is unique in my experience of Tibetan chests.

The top and sides of the chest may have originally been decorated as well, but do not retain any traces of paint. The boards are fairly roughly shaped and retain marks of woodworking tools.

Because of its unusual length this chest was probably designed for holding rolled up religious paintings, *thangka*, that were stored away for long periods and brought out for particular festivals or ceremonies.

Assigning a date to this chest with confidence is difficult since there are relatively few features that can be compared with other objects or paintings. The key-fret border is an ancient design that became widely used in decoration on ceramics and textiles from the seventeenth century onward and is particularly common on eastern Tibetan furniture in the eighteenth and nineteenth centuries.

122
Painted wooden chest
101 cm x 52 cm x 39 cm 17th century

This chest is an example of the red-and-gold style of furniture decoration, in this instance emblazoned with a single dragon that faces sideways and holds a tray with precious gems. A vine scrolls around the dragon, enclosing it to form a quatrefoil-shaped medallion. Around the medallion is a precisely laid-out background inspired by a brocade design, consisting of squares and floral roundels linked by diagonal bars. The corners are filled with abstract scrolls and the border is occupied by a flowering vine pattern.

The design on this chest is well executed, with considerable attention to detail. It has been applied over a layer of fabric that covers the front and also the top and sides. The texture of the fabric is visible beneath the painted surface.

This is a relatively early example of the red-and-gold style, which became increasingly popular in the seventeenth and eighteenth centuries. Later in the evolution of this style gesso was added to further accent the gold, and this technique was used to decorate some very large chests. During the eighteenth century the quality of the decoration on pieces of this type declined as they were produced in larger numbers. The earliest examples, such as this one, tend to show the finest workmanship.

123
Painted wooden chest
68 cm x 36 cm x 40 cm 16th century

This small chest is painted with a central medallion containing a curled dragon with a fishlike tail, in red and black over of gold leaf. The dragon supports a tray of gems and is surrounded by clouds. The style of the dragon, which is a rather tame specimen, as well as the shape of the clouds and other features suggest that this chest may have been made during the sixteenth century.

Around the medallion is a remarkable design (right) that appears to copy exactly a silk brocade pattern. Silk fabrics of this general type with designs of interlinked squares and rosettes were produced in China over an extended period from the tenth century to the nineteenth century; however, elaborate examples like the one replicated here are thought to date to the late Yuan to early Ming period (fourteenth and fifteenth centuries). This textile design is one of the most intricate I have seen on a chest, with a fine ground of *wanzi* lattice pattern and interlocking-Y pattern, superimposed with flowers and interlocking squares and floral rosettes. The degree of detail suggests that the artist paid considerable attention to getting the elements of the fabric design right in order to create a trompe l'oeil effect of a chest covered in silk. I have seen several other chests of roughly the same size with similar detailed textile designs, suggesting that they were a recognized style, perhaps even products of a particular workshop. The painting on this chest has been applied over a layer of fabric, another characteristic feature of this particular type of chest.

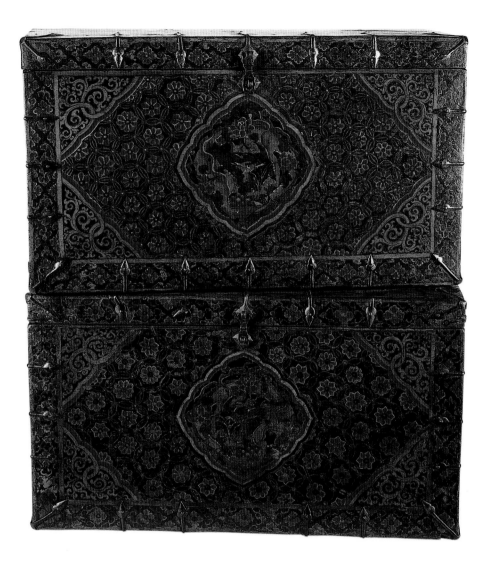

124
Pair of painted wooden chests
79 cm x 43 cm x 35 cm 15th century

I believe these to be one of the oldest pairs of Tibetan chests that I have seen, and are similar in style and date to the preceding example. Made as a symmetrical pair, they were intended to be placed side by side, with the inner side faces, which would have been hidden from view, left undecorated. The inner faces and the lids are painted plain red with a green border, though most of the paint has worn off the lids.

Each chest is decorated with a central medallion enclosing a dragon holding a tray of precious jewels. The dragons are lithe and athletic-looking, and their heads are placed in the lower halves of the medallions with their bodies arching above. Their mouths gape open

widely, their red tongues flick out, and their pink noses are shaped as *ruyi* scepters, all features characteristic of dragon designs from the fifteenth century and earlier.

Surrounding the dragons are dense patterns in rich colors. The field between the inner medallion and the corners is filled with a design of red flowers in overlapping circles (facing page, upper left), forming coinlike shapes where the circles overlap. Similar designs can be seen in Tibetan and Chinese textiles and decorative stone and metal work from the fifteenth and later centuries, as in an example from a Ming bronze sculpture in the Forbidden City in Beijing (facing page, lower right). The areas of the chest design that are now yellow in

color were probably once covered in gold leaf, now faded and worn away.

The outer, exposed sides of the chests are decorated with triple flaming gems (upper right), representing the three essential components of the Buddhist faith, on a background of green hexagons, a design also characteristic of chests from the fifteenth century.

Despite being similar in age and condition, the two chests are not identical. They show differences in detail and seem to have been painted by two different hands. They may have been painted by two different artisans in the workshop where they were made, or one of the chests may have been repaired or repainted.

Chests

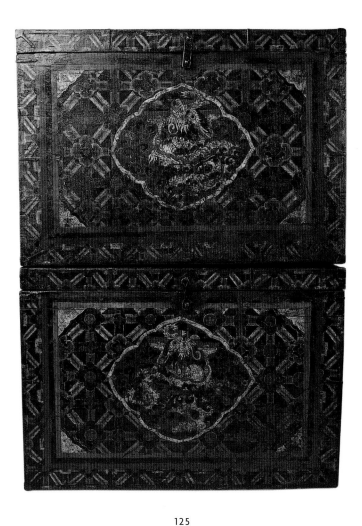

125
Pair of painted wooden chests
Each chest 96 cm x 38 cm x 67 cm 18th century or earlier

This pair of chests is decorated with symmetrically arranged dragons, facing to the left and to the right. Each dragon supports a tray of precious gems and grasps stems of twining vegetation in its other claws. Surrounding the central medallion is a background design based on a stylized textile pattern.

The dragon designs on these chests are characteristic of the late Ming period, the late sixteenth or early seventeenth century, though this style may have persisted for longer than this. This pair displays the white spikes or tufts of hair around the cheeks and eyebrows that are a common feature of dragons from this period. Despite their ultimate inspiration in Chinese textile designs this pair is unmistakably Tibetan. They have curious elephant trunklike snouts, a feature that is relatively rare in Chinese dragon designs. The elephant trunk is a characteristic feature of the *makara*, a type of water dragon derived from Indian art, and may have been borrowed from this creature by Tibetan artists.

The relatively tall proportions of these chests, their sturdy construction, and limited amounts of ironwork indicate that they were probably made in eastern Tibet. Their date is a little difficult to estimate since I have seen relatively few examples in this style.

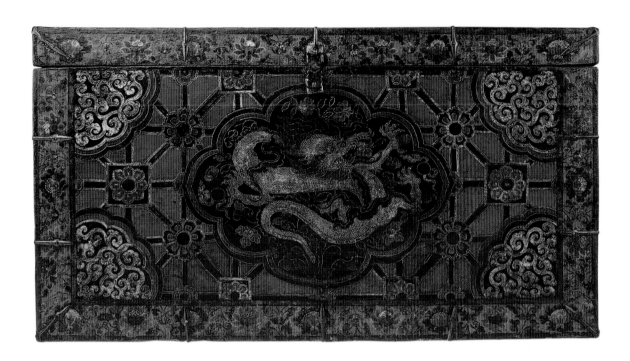

126
Painted wooden chest
113 cm x 41 cm x 61 cm 17th century

This chest is a representative of the better quality of chest produced in the central region of Tibet during the sixteenth and seventeenth centuries. It was almost certainly made as one of a pair, the other chest having a symmetrical dragon design facing the opposite direction. I have seen several similar chests, suggesting that this was a popular design, possibly produced by one workshop over a period of time.

The central medallion is painted with a lively dragon, with the curling and flowing green mane and high, bulging forehead and clawlike eyebrows that are characteristic of dragons from Chinese designs dating from the middle part of the Ming dynasty. The creature is pursuing several precious jewels and is set against a dark background with brightly colored flowering plants. Around the central medallion the background is filled with a simplified brocade pattern of squares and rosettes. The border of the chest is filled with a floral design that is also a characteristic feature of designs of this period. The sides of the chest have been left plain.

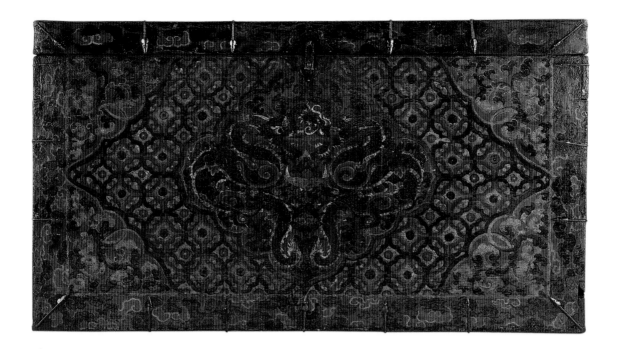

127
Painted wooden chest
138 cm x 76 cm x 50 cm circa 17th century

In the center of this large, striking chest are two serpent-like dragons (below), staring at each other with fierce expressions over a tray of precious jewels. A flowering vine twines in amongst them and surrounds them. Around them is an unusual background design (facing): an abstract pattern formed by two interlocking lattices,

one green, one red and purple. Gold leaf has been used in the background to the lattice design as well as in other places. The top and sides have been left plain.

The painting on this chest has been applied over a layer of fabric, the texture of which can be seen faintly underneath the design on the front of the chest. Both

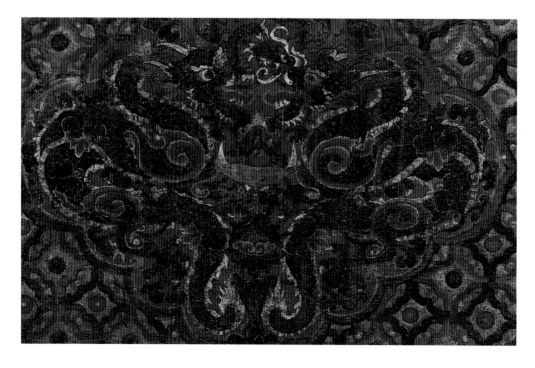

the painting and the gold leaf have developed a fine crackle with age. The lattice design in the background of the central area is quite similar to carved wooden lattices with rounded shapes on classical Chinese furniture and windows.

The spiky white fringes around the heads of the two dragons indicate that this chest was probably painted in the sixteenth or seventeenth century, when this style was current, a date supported by the shapes of the clouds around the edge of the chest. The energetic poses and expressions of the two dragons are typical of Tibetan art from this period, which was a time of lively artistic development. Many monastic institutions were also renewed and extended at this time, which contributed to the demand for large storage chests of this type.

128
Painted wooden chest
126 cm x 63 cm x 45 cm 18th century

The effects of time are evident on this chest. A large, coiling dragon, gazing out intently (facing), has faded into near invisibility, leaving little more than its grin in the manner of Lewis Carroll's Cheshire cat. Textile designs around it have also faded into dappled obscurity. In spite of or perhaps because of this, the chest retains its beauty and character.

The designs around the dragon have been rendered in gold leaf on a deep red-brown background, with traces of color applied to accent the dragon's eyes and a long, multicolored stripe down its back. A very successful decorative effect has been achieved by using almost equal amounts of gold and red and by filling the entire space with patterns, which are rendered with great precision. The interlocking-Y textile design that can still be seen in places is a very ancient pattern that was used on silk textiles, but that was probably originally inspired by the designs of body armor from the Central Asian regions. This design can often be seen in the armor worn by the Four Guardian Kings, who are depicted in the entrance-ways of many Tibetan temples.

The paint and gold leaf have been applied on top of a layer of fabric, coated with size. The gold leaf used in many Tibetan furniture designs is somewhat more vulnerable than paint and tends to fade, as has happened in this case.

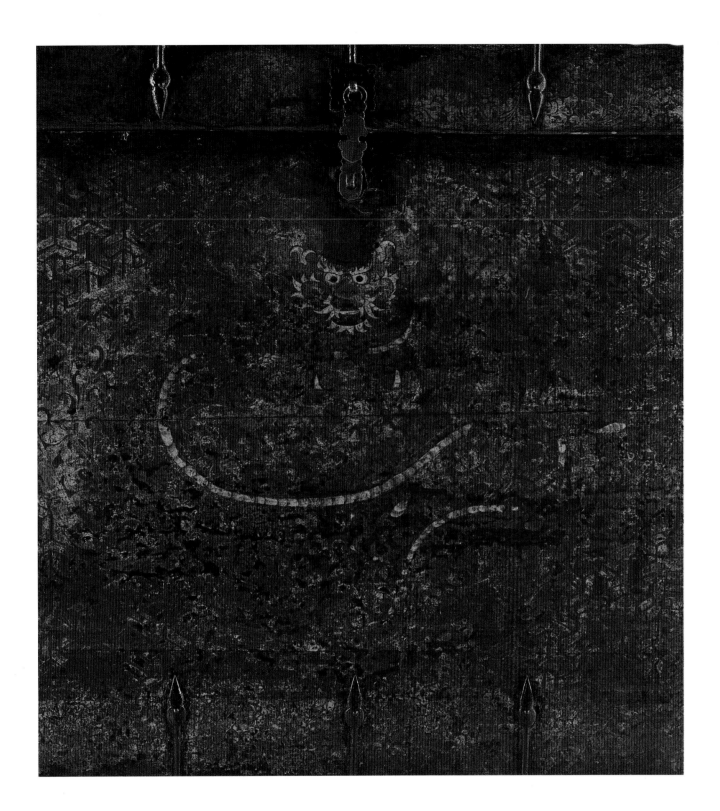

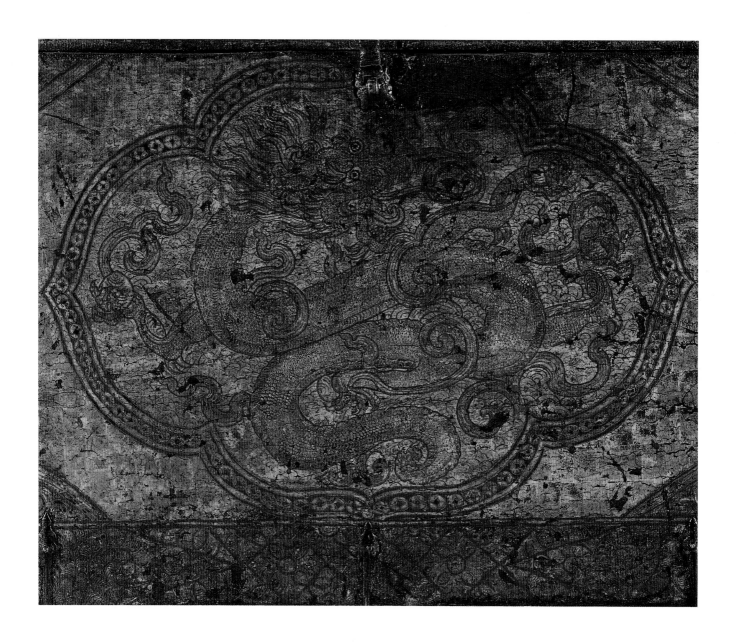

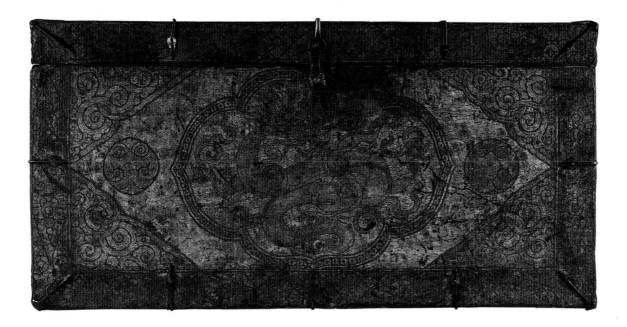

129
Painted wooden chest
99 cm x 49 cm x 41 cm 18th century

This medium-sized chest is decorated in the red-and-gold style, using red paint or lacquer, gold leaf, and gesso. A single dragon in the center of the design faces to one side and holds a precious gem in each claw. The dragon (facing) is outlined in red, with black used to define the details in some areas such as its eyes, horns, and nose. Around the dragon is a wave pattern presented as scallop shapes. On either side of the central medallion are two designs that resemble hybrids of bat and butterfly designs: they have characteristically Tibetan shapes with long, curling antennae. The top and sides of the chest have been left plain. There are several repairs and repainted areas using different materials on the lid of the chest and the area around the hasp, indicating that this chest was repaired more than once during its history.

A complex process has been used to produce the rich effect on this chest. By examining the layers of paint and comparing with traditional *thangka* painting techniques we can attempt to reconstruct the steps that were used. The chest was first covered in fabric, held in place with a layer of gum painted onto the wood. The surface of the fabric was then prepared by painting a mixture of clay and gum onto it, allowing it to dry and then burnishing the surface with a flat stone to make it smooth. This method of preparation is basically the same as for preparing a cloth scroll prior to painting a *thangka*.

The outline design was sketched onto the prepared surface, or perhaps transferred from a template; the raised parts of the design were then built up with layers of gesso, made of gum mixed with clay, probably in several successive layers. When this part had dried and hardened, the entire surface was painted with a layer of dark red paint or lacquer. Next, gold leaf was applied to the surface while it was still slightly tacky. The gold leaf came in small squares and the outlines of these squares can still be seen in some parts of the design, particularly in the background surrounding the central medallion. A considerable amount of gold leaf would have been needed, and would have added significantly to the cost of the chest. Lastly, the details of the design were applied in a brighter red color on top of the gold leaf. The entire surface would then have been given a protective coat of shellac, which also served to intensify and deepen the color.

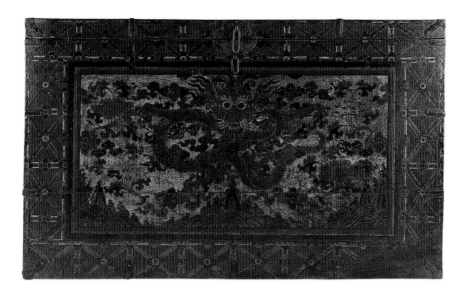

130
Painted wooden chest
156 cm x 95 cm x 50 cm 18th century

The central motif of this chest is a flying, front-facing dragon, claws outstretched, and surrounded by clouds and peony flowers. Below the dragon are wave designs with mountain peaks rising amid them; at the heart of each peak is nestled a single jewel. The outer border is filled with a textile design, while the sides are plain.

The edges and the corners of the chest are reinforced with short iron straps and the hasp plate is made of iron inlaid with silver designs. The style and sturdy construction suggest that it was made in eastern Tibet.

The painting is particularly striking because of the intense gaze of the central dragon and its multicolored mane streaming in all directions. This design is based on a standard Chinese decorative format developed during the late Ming and the early part of the Qing dynasty (seventeenth and eighteenth centuries), found on textiles, lacquerwork, stone carving, and other media. The mountain at the base represents the mythical Mount Meru, regarded as the center of the universe in both Buddhist and Hindu religions. It was also an important motif in China, where a mountain at the center of the world, holding up the sky, was closely associated with the emperor, who occupied a similarly central position in the cosmic order.

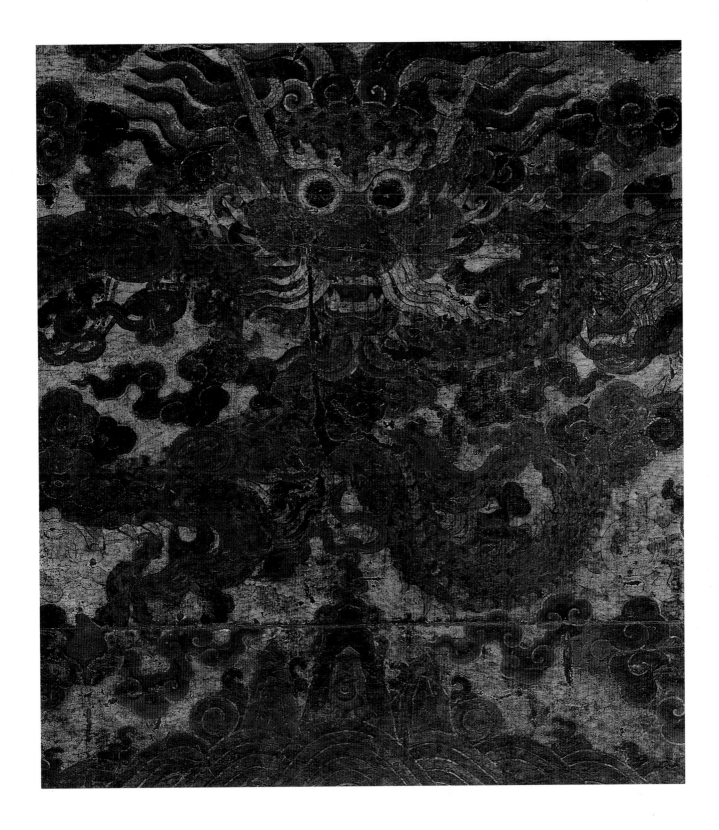

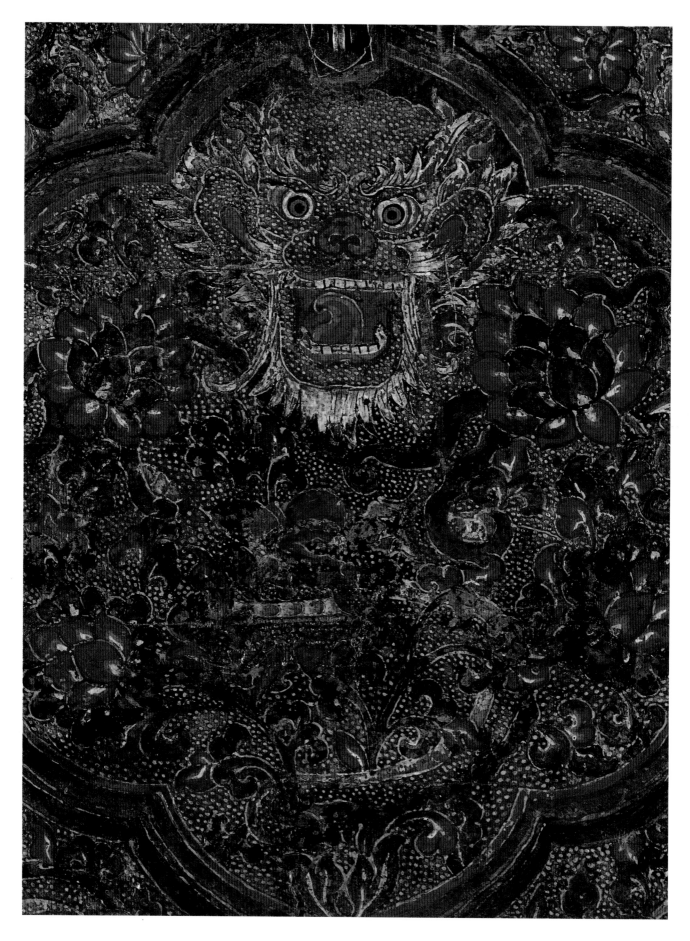

131
Pair of painted wooden chests
Each chest 117 cm x 60 cm x 43 cm 18th century

This pair of large chests probably dates from the heyday of the production of large and opulent chests during the eighteenth century. They were made to impress and must have belonged to an individual or institution of some wealth, possibly one of the larger monasteries.

Their size, style, and decoration are characteristic of eighteenth-century chests. Gesso has been used liberally to produce raised designs and a stippled background, with traces of gold leaf remaining, that covers most of the front faces. Deep reds, green, and blue hues have been used, but the dominant effect was intended to be the gilding. Despite the predominance of gesso there is no sign of the laziness that crept into Tibetan furniture decoration during the nineteenth century. Details such as the eyes and mouths of the dragons are crisply rendered (facing). The outer edge has a coin-design border, which is yet another characteristic of chests from central Tibet during this period.

The design consists of dragons holding gems, inter-mingled with foliage and peony flowers. The chests were clearly made as a pair and at first sight they look like mirror images of each other. In fact they are not quite identical. One chest has five dragons painted on it, the other four. The dragon that would have been in the lower left-hand corner of the lower chest in the illustration is seemingly missing. This leaves nine dragons between the two chests. In China a group of nine drag-ons and other groups of nine are uniquely associated with the emperor and his close relatives. Designs of nine dragons decorate walls and other places in the Forbidden City in Beijing, for example. This pair of chests seems to be a Tibetan attempt to emulate these Chinese imperial designs. We do not know whom this pair of chests was made for, but it must have been someone greatly hon-ored, since the design on the chests implies a flattering comparison with the Chinese imperial family.

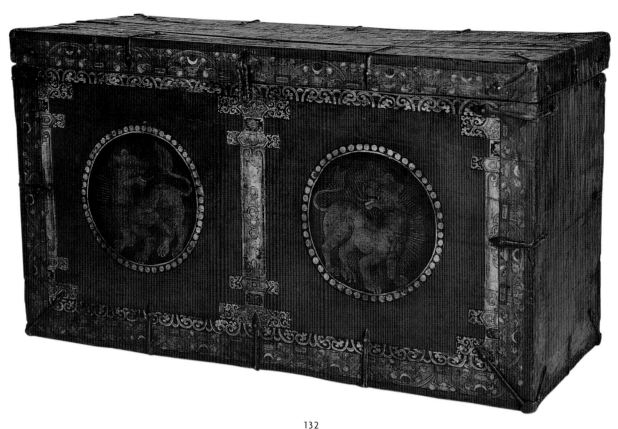

132
Painted wooden chest
99 cm x 54 cm x 41 cm circa 16th century

Examples of old furniture from far western Tibet are still relatively rare and less well documented than pieces from other regions. This chest shows features that associate it with the far west, as well as some details that allow a reasonable estimate of when it was made.

A design of two lions in roundels with pearl borders is flanked by pillar-like architectural forms in black and white, and borders of foliage and "curtain of jewels," constituting a distinctive decorative style; the borders of closely spaced pearls (facing, upper left and right) are particularly characteristic of western Tibetan art. In the roundels containing animals are also echoes of decorative designs and ancient textiles from Central Asia, which seem to have been a particular influence on western Tibetan decorative styles.

The details rendered in black and white, such as the pillars and the inner border of stylized foliage, contrasting with the strong color used elsewhere in the design, have close parallels in the decorative details depicted in

sixteenth-century murals at the great monastery at Tholing, an important center in the ancient Guge kingdom of western Tibet. A detail from those murals (facing, lower right) shows a folding table set with two vases on top of a platform decorated with a black-on-white vine design; the similarities between the decorative styles portrayed and those of the chest are striking. This can be seen most clearly in the shapes of the leaves on the black-on-white vine and the presence of a thin black line running through the center of the vine, a feature that can be seen in both examples. This technique of painting areas of black or solid color on a white background, contrasting with brilliant color in other areas of the painting, may have been borrowed from Newari (Nepalese) painting styles and is used throughout the Tholing murals.

From the very close parallels with the art at Tholing we can estimate that this chest was painted at around the same time, probably during the sixteenth century.

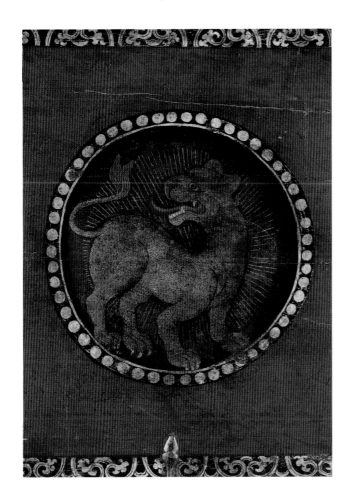
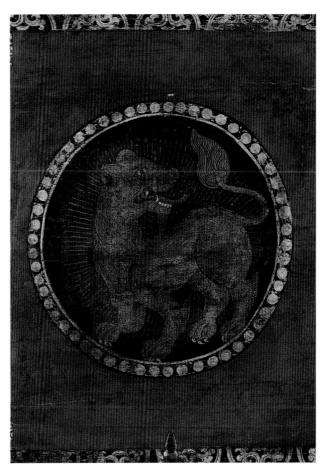
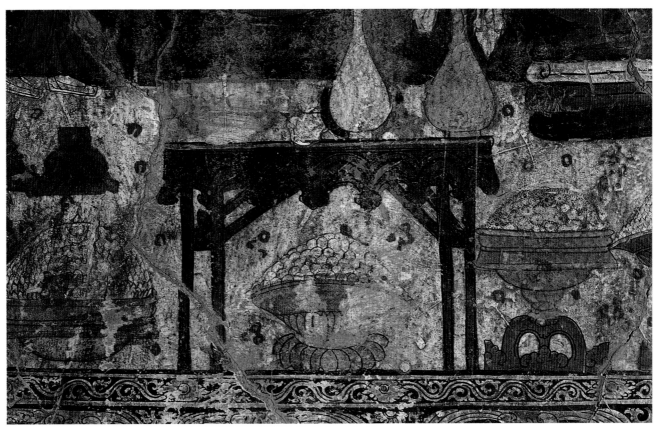

133
Painted wooden chest
75 cm x 47 cm x 39 cm 19th century

The front panel of this chest is painted with a single prowling tiger, turning and facing to the rear with its fangs bared and tongue curling from its mouth. The design dominates the central panel, which also has some floral designs, and is a masterpiece of Tibetan decorative art. By means of the unusual pose the artist has neatly solved the problem of fitting the tiger's rounded shape into a square frame and filling it to create maximum impact. The tiger's stripes have been rendered as concentric swirls that seem to be in motion and radiate

energy. The side panels are painted with a leopard skin pattern.

The chest is a sturdy box with competent joinery and without ironwork reinforcements. Unpainted areas on the left and right of the central panel show that it once stood on legs but that these were removed at some point, probably due to damage or decay.

The painting style and construction of this chest point to an origin in eastern Tibet, where many such tiger-design chests were produced.

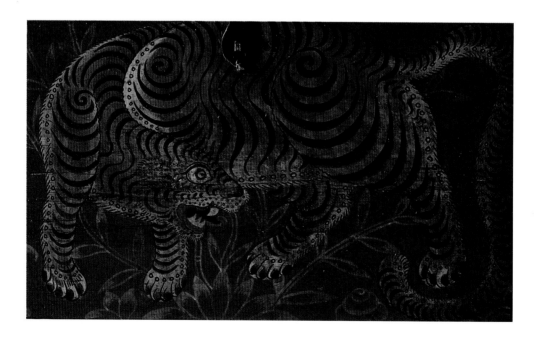

134
Painted wooden chest
149 cm x 68 cm x 50 cm 17th century

This long chest is decorated with a *zeeba* face, gazing out intently. Three jewels spill out of its mouth together with vines that scroll around its face and bear large peony flowers. The flowers are colored with delicate washes of pink on cream. The border has a faint and rather darkened design of cloud shapes. The sides and top of this chest are undecorated.

This chest is a representative of the sloping-sided style, though in this case the inward slope of the sides is very slight. The chest has a scalloped decoration carved along the top edge, a characteristic feature of this style. The lid, which can be seen protruding slightly above the top of the chest, is a flat board, hinged at the back and closed by a hasp that curls around the edge of the chest. A few iron straps reinforce the sides of the chest.

The *zeeba* face in this chest is unusual in several respects. Instead of the usual moon and sun symbol perched on its head it has a single precious jewel, while three more jewels spill from its mouth. The jewels symbolize the taming of the wild spirit of the *zeeba*, who has been forced into service as a protector of the Buddhist faith. This chest might have served as a repository of precious items in a monastery, jealously guarded by its *zeeba* protector.

Chests

135
Painted wooden chest
102 cm x 70 cm x 36 cm 19th century

A striking tiger-skin design appears to be draped over this chest. The pelt is depicted as completely covering the lid and upper part of the chest. The left-hand side of the chest (not shown) is painted with a leopard-skin pattern inside a plain border, while the right-hand side of the chest is undecorated.

The chest is constructed of comparatively thick and heavy boards, reinforced at the front and back edges with a few plain metal straps. These straps have been added purely to strengthen the chest and were not intended to be a decorative feature. The solid construction, the design, and the proportions of the chest, which is relatively tall in relation to its width, point to an eastern Tibetan origin.

Tiger-skin designs are a characteristic of furniture as well as other objects from eastern Tibet. The addition of a panel of leopard-skin pattern on one side of the chest is not merely decorative but has deeper sig-

nificance. The tiger and leopard combination is associated both with the Chinese idea of a harmonious balance between yin and yang. In a Tibetan context it is even more specifically associated with the Tantric Buddhist notion of the union of wisdom and compassion. It is probably not an oversight that only one side panel of the chest has been painted: a single panel of leopard-skin design may have been all that was required to create the symbolic balance. An alternative explanation is that the chest was originally one of a pair of chests that were made to stand side by side. In such cases it is not unusual for the painter to decorate only the outer side faces of the chests.

Assigning a date to this type of eastern Tibetan tiger chest is difficult since there is little comparative material from other fields to help. However, from the condition of the chest and the colors used a nineteenth-century date seems likely.

136
Painted wooden chest
83 cm x 68 cm x 46 cm 19th century

The design on this chest is similar to the preceding one, except that in this case a pair of animal skins have been painted to appear as if they are draped over the chest: a tiger skin (underneath) and a leopard skin (on top). The skins appear to rest on top of a plain design consisting of a dark red central panel and a black border.

Both the tiger and leopard skins have been painted with lifelike faces that seem to fix the onlooker with fierce and mischievous stares (facing), even though they are obviously intended to represent the skins of dead animals. This artistic license is common in Tibetan depictions of tiger skins and these designs are very similar to those on some woven tiger skin rugs from Tibet. The designs on rugs, as on chests, generally fall into two types: those that show abstract patterns of tiger stripes and those that try to represent a whole pelt. The bushy eyebrows are an unusual feature for tiger skins and recall similar eyebrows found on dragon and *zeeba* designs.

This chest displays the characteristic features of eastern Tibetan workmanship, including solid construction and proportions that are tall relative to the width, so much so that the front panel is nearly square, unlike the 2:1 proportion commonly found in central Tibetan chests.

As with the preceding chest, the painter sought to combine both tiger- and leopard-skin designs into one chest to achieve the proper balance in the overall decoration. This solution, painting two skins superimposed, is unique in my experience.

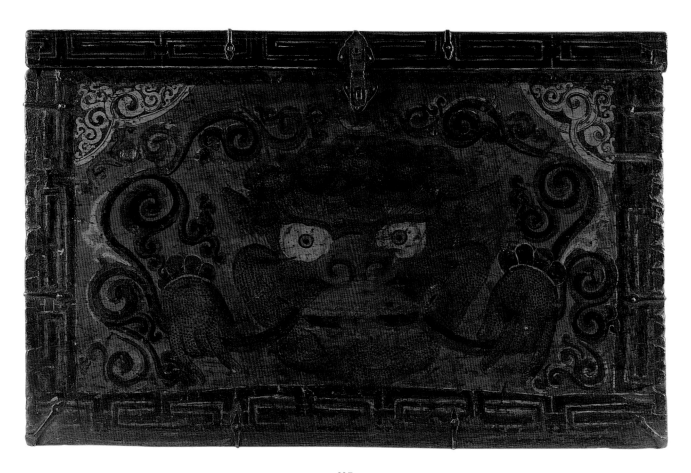

137
Painted wooden chest
93 cm x 58 cm x 38 cm 18th or 19th century

Like the preceding example, this *zeeba* chest is almost certainly from the eastern regions of Tibet and shows many of the characteristic features of furniture from this region. The timbers used to construct the chest are more substantial than the ones used in furniture from the central regions and the joinery is excellent: the planks at the edges of the chest are fixed with well-crafted butterfly joints. There is relatively little ironwork, probably because there was little need for it on such sturdy timber.

Other characteristic features of eastern Tibetan furniture include the bold and simple decorative scheme, lacking the elaboration of much of the furniture from the central regions. The border design is commonly found on a great deal of furniture from this region. Another characteristic feature of furniture from this area is painting that has been applied directly to the wood, in contrast with the fabric covering that is sometimes seen in furniture from the central regions.

Despite the fine woodwork, the *zeeba* face in the center of the chest has a provincial, almost rustic feel to it. The painter began with corner scrolls at the top of the painting but seems not to have left enough room to complete the design with corner scrolls at the bottom and so decided to leave them out.

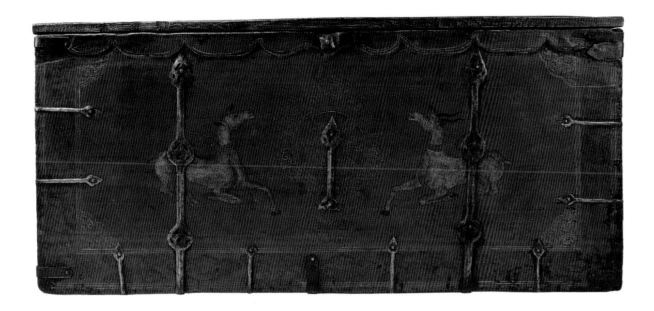

138
Painted wooden chest
111 cm x 50 cm x 38 cm 17th century

A pair of Tibetan antelopes (*chiru*) rest on either side and facing a Dharma wheel, painted in gold on a red-brown background. The border is a subtle design of clouds, applied in dark red. The decoration has been applied over a fabric layer, which has been so heavily sized in preparation for painting that the texture of the fabric cannot be detected in the paint surface.

The chest is constructed with straight and parallel sides but it has the scalloped decoration and the flat board lid that are often found in sloping-sided chests. The heavy decorative iron straps with openwork designs are also more characteristic of the sloping-sided style.

The motif of two deer facing a wheel symbolizes the Buddha's first sermon in the Deer Park at Sarnath. This grouping can be seen in gilded sculptures on the roofs of nearly all Tibetan temples, though in most cases the animals do not seem to belong to any particular species. On this chest they are clearly intended to be Tibetan antelope (right) rather than deer; the male animal has the characteristic long and slightly curved horns of this species.

The style of the painting, with its use of gold shading to outline features of the design, is close to *thangka* painting styles of the sixteenth and seventeenth centuries.

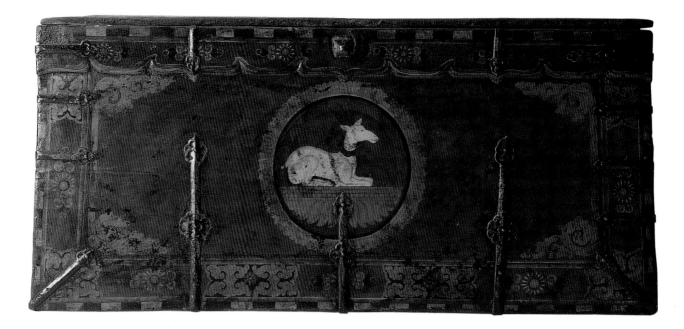

139
Painted wooden chest
134 cm x 64 cm x 44 cm 16th century or earlier

This large chest is decorated with a Tibetan antelope (*chiru*) with a green ribbon around its neck, kneeling on a plinth (facing). The corners of the central panel are decorated with simple vegetal scrolls and the border of the chest has floral designs. There appears to be a relatively thick layer of size composition on the wood surface underneath the paint layer and the surface displays a fine crackle, both of which are characteristic of many earlier examples of painted Tibetan furniture.

The sides of the chest slope inwards slightly and the top of the front panel is decorated with a scalloped edge presenting a false lid. The true lid of the chest is a flat board that sits on the top of the chest without overlap-ping the front or sides. The chest is decorated with substantial ironwork, the largest straps at the front showing openwork designs. The ironwork is clearly intended as a decorative feature as well as reinforcement.

The design of a single white antelope is unusual. Its significance on this chest is not known, though it may have been a symbol associated with a particular family or monastery. The style of the painting, in particular the stylized flowers in the border, the depiction of the ribbon around the animal's neck, and the overall simple and uncluttered decorative scheme suggest that this is a relatively early chest, probably dating from the fifteenth or sixteenth century.

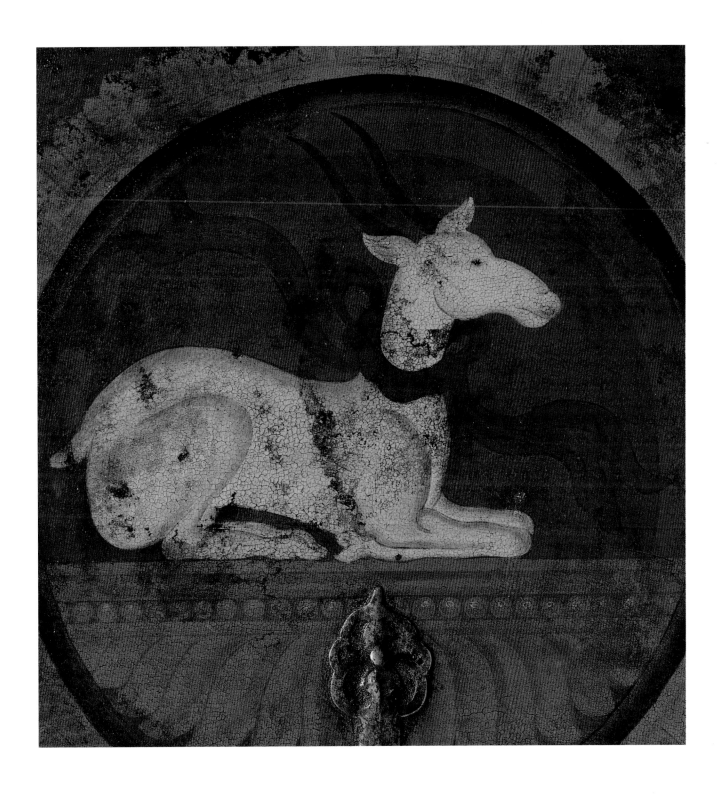

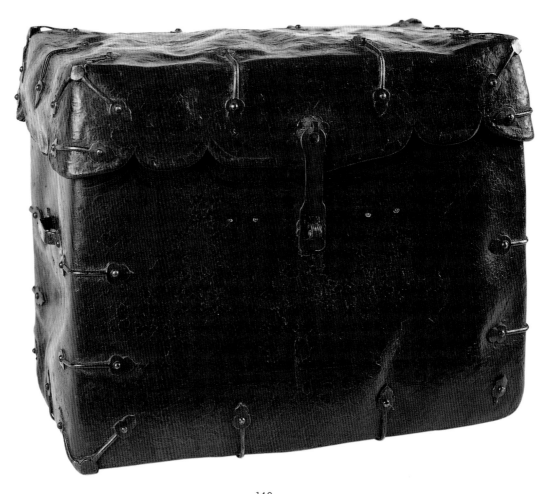

140
Leather chest
38 cm x 31 cm x 22 cm 16th century or earlier

This small chest is made of heavy yak hide and finished with iron bindings. It is a representative example of smaller Tibetan leather chests with no internal wooden structure. The chest tapers slightly at the top and the lid, which overlaps the body, is fastened with a bronze hasp that is probably a replacement for an earlier iron hasp.

The chest is decorated with black and gold paint on a dark red-brown ground. At the center of the design is a pair of two-headed birds, surrounded by trees and flowers. The painter might have had in mind the Western Paradise of the Buddha Amitabha, as described in the *Amitabha Sutra*. In that paradise supposedly dwell a variety of colorful and exotic birds, including two-headed species which constantly proclaim the Buddha's teach-

ings. Rebirth in the idyllic Western Paradise is considered very desirable and is the principal goal of some Buddhist sects.

A number of small leather chests of this type with no internal wooden frame are known, and many seem to be of a relatively early date. The majority of them are undecorated, although some chests have been painted later. This is difficult to detect if skillfully done; an important indication, if observable, is whether painting lies underneath or on top of dirt and damage on the leather surface.

Assigning a date to this chest with precision is difficult, but the form of the ironwork and the style of painting suggest that it is a relatively early example, probably dating from no later than the sixteenth century.

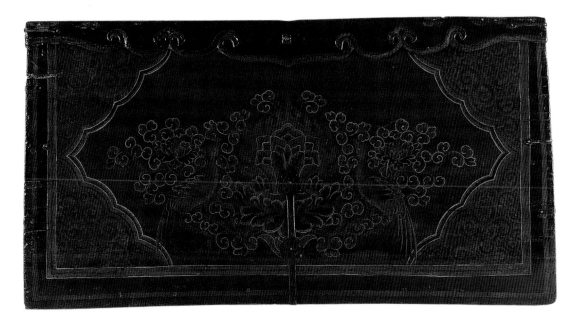

141
Painted wooden chest
136 cm x 72 cm x 56 cm circa 16th century

Two green parrots perch on either side of a central lotus blossom at the center of this large chest. In the middle of the lotus blossom is a cluster of flaming jewels, while scrolls of vegetation and lotus flowers surround the parrots, all set against a deep-red background.

The sides of this chest slope inward very slightly, and the top edge has the characteristic scalloped decoration associated with this style. The scalloped decoration has a rather subtle and beautiful shape, incorporating wavelike shapes and a couple of *ruyi* motifs resembling anchors. The lid is a flat board resting on top of the chest. A single large iron staple in the center of the chest is decorated with openwork. There would have been more small staples around the edges of the chest originally, but most of these have been lost over time.

Indian green parrots such as the ones painted here (right) crop up occasionally in Tibetan art. They are said to symbolize the transmission of Buddhist teachings from India. More prosaically, pairs of parrots can also be symbols of marital fidelity. The relatively sparse and simple decoration is characteristic of earlier chests of the sloping-sided form. This type of flaming-jewel design with its rather angular group of jewels is often found on chests from the sixteenth century and earlier.

Chests

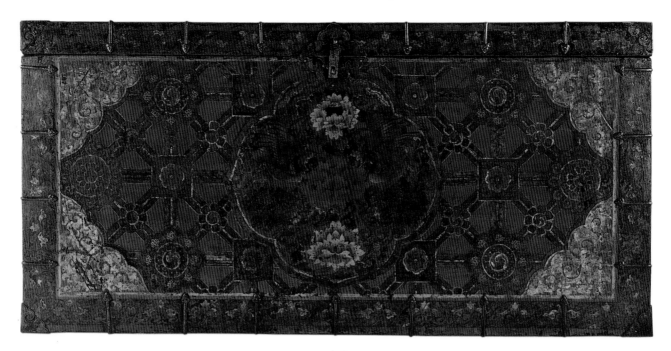

142
Painted wooden chest
138 cm x 66 cm x 49 cm 18th century

This large chest is decorated with a design of two birds, surrounded by luxuriant foliage and large peony blossoms. Judging by their multicolored plumage and streaming tails, the two birds are probably intended to be phoenixes. The artist has contrived to fill the remainder of the medallion with large blossoms, rendered with shading created by the repeated application of pale washes of color.

Around the central area is an intricate brocade-inspired design of linked floral roundels and squares. The floral heads are lotus-shaped, a feature that seems to have been an innovation of the painter since there appear to be no silk textiles with this design. The petals of the larger flowers are decorated with smaller flowers and scrolling work, also a feature that is not seen in the original textiles. Various parts of the design are highlighted with gold leaf. The top and sides of the chest are plain.

The paint is applied over a layer of fabric that covers the entire chest. The edges of the chest are bound with iron staples, with reinforcing pieces at the corners. The metal hasp plate is decorated with openwork.

The design and the style of painting are consistent with an eighteenth-century date for this chest, which is painted and finished to a very high standard.

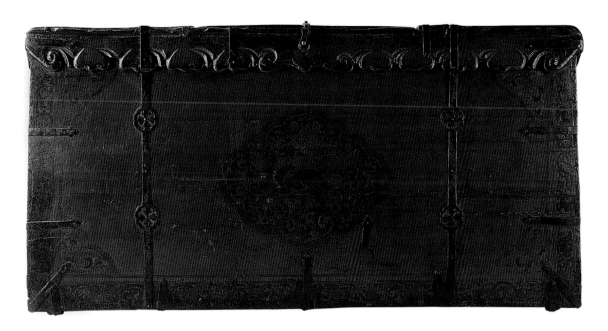

143
Painted wooden chest
154 cm x 78 cm x 51 cm circa 16th century

At the center of this large chest is a painting of the mythical beast called the *qilin*. The corners of the chest are decorated with simple vegetal scrolls and the border has similar decoration in the form of a continuous vine, painted in dark green and light brown with traces of gold leaf remaining in places.

The chest is rather massive, consisting of heavy wooden planks joined together and reinforced with metal straps. The straps are wide and flat with short points, a feature that seems to be characteristic of metalwork from some earlier Tibetan furniture. The top part of the chest features a board deeply carved with a scallop design to resemble the edge of an overlapping lid. However, the actual lid is a short hatch set into the top.

In addition to the short reinforcing metal straps the chest has two long metal straps decorated with openwork. At one time there appear to have been three shorter straps extending from the bottom of the chest to the base of the painted medallion, arranged so that they did not cover up the painted design. Only parts of these remain now. At the base of the chest are several boards that reinforce the bottom and also act as feet, raising the chest slightly off the floor by a centimeter or so.

The *qilin* is relatively uncommon in Tibetan furniture painting. This animal is said to have "the head of a dragon, the body of a stag, the hooves of a deer, the scales of a fish, and the tail of a bear," and several of these features can be seen in this example. The style of the painting resembles examples from Chinese textiles from the mid-Ming period (fifteeth or sixteenth century). The construction of the chest, its relatively sparse decoration and warm, dark-toned colors is also consistent with a date of manufacture during this period.

144
Painted wooden chest
127 cm x 62 cm x 44 cm 15th or 16th century

The central figure on this sloping-sided chest is Vaish-ravana, King of the North of the Four Guardian Kings. He is clad in armor and holds a victory banner in his right hand and a jewel-spitting mongoose in his left, attributes that serve to identify him. He is richly clothed and has huge flowing sleeves that billow up at his shoulders. He sits on a snow lion with a white body and a curly green mane, which twists back and snarls.

The remainder of the decoration is relatively sparse. The corners are filled with simple scroll designs and the borders have faint cloud designs in brown against the red background: these show signs of having been gilded at one time. Traces of gold on the border scrolls indicate that these were once outlined in gold as well. The painting has been applied on top of a layer of fabric and has acquired a fine crackle with age.

The Four Guardian Kings commonly appear painted in the entrance portals to Tibetan temples, where they act as protectors of the temple as well as guardians of the Buddhist faith. Representations of Vaishravana on furniture are relatively uncommon, however. He is a god of wealth, indicated by the jewel-spitting mongoose he holds, and he is closely related to the wealth god Jambhala, who more commonly appears painted on chests. Like Jambhala he holds a mongoose and victory banner, but unlike Jambhala his costume and demeanor are that of a warrior and his gaze is fierce and defiant.

The style of this well-rendered painting is similar to that of scroll (*thangka*) paintings from the fifteenth century and the chest probably dates from around this period. The depiction of Vaishravana's face, particularly the intense wide-eyed gaze, is also characteristic of this era.

145
Painted wooden chest
120 cm x 69 cm x 50 cm 18th century

This chest is decorated with a seated figure in a landscape setting. The figure is dressed as an Indian king with an elaborate crown, earrings, sash, and a waist garment called a *dhoti*. In his right hand he holds a jewel and in his left he holds a mongoose that spits jewels. The jewels seem to ripen and expand as they fall to the ground in a pile at his feet.

The Indian king is Jambhala, the god of wealth. The painting of him on this chest is of unusual delicacy and quality (facing), equaling good *thangka* painting from the eighteenth century, the period from which this painted chest dates. Jambhala sits on a lotus throne made of petals that fade from deep pink to pale cream towards their outer edges. His garments are decorated with designs picked out in gold, which create a rich effect, enhanced by the flowing curves and the way the fabrics drape. In front of him there is a variety of offerings, including a conch, a vase, tusks, a tiger skin, a leopard skin, and an ingot of silver.

The style of the painting with its flowing and confident outlining of the figures with strong calligraphic lines is suggestive of eastern Tibetan painting styles. This connection is reinforced by the tiger- and-leopard skin offerings on this chest, which are eastern Tibetan preferences.

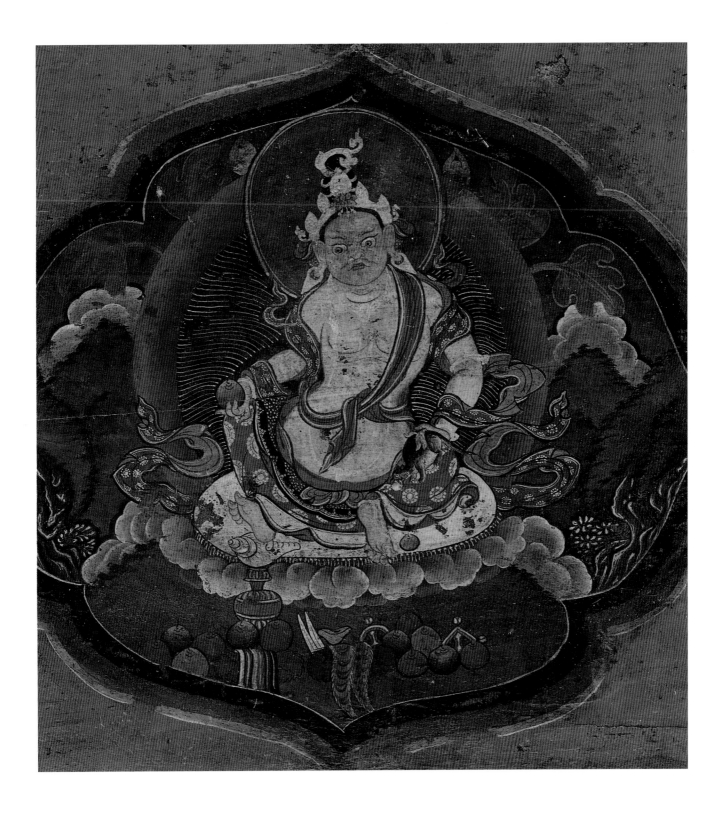

146
Painted wooden chest
90 cm x 63 cm x 51 cm 17th or 18th century

At the heart of the painted design on this chest is a fierce black deity holding a skullcap bowl brimming with blood in his right hand and a mongoose spitting jewels in his left. The chest is of the sloping-sided type with a lid that overlaps the top.

The deity is a fierce form of the wealth deity Jambhala, called Kalajambhala. This is an unusual painting for a Tibetan chest and it is uncommon to find a painting of this deity in any setting; he is only rarely depicted in scroll paintings or temple murals. Kalajambhala is best known from small statues that were popular during the eleventh through thirteenth centuries, but he seems to have fallen out of favor somewhat after that period. His body is black and corpulent and hung with garlands made of live snakes. His mouth is open, displaying fangs, and his head is seen against a halo of flames. In a peculiar twist occasionally seen in representations of fierce deities he is trampling on the corpse of Jambhala, his own peaceful form.

A chest with this type of design would probably have been used in a monastery rather than a domestic setting. It is also possible that the chest was used in the temple *gonkhang* (shrine to the protector god of the temple) rather than in the main part of the temple, perhaps for storing paintings or ritual objects.

The style of the painting, particularly the bulky form of Kalajambala and the style of the flaming halo, indicate that it dates from the seventeenth or eighteenth century. The chest itself might even be earlier in date since furniture was sometimes repainted when designs became worn or faded.

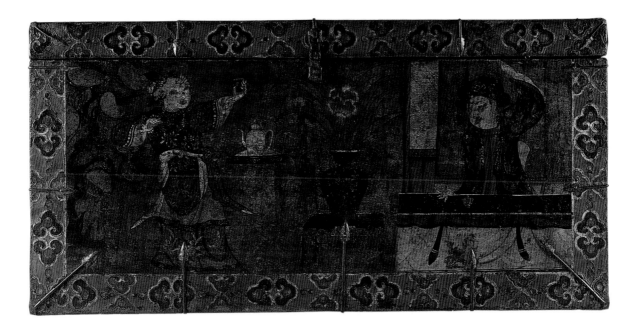

147
Painted wooden chest
110 cm x 55 cm x 40 cm 19th century

Two figures dressed in the Chinese style in an interior setting are painted on the front of this chest. The scene appears to be from a drama: the woman on the left holds up a small book or purse in her left hand and a comb in her right. The man on the left is seated with a Chinese teacup and saucer in front of him. Both figures have long fingernails indicating that they are wealthy nobility unaccustomed to manual work. The border of the chest is painted with a simple abstract design with raised gesso outlines, probably by a different hand than the one who painted the central scene. The chest is of the straight-sided style, with unusually long iron reinforcing staples at the edges. The painting has been applied on top of a fabric covering.

The choice of subject is an unusual one for a Tibetan chest, though such genre scenes were commonly painted or carved on Chinese domestic furniture such as cabinets throughout the eighteenth and nineteenth centuries. The scene appears to be an operatic performance. In former times Chinese operatic troupes toured the countryside in many parts of China giving performances. These troupes were well-known in the Tibetan border regions and the embroidered cloth backdrops used in these performances are occasionally found in Tibet. It is likely that Tibetan furniture decorators in the eastern regions were familiar with these dramas and probably copied them on occasions to make furniture suitable for opulent domestic settings. The painting in this case is of a higher order than that normally found on furniture and was probably commissioned from a specialist painter.

The scene is interesting for the details of the embroidered costumes of the actors, and for the small lacquered Chinese table between them that supports the vase of flowers. This type of table with "cloud" feet and gold decoration seems to have been common during the eighteenth century and earlier and was well-known in Tibet, where imported Chinese tables of this kind were used as altar tables. Few have survived, however, probably because of the fragility of their lacquer and their delicate proportions. It is interesting to compare the shape of this table with another example (see fig. 156) that was probably made in Tibet based on this type of small Chinese table.

The design shows a certain amount of deliberate defacement: the eyes of the main figures have been scratched out but the design is otherwise undamaged. This type of defacement is consistent with damage to furniture carried out during the period of Cultural Revolution during the 1970s.

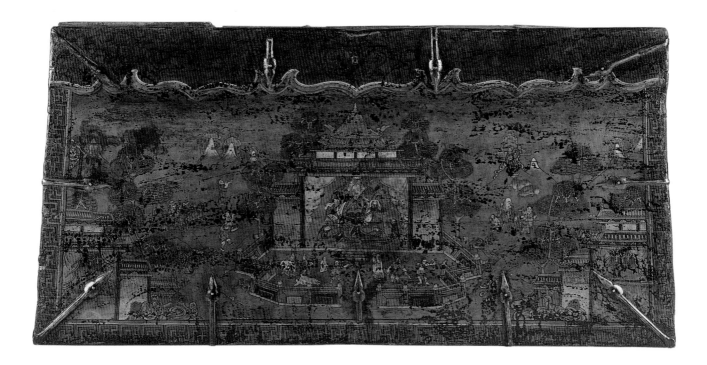

148
Painted wooden chest
101 cm x 51 cm x 30 cm 19th century

This chest is painted with a scene set in an idealized garden landscape. At the center is a king or prince in a royal palace, surrounded by an enclosure (facing). A variety of scenes are enacted in front of the enclosure and at the sides. On the right-hand side is an elderly white-haired figure riding a deer (right). On the left are figures riding a horse, bearing gifts, and playing a horn. To the extreme left and right are more buildings set amongst trees. Fabulous birds sing in the trees and the trees themselves are draped with gems. In the distance are snow-capped mountains surrounded by clouds.

The chest is of the sloping-sided style, with characteristic carved scalloped decoration along the top edge and substantial ironwork. There is a hatch-type lid in the top of the chest.

The regal figure in the center seems to be the Buddha of the present age, Siddartha Gautama, shown in the period of his early life, before he renounced his wealth and began to lead a life of austerity. The Buddha's early life was marked by a series of miraculous events, several of which are shown in the palace grounds in front of the principal seated figure. On the left is a depic-

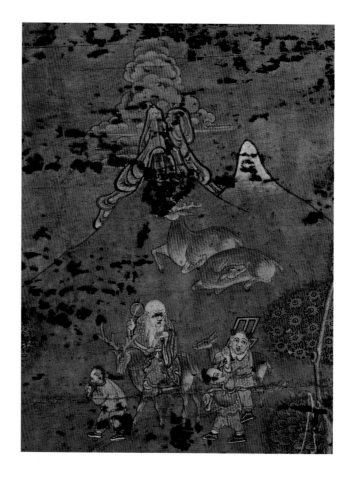

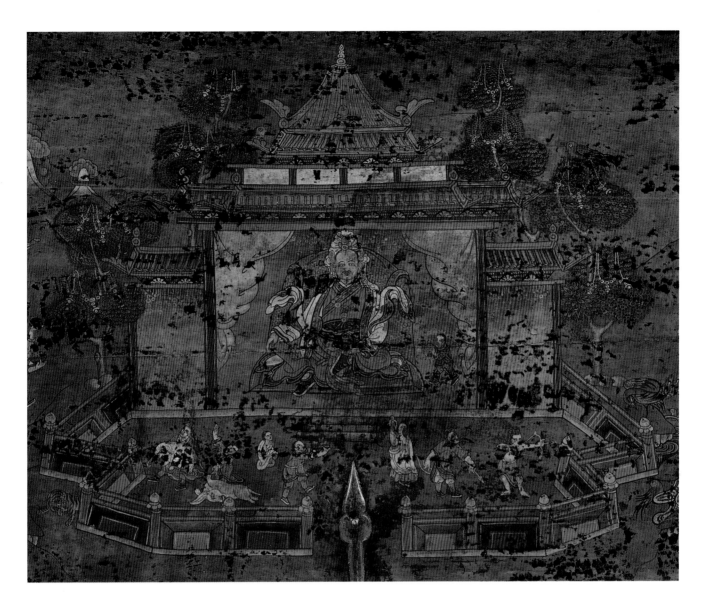

tion of the time when the local people near the palace were endangered by a rogue elephant, which was defeated by Siddartha, who then also threw its corpse away. On the right is Siddartha firing an arrow, probably a reference to the time when he demonstrated his mastery by firing an arrow that penetrated a series of tree trunks. Other figures bring gifts and pay homage.

The sumptuous palaces in this painting represent a Tibetan idea of what an Indian royal palace might look like, with multitiered roofs, fabric hangings, and pre-cious jewels set in a lush, idealized landscape. The design is a fusion of Indian, Chinese, and Tibetan elements.

The style of the decoration is consistent with a date in the nineteenth century. The chest itself may have been made at the same time but could also be significantly earlier in date. Many chests of this type were made during the fifteenth and sixteenth centuries but at that time they were finished with much simpler decorative schemes. Some were later repainted as tastes changed, which may have happened in this case.

149
Painted wooden chest
114 cm x 72 cm x 61 cm 19th century

Most of the front panel of this chest is occupied with an expansive royal hunting scene, with the hunt proceeding on the left in full view of a palace on the right. A border of dark-red, green, and gold lines surrounds the painting. The chest is solidly constructed, with heavy metal straps at the edges. The paint has been applied on top of a fabric covering.

This is one of the liveliest and most detailed landscapes I have seen on a Tibetan chest. Though the scene is an idealized one it nevertheless depicts many elements of Tibetan life in a naturalistic manner. In the left and center of the painting the hunt progresses on horseback. Several figures are pursuing a tiger and attempting to shoot it with arrows. It appears that they have been unsuccessful so far since one of the figures is shooting to the left but the tiger has slipped around behind them

(facing). The center of the scene is occupied with lively prancing horses rendered skillfully and naturalistically. An incense burner is piled with juniper brush, creating clouds of scented smoke.

On the right-hand side stands a palace with figures inside who are observing the hunt from galleries. The throne room, which is on the top story, is empty since the king is out on horseback participating in the hunt. Behind the palace are a series of conical hills, one of which has a group of prancing yaks. On two of the hilltops are groups of tall staves plunged into the ground with prayer flags attached. These closely resemble green hilltop sites with large staves that can be seen to this day in northeastern Tibet, particularly the Amdo and Kham regions. The style of the painting and the landscape scenes also suggest that this chest comes from eastern Tibet.

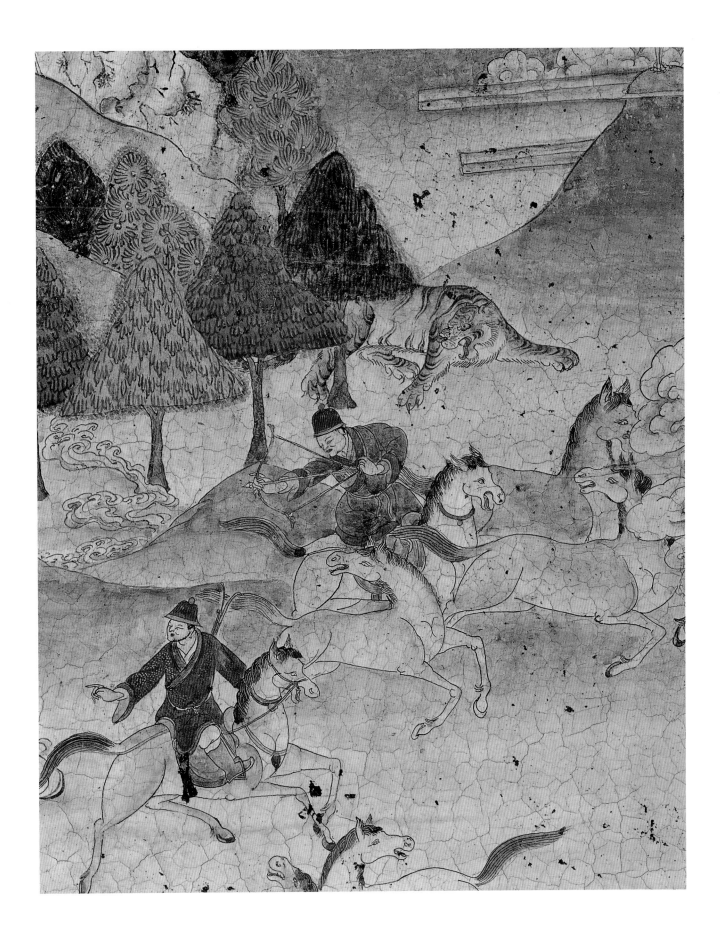

TABLES

150
Painted wooden table
100 cm x 58 cm x 31 cm 17th century or earlier

The unique carved faces on this table indicate that it is a particularly ancient example, perhaps dating from the seventeenth century or earlier. The construction is relatively simple, consisting of four panels at the front set into a frame and additional undecorated panels at the sides. The panels at the front are floating, that is, held in a manner similar to glass in a picture frame.

The most remarkable feature of this table is the pair of grotesque faces carved into the two lower panels at the front. These are reminiscent of a skull-and-crossbones motif but in fact are lion faces; the four projections at the sides are depictions of paws and ears. These designs were probably copied from scroll paintings, *thangka*. Paintings made in Tibet from the eleventh through thir-

teenth centuries often have rows of lion and elephant faces at the bases of the thrones of deities; the carved faces here resemble these grotesque faces quite closely. Such *thangka* are rarely seen today but were probably still commonplace in Tibetan temples at the time that this table was made.

Some paint adheres to the rather worn surfaces of this table. The carved faces were painted white, or perhaps a yellowish color, against a dark-red background. The mouths of the lions are painted red. On the sides of the frame are some faded cloud motifs.

Assigning a precise date to this table is difficult, however it is unlikely that it dates from after the seventeenth century.

151
Painted wooden table
37 cm x 18 cm x 20 cm circa 17th century

This small table is a relatively early example of its kind. Its construction is very simple, consisting of a flat board for a top, with grooves on the underside into which the front panel and the two side panels slide. Originally there were no pins or glue securing the panels, which suggests that it may have been made in such a way that it could be dismantled for transport. More recently, however, nails have been added to strengthen the joinery.

The front panel is carved with two snow lions, facing outward, surrounded by carved designs representing stylized vegetation. The snow lions are painted green with orange fur. The side panels are carved with lotus designs. The front of the table around the snow lions was originally covered in gold leaf, but most of this has worn away. The top of the table is carved into a lotus petal design, which was also painted in vivid colors.

The layout of this table, with a pair of snow lions below and a lotus carving at the rim, is identical to the layout of the thrones of many peaceful Tibetan deities. This suggests that this table was intended for ritual use, possibly as a support for a statue or for offerings, or for the use of an individual who commanded respect. The style of carving, particularly of the snow lions and the vegetal scrolls, is similar to book covers and *thangka* paintings from the sixteenth and seventeenth centuries, and the table probably dates from around this period.

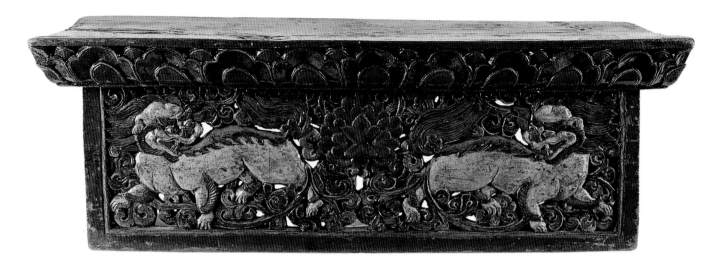

152
Painted wooden folding table
50 cm x 18 cm x 17 cm 17th century

This small folding table is similar in style and age to the preceding example. It is in good condition and has retained most of its original coloring. The upper part consists of a frame built around a single board. The front and side panels hinge into this frame so that the table can be folded flat for transport.

The front panel is decorated with a pair of snow lions, walking away from each other but looking back toward the center, where there is a red lotus flower. Around them is openwork carving of vegetal scrolls. The two snow lions are painted in the classic colors for this animal: white bodies with green manes. The side panels also have finely carved *zeeba* faces (facing), topped with precious jewels and surrounded by scrollwork. The *zeeba* faces and snow lions have pink *ruyi*-shaped noses, the

shapes of which were probably originally inspired by the animals depicted on Chinese rank badges from the Ming dynasty (fourteenth through seventeenth centuries), most of which also show this characteristic shape.

The frame around the top panel is deeply carved with a lotus-petal design. This type of deep carving seems to be a more common feature on earlier tables and cabinets; later furniture is more likely to have lotus designs rendered in paint or gesso rather than carving.

One of the unusual features of this table is that its top surface has painted decoration. In the center of the top panel is a lotus-flower design, on either side of which is a whirling-disc design. These were originally rendered in four colors, representing four elements, although they have faded and darkened somewhat.

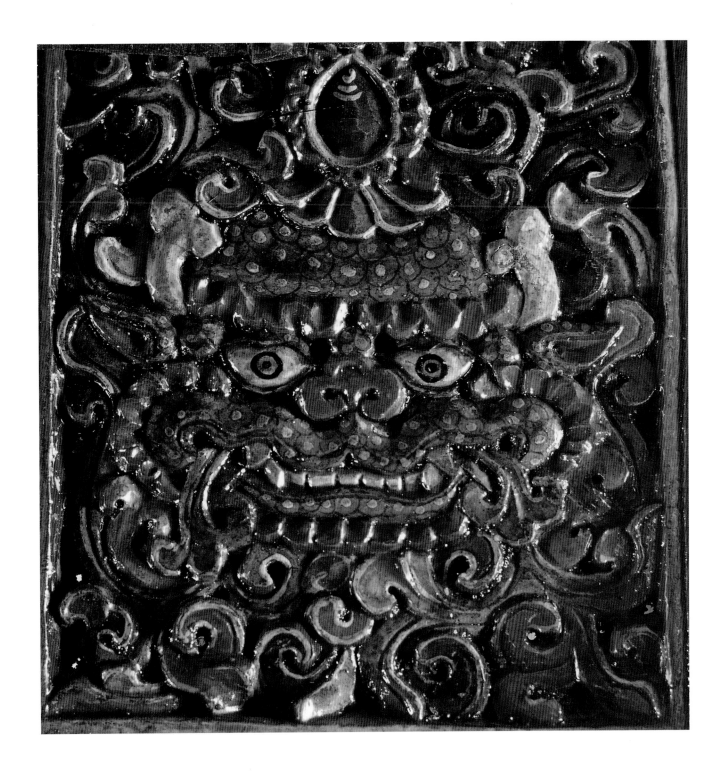

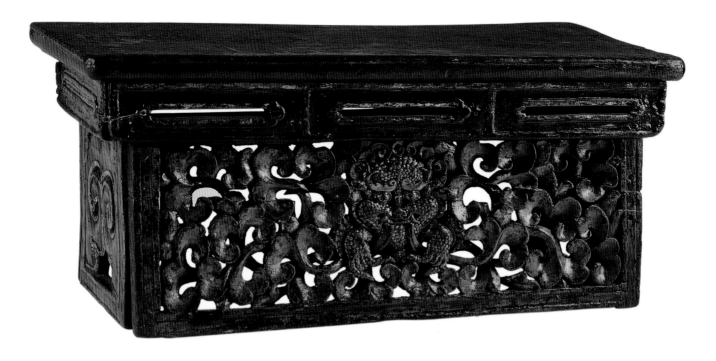

153
Painted wooden folding table
56 cm x 23 cm x 26 cm 18th century

This folding table is a representative example of a ubiquitous Tibetan type. It consists of three folding panels that hinge into the frame at the top by means of wooden rods, in the same way that the doors of Tibetan cabinets hinge into their frames. To fold the table for transport, it is simply turned upsidedown, the sides are folded inward, and the front is folded on top of them. The folded table is flat and compact, and can be easily stored in a home or temple, or tied to a yak or horse to be carried from place to place. To unfold it a deft shake is all that is needed. We once watched a monk at a temple assemble twenty or so folding tables in this manner in the space of a few minutes, in preparation for an outdoor ceremony.

The front panel of the table is decorated with openwork carving of foliage, with a *zeeba* face in the center. The skin of the *zeeba* has been given texture by applying dots of gesso before finishing with gold leaf. The swags of foliage hanging from the mouth of the *zeeba* fill the space around it. The openwork and carving on this table combine to give a sense of lightness, despite the fact that it was carved from fairly substantial timber.

The principal problem with the folding table form is that it is relatively weak: the point at which the side panels hinge into the frame is particularly vulnerable to damage. An examination of this table reveals several glued repairs, nails that have been added to strengthen the link between the top board and the frame around it, and some metal wire that has been used to strengthen the frame. It is not uncommon to find folding tables where the hinges have broken completely and the sides have been nailed in place to convert the table to a rigid form. As a result, earlier examples of these tables in good condition are difficult to find.

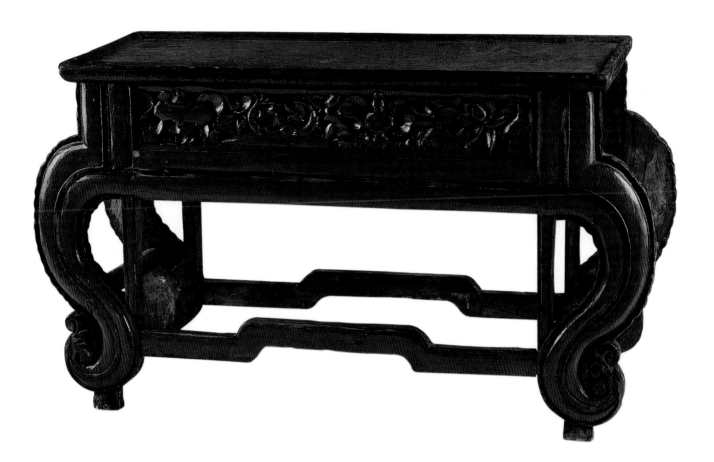

154
Painted wooden table with cabriole legs
87 cm x 48 cm x 31 cm 19th century

This is an example of a type of small Tibetan table with curving, cabriole legs. The construction method is quite different from the folding or simple box-type table. Curving legs extend from a fixed frame attached to the top; the legs end in a small scrolling flourish and rest on small feet resembling hooves. The legs are thin and delicate, so reinforcing stretchers have been added.

The frame of the table is decorated with carved openwork panels at the front and the back. These contain floral carvings together with the Eight Precious Objects. The table has been painted red, except for beading around the frame and legs that is picked out in dark green.

The basic form of this table with its curved legs probably derives from a prototype altar table that has been present in central China at least since the fourteenth century. This type of table would have been well-known to Tibetans due to their contacts with China through the border regions to the east. Unlike most Chinese altar tables, however, which are meant to be viewed from the front only, this table is equally well finished on all sides and can be viewed from any angle. This probably reflects the wider range of uses of small tables in Tibetan monasteries as compared with their Chinese prototypes.

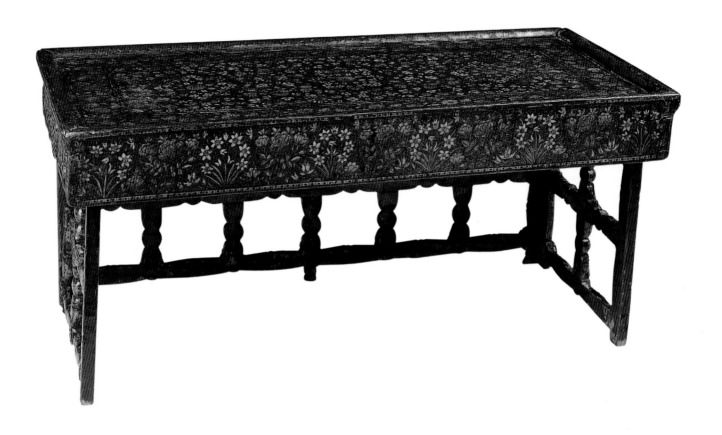

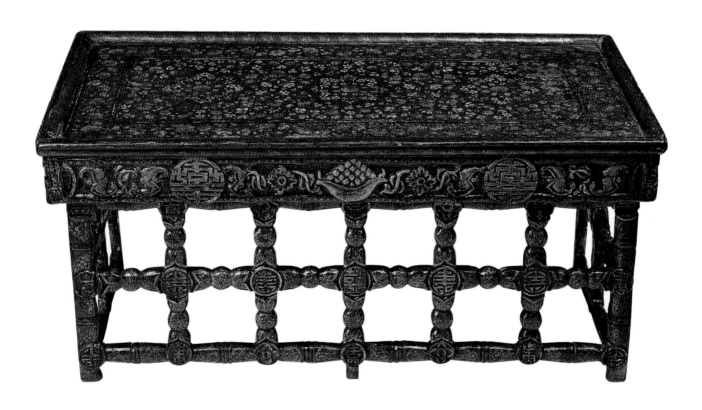

155
69 cm x 31 cm x 33 cm
Painted wooden folding table 19th century

This exceptional folding table shows an unusual mix of features, combining a traditional Tibetan form, carved decoration including Chinese characters, and Kashmiri-style painted decoration.

The table is of conventional Tibetan construction, with three sides that fold inward so that the table can be transported. The sides are carved into lattice designs, with auspicious Chinese characters, bats, and bowls of jewels, motifs that indicate that the piece dates from the nineteenth century. What sets this table apart from most other Tibetan furniture is its finely detailed Islamic-style painted decoration. The top of the table displays three stars surrounded by flowers and leaves. There is a minuteness and precision in the decoration that is distinct from Tibetan style; the impression it leaves is more like that of a Persian rug than a Tibetan design.

Two very similar tables are illustrated in *Furniture from British India and Ceylon* by Amin Jaffer (London: V&A Publications, 2001), where they are identified as copies of Tibetan folding tables made in Srinagar, in Kashmir, principally to meet a demand for Tibetan objects among British tourists in the mid-nineteenth century. It may be that this table was also made or decorated in Srinagar and subsequently exported to Tibet. It is also known, however, that Muslim artists of Kashmiri origin were in residence in Lhasa, suggesting a second possibility: that the table was decorated locally to meet Tibetan demand.

Whether made locally or imported, this small table is an illustration that Lhasa was a cosmopolitan center for much of its history. Its inhabitants were familiar with decorative styles from distant regions and ready to buy or commission works in foreign styles.

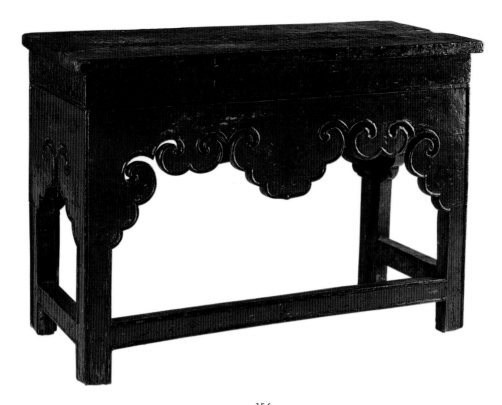

156
Painted wooden table
77 cm x 54 cm x 32 cm circa 16th century

This small table was made in Tibet, based on a Ming-dynasty Chinese lacquered prototype. The table has a boxlike construction, with straight-sided legs at each corner and reinforcing stretchers on three sides, an unusual construction for a Tibetan table.

Under the rim of the table there is a band of floral designs painted in black (right), similar to that found on other Tibetan furniture from the fifteenth and sixteenth centuries. Below there is a set precious objects including crossed horns, coral, interlocking rings, a flaming jewel, interlocking rhombuses, and other symbols. This set is characteristic of decoration on earlier Tibetan furniture and is rarely found after the fifteenth century.

The sides of the table are carved with downward-pointing *ruyi* shapes, a common motif on both Tibetan and Chinese furniture. These have been combined to form a smooth and continuous carved edge with a profile resembling clouds.

The shape of the table closely resembles Chinese lacquer furniture from the early Ming period, which was sometimes decorated with black or gold paint over red lacquer. Chinese sponsors gave a number of small Chinese lacquered tables as gifts to Tibetan monasteries. A few examples of these have been found in Tibetan monasteries, such as the Ming-dynasty table thought to have been given to the Sakya monastic order by the Yongle emperor of China (r. 1403–1423), now in the Minneapolis Institute of Arts. It is clear that these tables were greatly admired in Tibet since they often appear in *thangka* and mural paintings. One or more of them probably served as the inspiration for this table.

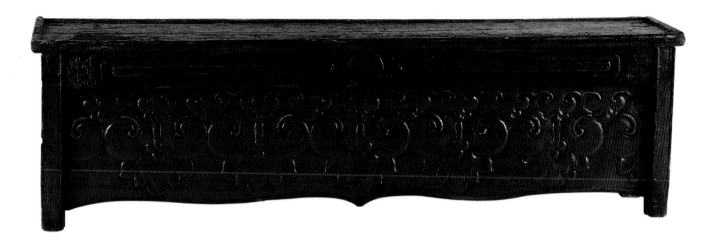

157
Painted wooden table
137 cm x 39 cm x 28 cm 19th century

This piece is representative of a type of long, low Tibetan table commonly found in monasteries. Their function, as other low tables, was to provide surfaces for placing ritual implements and tea bowls during ceremonies or supporting offerings, as well as for more prosaic uses.

The top of the table is constructed from several planks and has a molding around the edge. Just below the molding there are two long, narrow panels, separated with geometric figures that are probably stylized Chinese characters for *shou* (longevity). The panels are colored dark green and red, with traces of gold leaf in places.

Below the panels is a long apron, carved with a design representing hanging tassels. Similarly shaped tassels made of fabric were used to cover doorways and altar coverings in Tibetan temples. This whole panel is colored deep red, apart from some lines of detailing in gold leaf. The base of the panel is carved with subtle wave shapes that meet at a point at the center and impart lightness to the design.

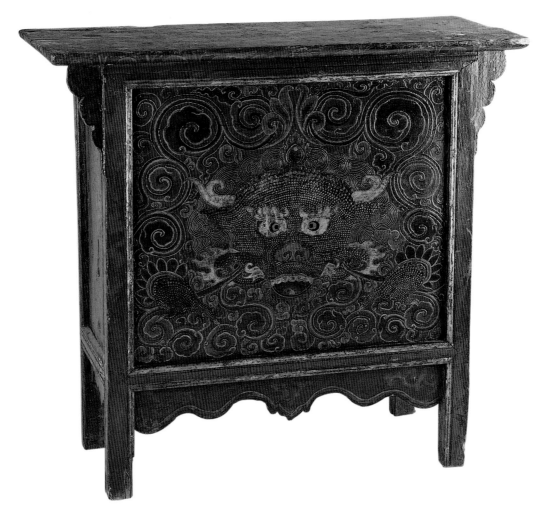

158
Painted wooden high table
84 cm x 80 cm x 30 cm 18th century

Tibetans call this unusual type of high table *thrichok*; as with other pieces of this height it was probably made for use by a lama, who would occupy an elevated seat during a ceremony, or for an honored guest, who would have a high seat relative to others at gatherings. The table is constructed around a square frame, with a simple flat board on the top. The junction between the top and the frame is softened with two flangelike moldings, similar to those seen on northern Chinese "coffers."

The front face of the table is taken up with a single panel, painted with a bold design of a *zeeba*, a mythical creature that is said to have devoured its own body, leaving only its head and a disembodied pair of hands. The *zeeba* disgorges two strands of vegetation from its mouth, which fill the surrounding space with abstract spirals.

Both the creature and the surrounding vegetation have been drawn in outline with thick dots of gesso (facing), with the colors and details added later. The resulting knobby skin of the *zeeba* and its tight curls of green hair are particularly well done in this example, rivaling similar designs on chests from the seventeenth and eighteenth centuries.

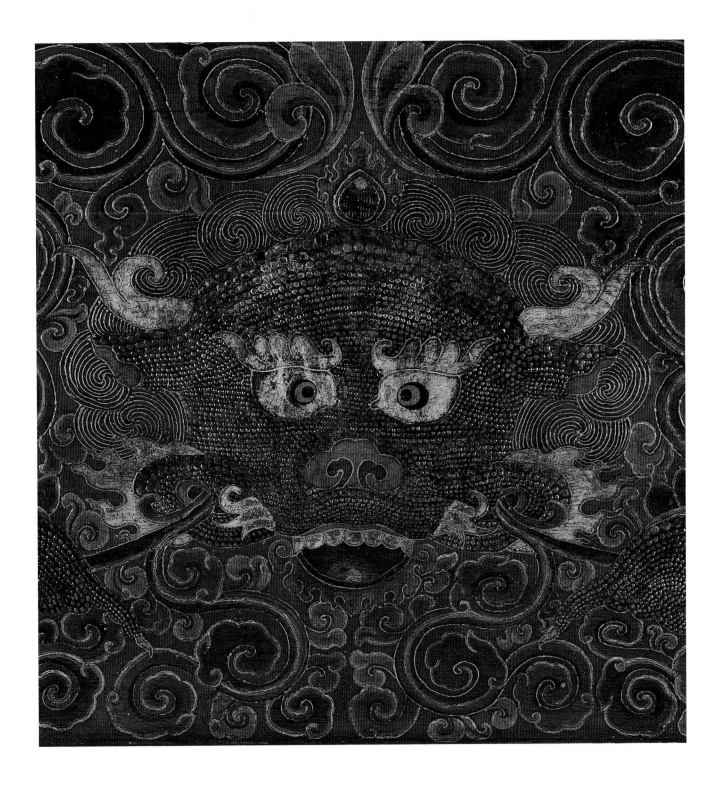

159
Painted wooden table
63 cm x 52 cm x 62 cm 19th century or earlier

This is an example of an octagonal table, with all eight sides identical in their shape and decoration. Although octagonal tables of this type are found occasionally in Tibet, most of them are smaller than this one. The smallest should perhaps be referred to as stands rather than as tables.

Below the octagonal top there is a frame constructed of eight short panels decorated with low relief carving. Into this frame are inserted the eight sides of the table, mitered together at the edges. A relatively thick layer of sizing and paint conceals the joints. The feet of the table have been made by cutting away parts of the panels, leaving cusped openings.

The sides of the table are decorated with gesso and with paint. The design, which is somewhat faded with age, represents tassels and strings of gems. Similar designs can be seen on walls and on beams in Tibetan temples. Most octagonal tables have similar decoration, imitating either tassels or cylindrical temple banners made of silk fabric.

It is difficult to be sure what this table was used for, though it was almost certainly made for use in a temple setting, possibly for supporting an object that needed to be approached from many directions or circumambulated. This might have been a statue or another ritual object such as a prayer wheel.

CABINETS

160
Painted wooden cabinet
69 cm x 77 cm x 28 cm 18th century or earlier

This small cabinet has several features that suggest a relatively early date compared with the majority of Tibetan cabinets. The painted decoration in particular is similar to designs on some chests from the seventeenth and eighteenth centuries.

The cabinet has four doors. Inside, it is divided into upper and lower halves; a shelf further divides the upper half. The doors fit into the cabinet by means of tenons that slot into holes in the frame, which has grooves to allow the doors to be inserted and removed easily. The base of the cabinet is raised a short distance from the ground and there was probably once an apron below that has been lost.

The proportions of this cabinet are somewhat taller and narrower than the majority of Tibetan cabinets and the piece is also rather small compared with cabinets from later centuries. It is decorated with a stylized brocade design, consisting of linked flower heads and diamonds (right). The painter has chose to interpret the linking bands as ribbons, which overlap to form a woven effect. The background to the design is gold leaf, applied directly to the wood, though this has worn away to some extent.

This type of silk brocade-inspired decoration is more commonly found on chests dating from the seventeenth and eighteenth centuries than on cabinets, still a relatively rare type of furniture at the time this one was made.

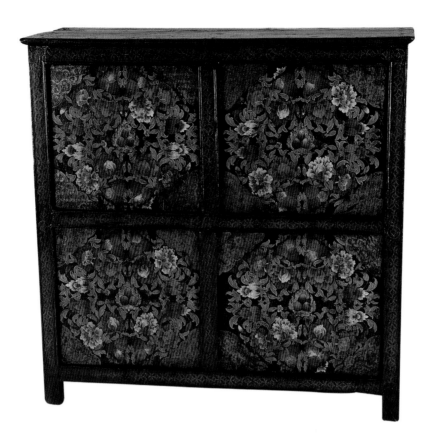

161
Painted wooden cabinet
106 cm x 102 cm x 42 cm 18th century

This cabinet dates from the late eighteenth century or early nineteenth century, from a period when cabinets were starting to be made in larger numbers for domestic and monastic use. It has a single shelf and four doors. A limited amount of gesso has been added to highlight the gilded areas of the design, such as the corner scrolls and the flames around the triple-gem designs.

The decoration on this cabinet is very similar to that on chests and other furniture from the eighteenth century, particularly the coin designs on the frame and gilded scrolling designs in the corners of the doors. In the center of each door is a group of flowers and pomegranate fruits (right), with the triple-gem motif. The gems symbolize the three essential components of the Buddhist faith: the Buddha, the Buddhist teachings, and the spiritual community of monks and lay believers.

In the later eighteenth and nineteenth centuries, as the art of cabinet making matured in Tibet, a variety of distinctive decorative styles were developed unique to the cabinet form. In contrast, earlier eighteenth-century examples such as this one have designs borrowed from those traditionally used to decorate chests with relatively little adaptation to suit the new form.

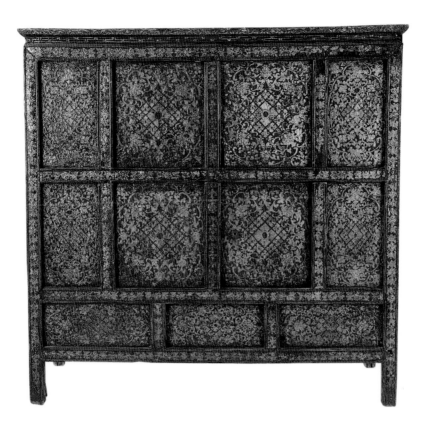

162
Painted wooden cabinet
117 cm x 112 cm x 53 cm 19th or early 20th century

During the nineteenth and early part of the twentieth century many cabinets and other pieces of furniture were made and decorated in central Tibet using the same techniques as in this piece. The gold-on-red gesso technique is particularly characteristic of this period.

The cabinet has four doors in the center, with four smaller panels on the sides that are fixed. All the panels and doors are constructed using the floating-panel technique, similar in basic design to a picture frame, and which is used extensively in Chinese and Tibetan cabinetry. There are three more fixed panels at the base, forming an apron. The top of the cabinet is finished with a recessed molding with a carved key-fret design.

The cabinet is decorated with gold paint on top of gesso, on a red ground. The center of each panel has a diamond design, surrounded by floral vines and peonies. The frame surrounding each panel is also decorated with floral designs. Care has been taken to balance the red and gold and to fill all the available space, creating a rich effect. The same technique can also be seen on other types of furniture from this period. The gold paint and gesso technique used in this case is a greatly simplified version of the gold-leaf-based techniques used on some chests in earlier centuries. This simplified method was no doubt adopted in order to streamline production and meet the high demand for furniture during this period.

Cabinets similar to this one can still be seen in situ in many Tibetan monasteries, both in temples and in living quarters; there are many examples in the Potala Palace in Lhasa among other places.

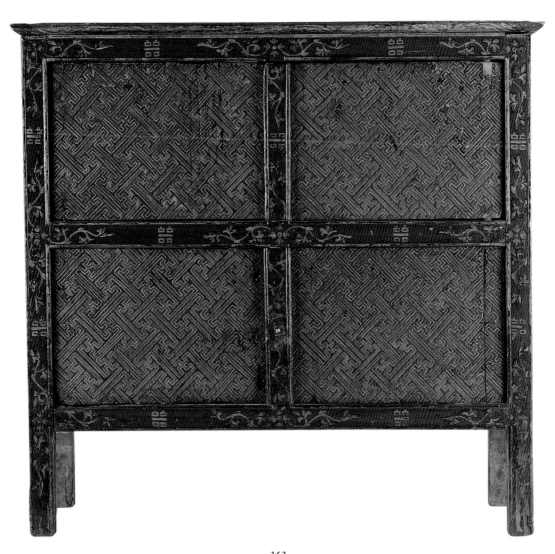

163
Painted wooden cabinet
96 cm x 91 cm x 39 cm 19th century

This cabinet is an example of the classic four-door style. Pins protruding from the top and bottom of the doors fit into holes in the top and bottom of the frame, acting as hinges. This type of construction is vulnerable to damage if the door is opened too far, causing the pins to break. A typical repair can be seen at the top right-hand corner of the cabinet. This cabinet would originally have had an apron at the base, though this has been lost.

The design on the cabinet is painted directly onto the wood surface using red, green, and gold paint. The design is a striking version of the *wanzi* lattice (facing), which is a nearly universal decorative motif across East and Southeast Asia. This pattern acquired Buddhist associations over the centuries, though it undoubtedly predates Buddhism. It also has a more general association with good fortune. The frame of the cabinet also has painted floral scrolls and Chinese "double happiness" characters.

This cabinet was probably made during the nineteenth century, when these types of designs reached the height of their popularity as decorative motifs.

Cabinets

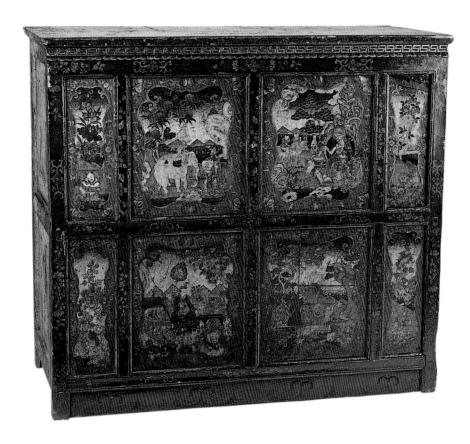

164
Painted wooden cabinet
117 cm x 113 cm x 56 cm 19th or early 20th century

This a good example of a type of cabinet decorated with mythological and landscape scenes and that was popular in the nineteenth century and early twentieth century.

The cabinet appears to have eight wooden panels at the front, though in fact some of the divisions are false and there are really four separate panels. These are hinged at the edges, forming four large doors. This neat solution preserves the typical appearance of a Tibetan cabinet with its small decorative panels while allowing ready access to the full width of the cabinet.

The cabinet is decorated on three sides, with the most elaborate painting reserved for the front face. The eight front panels are all decorated with different mythological and auspicious scenes that are a blend of Chinese and Tibetan folk themes. Clockwise from the top left these are:

- A boy with pigtails, holding a fish. This is a common Chinese good fortune motif, signifying a wish for male heirs and for prosperity.
- Four animals—an elephant, a monkey, a rabbit, and a bird—standing on top of one another. In Tibetan folk tales there are two stories connected with this illustration, one concerning a discussion between the animals on age and seniority, the other a story of cooperation between the animals to reach the peaches in the tree.
- An elderly sage, pouring water onto some offerings in a bowl. He represents a wish for a long and healthy life.
- A lion dog (*shizi* in Chinese) playing with a ball.
- Two boys playing in a garden.
- A nobleman with a long sword, standing in a garden with two servants.
- A wealthy man sitting beside a table spread with money, a small chest and a tiger skin and other precious items. He holds a *lingzhi* fungus, associated with magical properties and the gift of long life.
- A musician playing a pipe, seated in a garden with a deer.

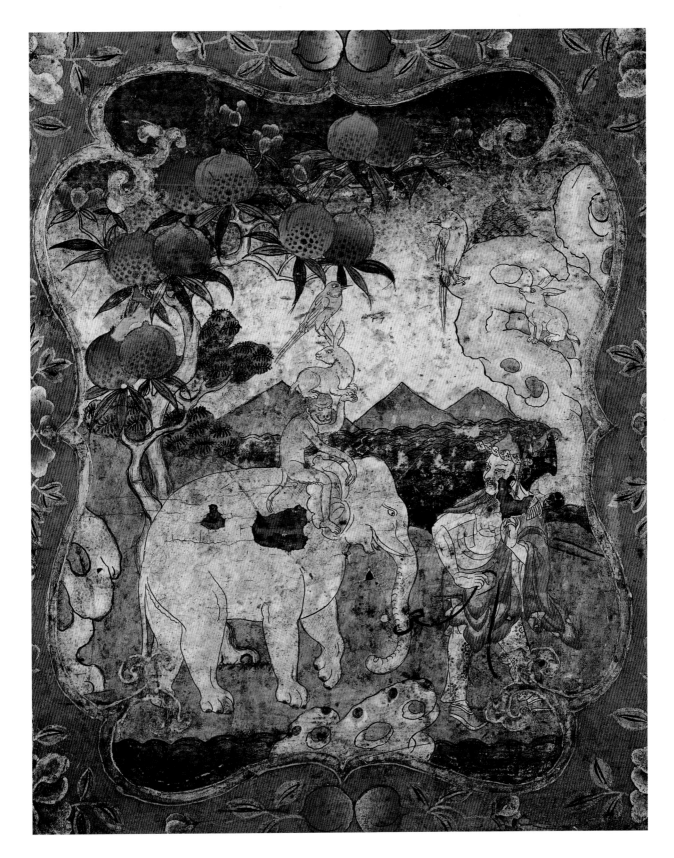

Each of these scenes is set in a Chinese-style formal garden, complete with fantastic rocks, small pine trees, birds and other animals. Viewed as a whole the paintings on this chest represent a wish for a long and prosperous life, as well as signaling the taste and sophistication of their owner.

BOOK DESKS AND BOXES

Painted wooden desk
84 cm x 100 cm x 38 cm 18th century

The painted decoration on this tall reading desk is particularly interesting. The six panels on the front face are each decorated with a flower. These hold representations of the Offerings of the Five Senses, each representing a different sense faculty. This type of offering is normally made to a deity or to a revered teacher. Clockwise from the top left the offerings are:

- A lute, representing hearing
- A mirror, representing sight
- A conch filled with incense, representing smell
- A book
- Fruit, representing taste
- Cloth, representing touch

The anomaly in this case is the book, which is not normally part of this set of five offerings but has been added to maintain symmetry.

The back panel (left) has a painting of a sage meditating in a cave on a mountainside. He sits cross-legged on a rush mat and holds a small vase with a jewel on top. This is a so-called treasure vase (*tergyi bumpa*) that contains the elixir of immortality. Nearby are rocks, a waterfall, and a tree laden with peaches, two birds, and two deer. As well as representing meditation and insight this depiction communicates a wish for a long and healthy life. To the left of the sage is a painting of a Tibetan temple, set high in the hills with prayer flags on the hilltops around.

This piece of furniture was probably made as a gift for a revered individual, perhaps a lama, since as well as being taller than usual it contains symbolic offerings suitable for a respected teacher and wishes for his health and longevity.

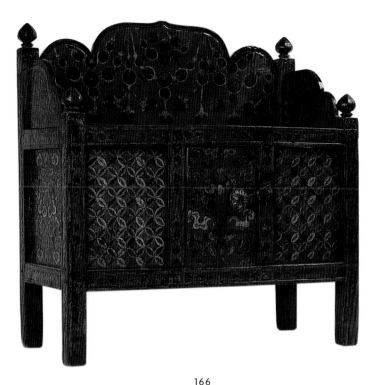

166
Painted wooden book desk
73 cm x 30 cm x 33 cm 18th or 19th century

This *pegam*, a desk for supporting books, might be considered standard in terms of its size and proportions. It has a single door, fastened with a brass catch. The two panels at the sides are decorative and do not open, so only small objects could have been stored inside the desk.

The style of decoration is typical of eighteenth century and early nineteenth century Tibetan furniture, particularly the coin design on the outer panels of the front, which is also found on Tibetan chests from the eighteenth century. The front central panel is decorated with flaming jewels with multicolored clouds around them, while the sides are decorated with more multicolored clouds (right). Similarly shaped clouds are found on Chinese silk court robes from around 1800.

The style of the decoration on the panels at the front is slightly different from that of the back panel, leading me to suspect that the front panels may have been re-used from an earlier piece of furniture, a common practice in Tibet.

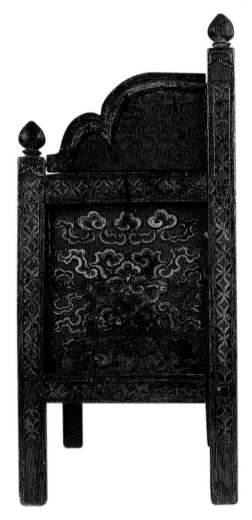

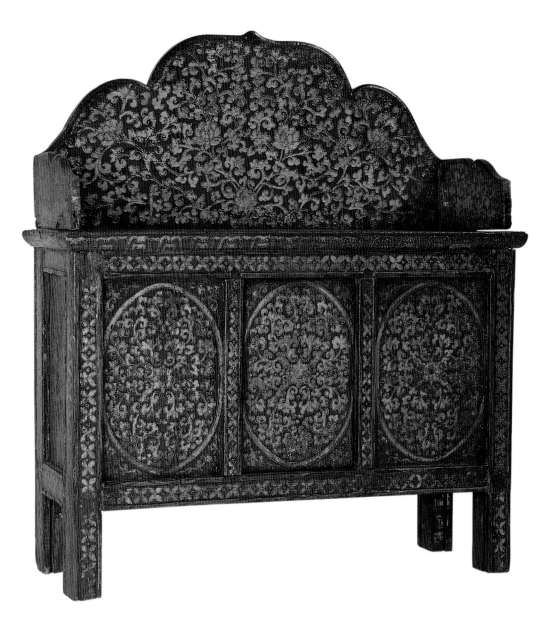

167
Painted wooden book desk
72 cm x 80 cm x 27 cm 19th or early 20th century

This piece was produced toward the end of the period during which *pegam* were popular in Tibet. This type of furniture seems to have declined in the nineteenth century and does not seem to have been made much after the early part of the twentieth century.

This *pegam* has a single door in the center at the front, with a small leather pull for a handle. The two panels on either side are fixed in place and do not open. The flat top has a lotus border at the edge and a high back for propping up the wooden covers and pages of a sacred text.

The decoration is characteristic of furniture from the late part of the nineteenth century, consisting of gesso highlighted with gold paint against a red background. The motifs are mainly floral, with a vine design incorporating lotus flowers on the high back and similar but more abstract versions on the door and front panels. The frame is decorated with a coin design.

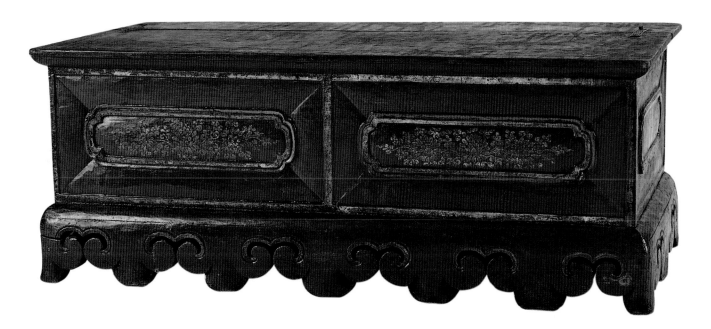

168
Painted wooden box
60 cm x 23 cm x 27 cm 18th century

This small box is an unusual type; to date I have not come across any other examples with exactly this design. It seems to have been intended as a type of book cabinet, though the space inside could only have been used for storing Tibetan texts that were smaller than the standard size. The inside space is reached through a panel, fastened with a hasp, which opens on one of the short sides.

The box is rather delicately and beautifully constructed, with two rectangular panels on each of the long sides and a flat top that probably functioned as a low table or reading surface. Some repairs can be seen on the top surface. The box rests on a carved base pierced with *ruyi* motifs, curved like pairs of ram's horns.

The box is painted red, with floral designs in gold leaf in the centers of the panels. The gold-on-red technique used resembles gold-on-red lacquer decoration on the covers of Buddhist texts made at the Chinese court in Beijing and given to some Tibetan monasteries, as well as similar decoration on some luxurious pieces of lacquer furniture made in China. This decorative technique was much admired and copied in Tibet.

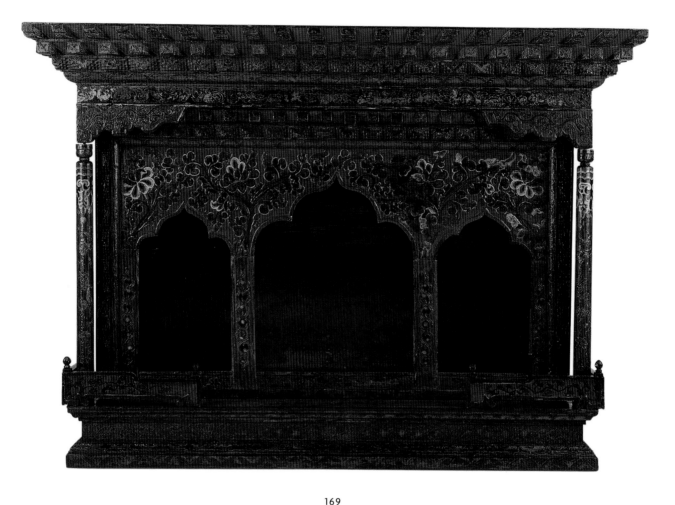

169
Painted wooden shrine cabinet
121 cm x 85 cm x 52 cm 19th or early 20th century

This is a representative example of a shrine cabinet, a type of furniture used for housing statues of deities. In this case, because of the relatively small size of the cabinet, it is more probable that it was used in a private home than in a temple.

The shape of this cabinet resembles a miniature temple. It rests on a waisted plinth, with a low railing around the corners. The main part consists of a single space with three arched openings. These are set back on the plinth so that the space in front can be used for placing offerings. At either side there are decorative columns. Both the columns and the railings can be dismantled if the cabinet needs to be moved.

The top panel of the cabinet is a decorative board, the uppermost part of which is carved to resemble the exposed beam ends in a temple roof. Below this is a stepped design similar to the carvings that are often seen on Tibetan door and window frames.

The wood surface has been decorated with gesso and then painted with floral designs and precious jewels on the struts between the arches. The columns are decorated with gesso intended to resemble hanging tassels.

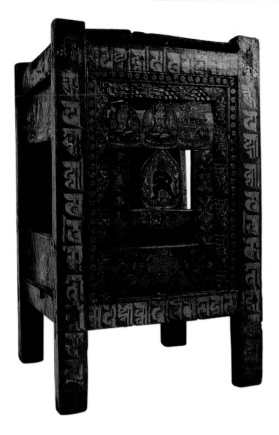

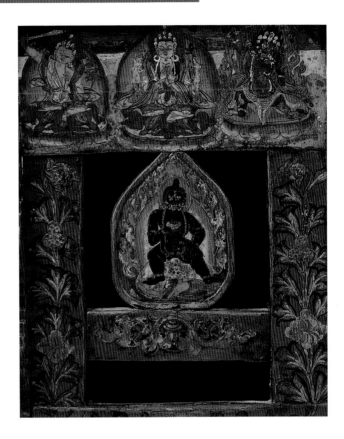

170
Painted wooden prayer wheel
54 cm x 85 cm x 54 cm 19th century

This freestanding prayer wheel has as its central figure a wrathful form of Jambhala, the wealth deity, who is also painted on the chest of figure 146. Jambhala is more commonly seen in his peaceful form as a plump, reclining Indian king, cradling a mongoose. On this prayer wheel he appears in the guise of a wrathful protector—jet-black, wearing a fierce expression, and holding a skullcap bowl filled with blood. In his other hand he still holds the mongoose that is an attribute in all his forms. Jambhala is associated with the protection of wealth and fortune, hence his popularity among the faithful.

Above the figure of Jambhala is a conventional group of three protectors (above right) known as the *Rigsum Gonpo*, comprising the bodhisattvas Manjushri and Avalokiteshvara, representing wisdom and compas-

sion respectively, and the fierce protector Vajrapani. On the sides of the prayer wheel (not shown) are other groups of well-known deities, including: the medicine Buddha, Bhaishajyaguru; the historical Buddha, Shakyamuni; Green Tara; and the Buddha of long life, Amitayus. All of these figures offer direct protection and benefits to the worshipper who makes offerings to them or recites their mantras. The edges of the prayer wheel are also inscribed with mantras in gold on a red background.

The painting style suggests that this prayer wheel dates from the nineteenth century. As with other furniture of this type, the deities seem to have been painted by a different hand than the remainder of the decoration, probably by a specialized *thangka* artist who was capable of rendering these figures accurately.

171
Painted wooden prayer wheel
63 cm x 127 cm x 63 cm 18th century

This particularly beautiful prayer wheel is remarkable both for its painting and for the carved openings around its sides. It was probably used in a wealthy household or in the residence of an important lama rather than in a temple.

The front face of the prayer wheel enclosure (above left) has an unusual, openwork carved panel leaving a plaque suspended in the middle (facing). On the left and right sides of the enclosure are panels with keyhole-shaped openings (above right). These openings are all too small to allow the wheel to be turned by hand; instead it was turned by means of a handle or a rope fixed to the axle on the outside, a mechanism now missing.

A floral vine that begins at the base and flows up the sides dominates the painted designs on the front face. At the top of the frame is a bold design of clouds, while at the base of the frame are lotus petals painted on a curved panel. Just below the clouds at the top is a red band with a Kalachakra symbol (*namchu wangdän*) painted in the center. This symbol is a combination of syllables representing various aspects of the cosmos, and symbolizes the Kalachakra system of teachings favored by the Gelug order in Tibet.

The sides of the prayer wheel are painted with a grouping of well-known bodhisattvas, Buddhas, and pro-

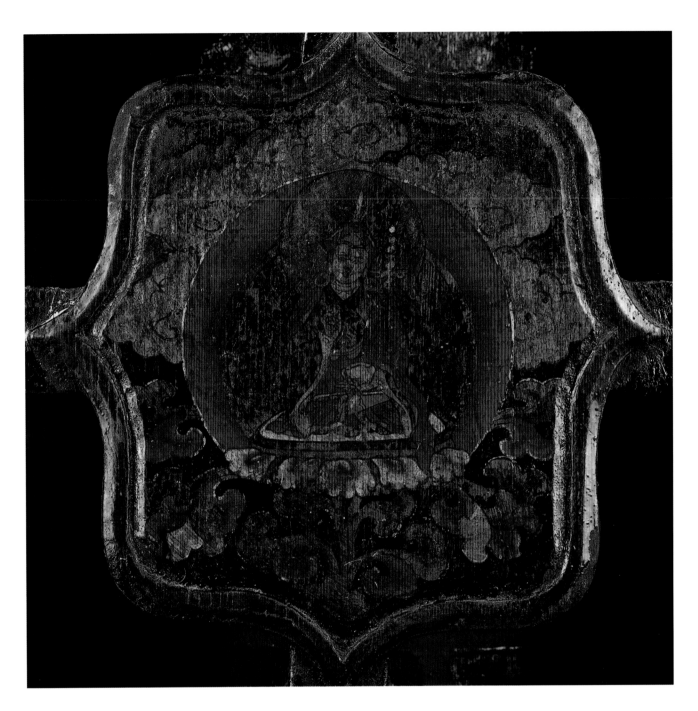

tector figures. Around the keyhole opening shown are painted (from top left and proceeding clockwise): the bodhisattvas Manjushri and Avalokiteshvara, the protector Vajrapani, the Buddha of longevity, Amitayus, the bodhisattvas Green Tara and Red Tara, the wealth deity Jambhala, the bodhisattva White Tara, and the medicine Buddha, Bhaishajyaguru.

In the center plaque is a painting of the teacher Padma Sambhava, literally the "Lotus Born," who was one of the earliest Indian sages to enter Tibet, bringing the Tantric Buddhist teachings with him. He wears his characteristic hat and carries a Tantric staff, a *vajra*, and a skullcap bowl, all symbols of his deep insight and power. He has the front face of the prayer wheel to himself, consistent with his importance as one of the founder figures of Tibetan religion.

This prayer wheel was probably painted during the eighteenth century, based on consideration of the style of painting of the deities, their draperies, and the landscape backgrounds.

BUTTER LAMP STANDS

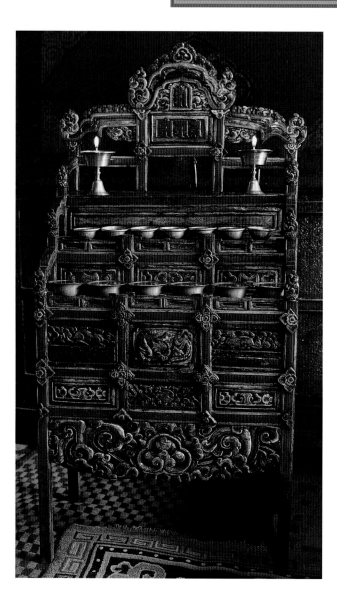

172
Carved and painted wooden butter lamp stand
75 cm x 130 cm x 40 cm approx. circa 16th century

In common with most butter lamp stands, this unusually ornate example consists of three shelves, arranged like three steps. Unlike most stands it has a great deal of carved and painted decoration around the shelves.

At the base of the stand is an apron of openwork carving that stretches the entire width between the legs. This contains a carving of the three jewels with curling foliage around. Above this apron the stand is divided into panels. In the center panel is a carving of a dragon clutching precious jewels. The dragon has green-spotted skin and a mane of flowing orange hair. On either side of him are panels containing carvings of two more beasts that may be deer. Other panels contain carved designs of ingots and auspicious *ruyi* shapes.

At the back of the stand is a high panel with carving which includes a simplified Kalachakra symbol (*namchu wangdän*), representing a form of Tantric initiation that is important to the Gelug sect, the predominant order in Tibet since the fifteenth and sixteenth centuries.

The rather formal construction of this stand, with its division into many small panels and its high, arched back, resembles that of thrones that were made to support sculptures of lamas and sages during the fifteenth and sixteenth centuries, for example in the fifteenth century Lamdre Lagyu chapel at Gyantse. The style of the small dragon also seems consistent with a date of manufacture during this period.

The stand was photographed in the home of a Lhasa antique dealer. It has been set out with typical offerings consisting of two large butter lamps and water offerings in the small brass bowls. Similar offerings can be seen in most Tibetan temples and in front of shrines in many Tibetan homes.

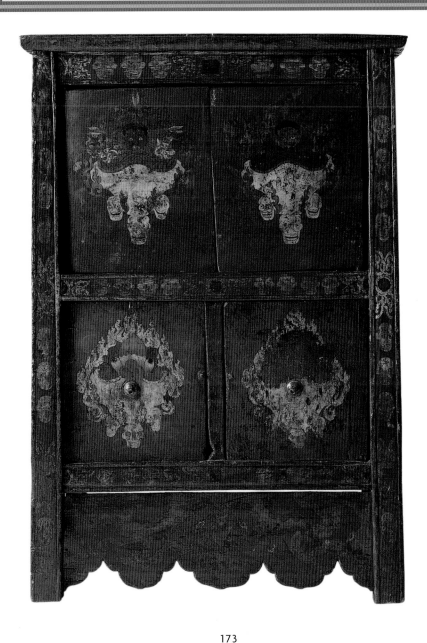

173
Painted wooden offering cabinet
72 cm x 103 cm x 45 cm 17th or 18th century

This tall, narrow offering cabinet, or *torgam*, is one of the older examples of this type that I have seen. It has four doors at the front and is tall relative to its width. It has a slight taper, like many Chinese cabinets, that gives it an elegant and balanced appearance. The base is finished with a panel with scalloped decoration resembling clouds, a feature sometimes seen on low tables from the seventeenth century. The lower doors each have iron pulls in the center, and there are remnants of a hasp between them. The left door has split along its left-hand edge at some stage and was repaired in typical Tibetan fashion, by sewing it tightly with a leather thong.

Each of the four doors is painted with a fierce offering, consisting of a gruesome arrangement of human and animal parts in an upturned skull. These symbolic offerings, which are sometimes made in three-dimensional form in butter and *tsampa* (a barley and butter paste), are reserved for fierce deities.

The lower left-hand door has a Fierce Offering of the Five Senses, consisting of human sense organs such as the eyes, tongue, nose, and ears in a skullcap cup. Peaceful versions of this offering are also commonly made to peaceful deities such as bodhisattvas. The peaceful version consists of a group of five pleasant objects that symbolize the five senses, including a musical instrument, a mirror, silk cloth, incense, and fruit (see fig. 165); these offerings are also occasionally painted on furniture such as cabinets. When the offering is being made to a fierce protector deity, as in this case, the macabre version consisting of dismembered sense organs is more appropriate.

The offerings on the other three doors follow the same basic form, but the offerings are more unusual. The skulls on the two upper doors contain fresh human heads: the head of the left-hand door (right) is blue in color and is pierced by arrows from three directions. On either side of this head are a snow leopard's head and a tiger's head. The skull offering on the right hand door is similar, except that the head is yellowish in color and is pierced by knives. On either side there is a horse's head. The offering on the lower right-hand door is somewhat worn and difficult to read, but seems to consist of animal heads, possibly including a wild boar. The worn patch in the center may have been caused by this spot being repeatedly touched by pilgrims filing through the chapel where the cabinet was housed.

Around the four door panels, the frame of the cabinet is decorated with a frieze of skulls, a design commonly found on offering cabinets and on the doorframes of protector deity chapels. The base panel of the cabinet is decorated with flayed human skins, though this part of the design is somewhat faded.

The painting on the cabinet was probably executed by an accomplished painter of murals and *thangka* rather than by a regular furniture painter. This is typically the case with work on offering cabinets, where precise iconography and proportions are important for the effectiveness of the work. The shape of the cabinet is similar to tables and other furniture items made during the seventeenth and eighteenth centuries and probably dates from around this time. The painting style is also consistent with this dating.

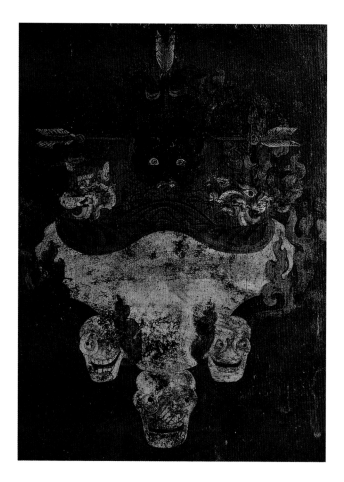

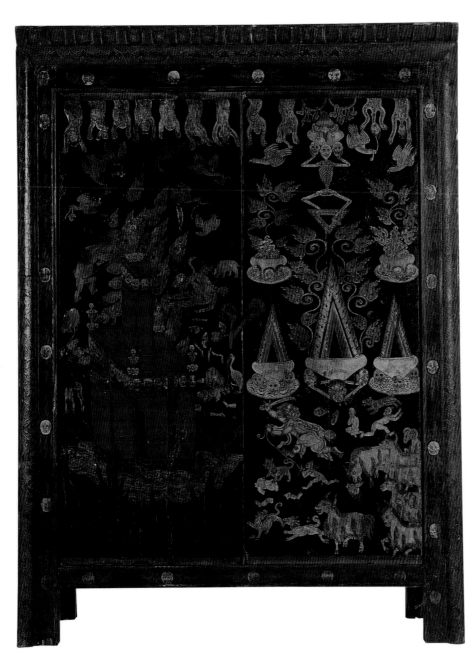

174
Painted wooden offering cabinet
84 cm x 114 cm x 51 cm circa 18th century

This offering cabinet is illustrated with remarkable paintings that depict symbolic offerings to a fierce deity. The two doors of the cabinet are painted with distinct but related scenes: the left-hand door presents a glowing red palace constructed of skeletal parts, while the right-hand door contains three triangular-shaped offerings in skullcap bowls. Although this latter is a standard form for an offering to a protector deity, there are some unusual features here: orange flames lick upwards from the offerings and

above them rides a skeleton carrying yet another offering of sense organs (facing following page). The skeleton is balanced on a triangular fire hearth, a type of ritual hearth used for making offerings via the fire god Agni. The shape represents the mouth of Agni, which consumes the offerings and carries them to a wrathful protector deity. Tibetan Buddhists sometimes made hearths with this triangular shape for presenting physical offerings, and they were also visualized as part of meditational practices.

At the top of the painting is a frieze of flayed human and animal skins similar to those found decorating the walls of chapels dedicated to protector deities. At the base of the painting are scenes of cruelty and sacrifice. A huge running demon with a curved sword wears a flayed human skin on his back and leads a trussed victim on a rope. Tigers, yaks, and other wild animals devour body parts. These scenes are part of the charnel-ground imagery that accompanies fierce protector deities. As with the fire hearth they are routinely visualized in Tantric meditational practices that use such scenes to induce loathing but ultimately to transform this feeling into a sense of detachment from the physical world.

The scenes painted on the left-hand door are even more macabre. In the midst of a sea of boiling blood, surrounded by rocks that glow dull red, there is a dark-red mandala palace (right), representing the type of palace that fierce protector gods are believed to reside in. The palace is adorned with skulls and "skull clubs," a ritual weapon consisting of a human spinal column with rib cage and skull attached. The palace appears at first glance to be conventionally three-dimensional in form, but in fact has a strange and illogical perspective that adds to the sense of terror and dislocation. Above the palace more flames lick upward and a hooded victim is led toward them for sacrifice. Around the palace there are more body parts and a demon with a sword cleans the flayed skin of another victim. Another corpse has been thrown down and can be seen impaled on the pointed rocks below.

The painting on this cabinet is intended to invoke awe, as well as to be a fitting offering for the powerful forces it propitiates. It was not intended for casual viewing, but for use during annual ceremonies to summon and ensure favor from the most powerful protector deities with power over life and death. The style and technique of the painting recall the black *thangka* of the seventeenth and eighteenth centuries,

in which the technique of painting vivid colors on a black background was used to create powerful images of fierce deities.

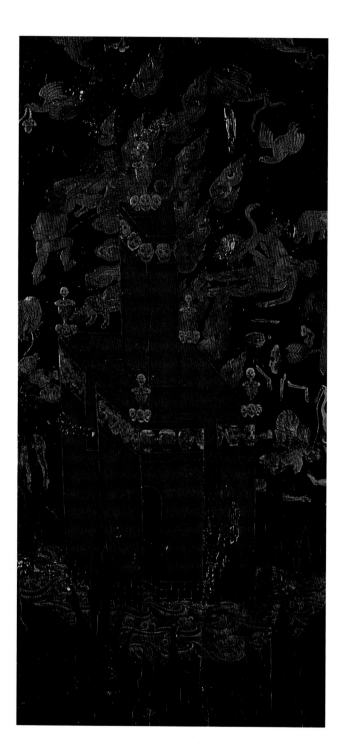

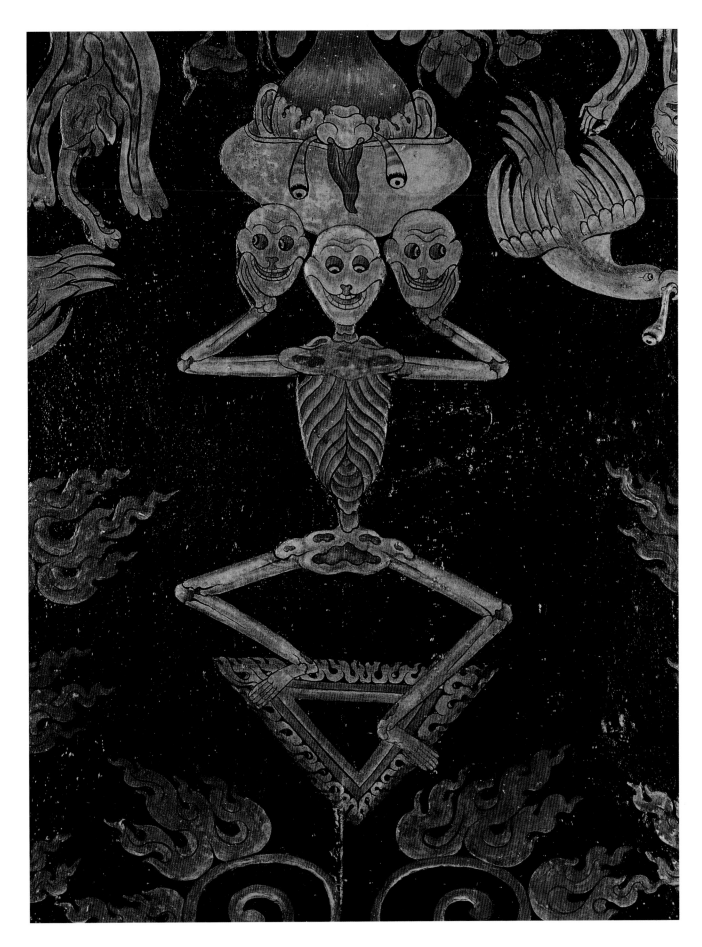

Protector Shrine Furniture

175
Painted wooden offering cabinet
82 cm x 104 cm x 41 cm 19th century

Most offering cabinets are painted with complex pictorial scenes; this two-door cabinet is an exception to the rule. Its shape was directly inspired by Tibetan architecture, with rows of carvings evoking wooden beam ends and the kinds of decoration seen around doorways and the tops of pillars inside temples. Beneath the faux beam ends is a stepped pattern, then a row of lotus petals.

The two plain red doors have decorative brass pulls, with areas of gesso and gold around them. The functional door fastening is the iron latch at the center.

Inside the cabinet is a single shelf. The formal design of the cabinet and the relatively shallow proportions suggest that it was used for storing butter sculpture offerings rather than general household items. Most butter sculptures were constructed on flat wooden boards and so they were propped up in a cabinet that was wide but relatively shallow like this one.

The relatively restrained decoration on this cabinet suggests that it might have been made to house offerings for a peaceful deity rather than a wrathful one.

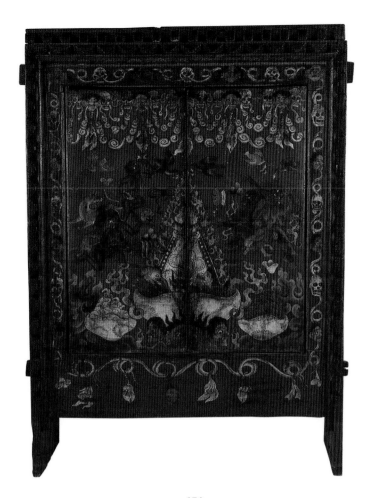

176
Painted wooden offering cabinet
74 cm x 100 cm x 27 cm 18th or 19th century

This cabinet is interesting on several counts. In addition to its unusual construction it is decorated with a rarely seen type of fierce offering and it includes a painting of creatures that appear to be the elusive Yeti.

The cabinet consists of two doors set into a boxlike frame. The method of joining the frame members at the top and bottom into the sides of the cabinet is unusual; tenons pass through the sides and protrude from the surface. They are fastened in place with large wooden pins that pass right through the ends of the tenons. This method represents a simpler and probably an earlier style of cabinet-making technique than that used for the majority of domestic cabinets in Tibet.

The central illustration on the doors is an Inner Offering. The visualization of this symbolic offering is central to many of the most advanced Tantric Buddhist meditational practices, designed to speed progress toward full enlightenment. Robert Beer in his book *Tibetan Symbols and Motifs* describes the composition of the Inner Offering:

"It consists of the visualized offering of the inner substances derived from the bodies of humans and animals. These substances are the 'five nectars' of human feces, marrow, semen, blood, and urine; and the 'five meats' of a cow or bull, a dog, an elephant, a horse, and a human being. These ten 'impure' substances are visualized as boiling or melting within a skull cup to create a pure elixir of concentrated nectar or *amrita* that is then used to bless the outer offerings and *tormas,* and transform the five impure aggregates and elements of the practitioner into the wisdoms of the Five Buddhas."

From a non-Tibetan perspective these are difficult and bizarre ideas. It is worth remembering, however, that a central idea in Buddhist thought is that of letting go of

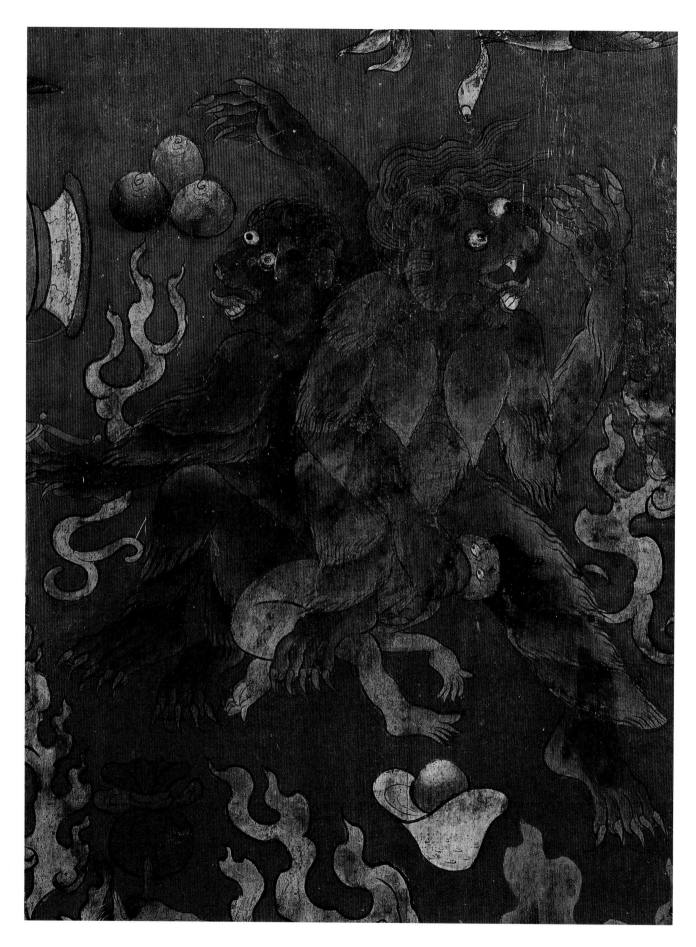

the attachments and false notions of earthly things that cause reactions of revulsion. To the Tibetan Buddhist all these things consist ultimately of emptiness and can be contemplated with equanimity.

The Inner Offering can be made as part of the study and contemplation of many different deities, however in this case the deity to whom the offering is made is probably the protector deity Mahakala. A small skullcap bowl placed above the larger one is a characteristic of offerings made to this protector, and two of his attributes, the *damaru* (skull drum) and noose appear in the painting.

Around the central offering are a series of energetic paintings of animals and humans (below), some carrying additional offerings. On the left-hand side is a pair of wild, naked female figures, dark blue in color, carrying skullcap bowl offerings and body parts, their poses suggesting a kind of dance. On the right-hand side are two remarkable figures of giant size with long, shaggy hair (facing). One of them holds an unfortunate human victim. Their expressions are fierce, with open mouths and protruding tongues. These creatures are almost certainly intended to be Yetis, whom many Tibetans believe still inhabit the mountainous regions in Tibet. "Sightings" of Yetis are common to this day in remote regions, though in most cases these are limited to discoveries of mysterious footprints of immense size.

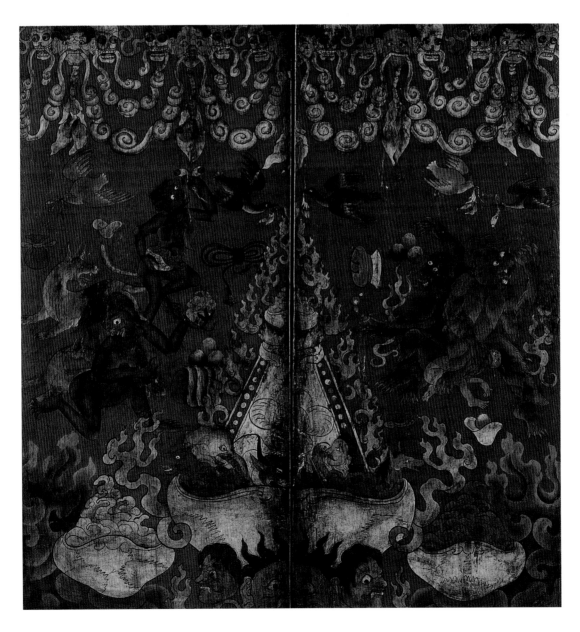

Protector Shrine Furniture

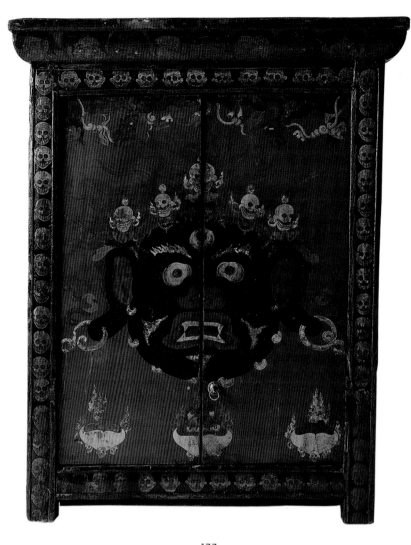

177
Painted wooden offering cabinet
62 cm x 77 cm x 36 cm 19th century

This cabinet is a good example of the most typical form of Tibetan offering cabinet, built to house offerings to a fierce protector, perhaps Mahakala (in Tibetan, Gonpo).

The cabinet consists of two large doors in a frame, with narrow shelves inside suitable for propping up butter sculptures. Smaller offering cabinets like this one were usually placed on top of tables or other cabinets within the protector deity's chapel.

A fierce black face dominates the front face of the cabinet (facing). Five skulls draped with jewels crown him and his wild hair, resembling flames, flows out in all directions. The third eye shows that he has achieved some degree of enlightenment. Below him are three skullcap bowls containing offerings of different substances, the center bowl containing a Fierce

Offering of the Five Senses, consisting of dismembered human sense organs. Above the fierce head is a frieze of flayed human skins and entrails. This same design is commonly seen on the walls of protector-deity chapels.

The frame of the cabinet is decorated with an amusing row of grinning skulls, each gazing in a different direction. The molding at the top is painted with a row of mournful severed heads. The skulls represent the palace where a fierce deity resides, so this cabinet is intended to be a home for such a deity, albeit temporary.

The painting is of a high standard and includes some subtle shading, for example around the eyes and other features of the face, recalling nineteenth-century *thangka* painting.

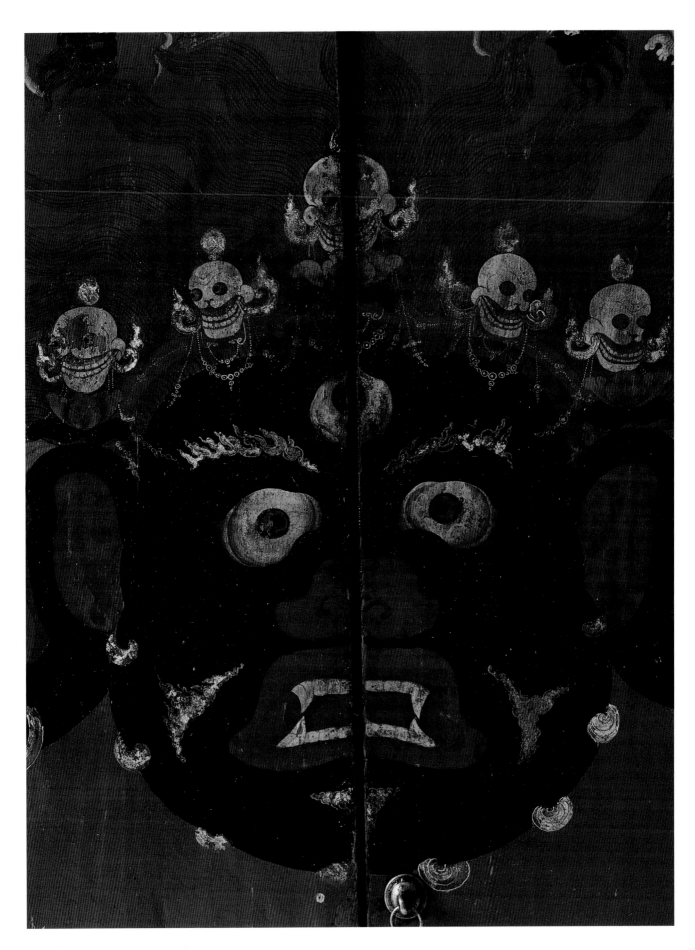

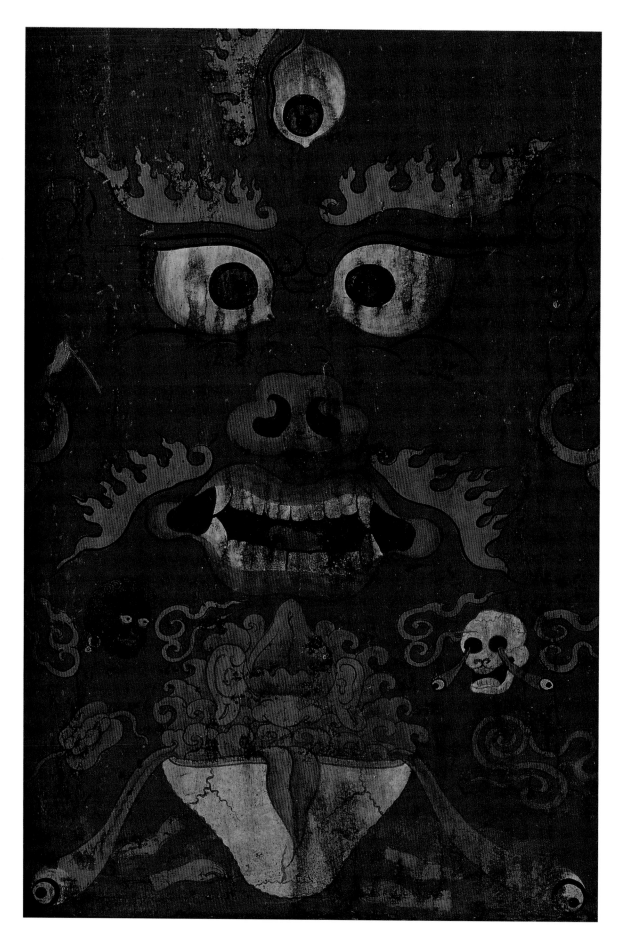

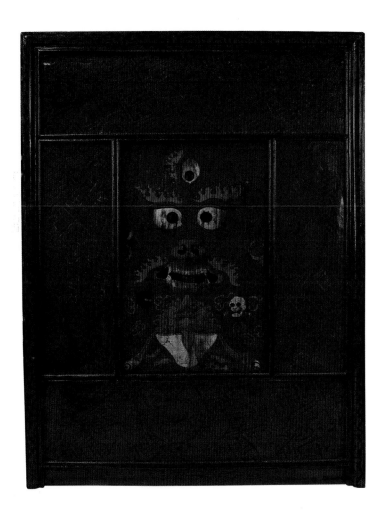

178
Painted wooden offering cabinet
84 cm x 109 cm x 22 cm 18th or 19th century

This offering cabinet is arresting because of its deep red color and the fierce, disembodied features that stare out of the single door in the center. Behind the door there are narrow shelves for placing butter offerings.

On the panels around the door is a lattice pattern with cloud designs superimposed; originally this was gilded, although the gilding has faded somewhat. Along the base panel there are several skullcap bowls on top of the lattice background.

The painting on the central door is of a higher standard than the surrounding panels and seems to have been done by a different artist, probably a *thangka* painter brought in to do the job of painting the representation of a deity. Unlike decorative painting, this type of painting cannot be left to chance or to the unskilled since the proportions of the painting need to be right if it is to serve its purpose. In this case a fierce face has been painted in the center, with piercing eyes and eyebrows resembling flames.

In front of the face is a skullcap bowl containing a Fierce Offering of the Five Senses (facing), a suitable gift for a fierce deity, consisting of the heart, ears, tongue, eyes, and nose of a sacrificial victim. Offerings of this type are frequently painted on offering cabinets and offering *thangka* from protector-deity shrines. They are also sometimes represented in three-dimensional form as butter sculptures, which may be housed inside the cabinet. Just above the fierce offering is a severed head and a skull, the latter with eyeballs trailing whimsically from their sockets.

The style of drawing of the skull and other details, the precise calligraphic line of the central decoration, and the gold-on-red lattice suggest an eighteenth- or nineteenth-century date for this cabinet.

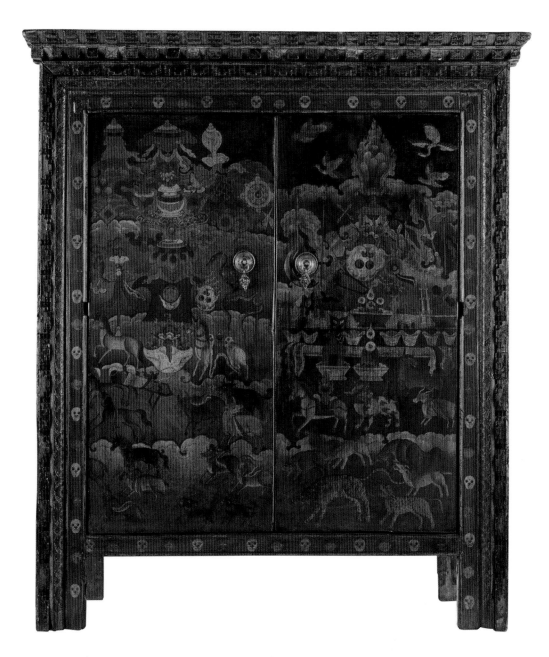

179
Painted wooden offering cabinet
92 cm x 105 cm x 50 cm 19th century

This is an unusually fine offering cabinet, set apart from other furniture of this type by the high standard of the painting on the doors. The cabinet has two doors set in a frame, resembling a miniature version of the double doors of a temple, and opened by means of two silver pulls. The doors have been covered with sized cloth, on top of which paint has been applied; the texture of the cloth can still be seen in the painted surface.

The painting depicts lively scenes similar to those more commonly found on scroll paintings of the Host of Ornaments type (facing). Each door is painted with the key attributes of a fierce protector deity, together with a group of offerings. These images are intended to summon the deities to the chapel and to appease them with offerings. Each painted door is, in effect, a stage set awaiting the entrance of the principal player.

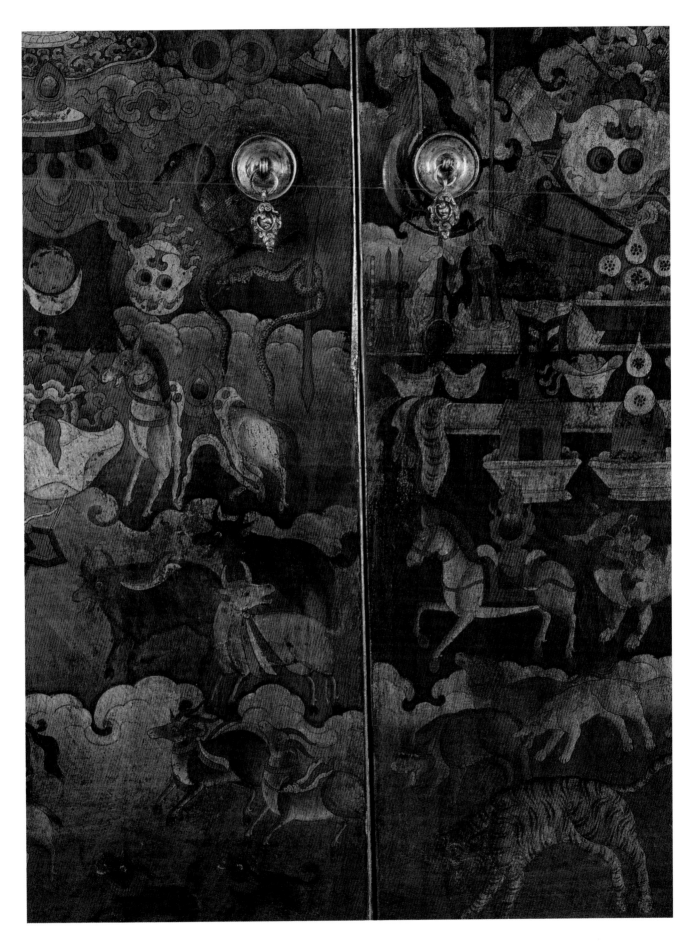

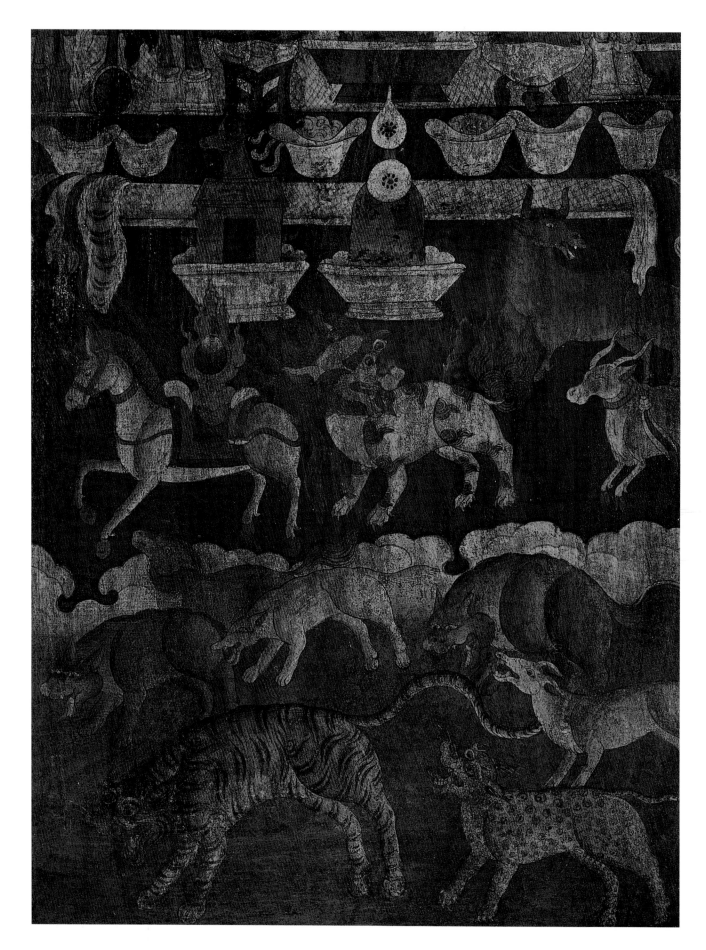

The left-hand door presents most of the attributes of Palden Lhamo, the protectress of Lhasa. Certain unique objects serve to identify her, including the halo of peacock feathers above her head and the ball of multicolored sacred threads that she uses as a weapon against her enemies. There are two horses in the middle of the scene, one of which carries a precious jewel on its saddle. Below the horses is a group of various animals with ribbons around their necks, galloping across the foreground, with mouths open with wild and amusing expressions. These animals and the horses are probably intended as additional offerings to the goddess.

The deity summoned by the right-hand door (facing) is more difficult to identify from the attributes, but he is probably Pehar, another important protector. Pehar's attributes include an armored hat, a lance with a banner attached, and a bow and quiver, all of which can be seen on this door. Pehar's usual mount is a snow lion and one can be seen in the middle about half way down the painting. Besides these attributes there is also a group of various offerings of near the middle of the painting, with one such offering consisting of a skullcap bowl filled

with sense organs (similar to an offering on Palden Lhamo's side). At the bottom of the painting is also a group of ferocious animals, including a fine snarling tiger.

Both Palden Lhamo and Pehar have special importance in the Tibetan capital, Lhasa. The state oracle, who lived at the nearby monastery of Nechung, was a spirit medium who was possessed by the spirit of Pehar during certain ceremonies designed to summon him. In this state he would make predictions about the future that were carefully considered before decisions were made on Tibetan affairs of state. Both Pehar and Palden Lhamo were adopted as personal protector deities by the Fifth Dalai Lama during the seventeenth century and they have played a major part in Gelug ritual and offerings ever since. It is likely therefore that this cabinet originated in a Gelug establishment in the Lhasa area.

This cabinet, like others of its kind, was intended to contain butter sculpture offerings within a protector-deity chapel; however, in this case it is arguable that the most potent offering is actually the painting on the doors.

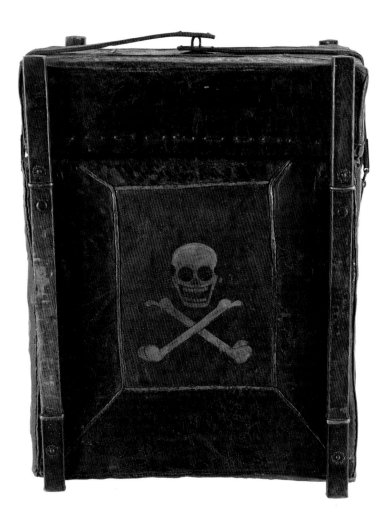
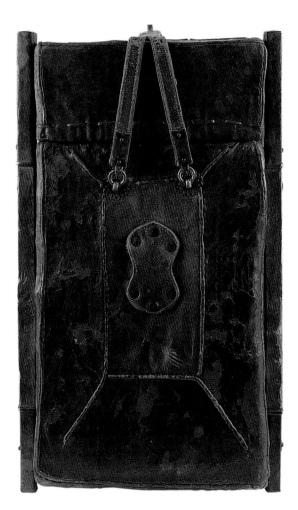

180
Leather box with wooden struts and painted decoration
44 cm x 55 cm x 32 cm 18th century or earlier

This unusual leather box is made from yak hide, reinforced with wooden struts at all four corners. The struts are bound in brass at the top and bottom, where they serve as feet, lifting the leather just clear of the ground. The lid, which lifts free of the chest, is secured by straps fixed at the sides and fastened onto a plate at the top, presumably using a pin or a lock, now missing.

The outer part of the box is made of dark-colored hide, while the inner panels are made of a lighter brown hide. The inner panels are painted on three sides. The front side is painted with skull and crossbones (facing), while the sides are painted with skeletal limbs.

Judging by its macabre imagery this box was likely used in the chapel of a protector deity. It was probably specially made to hold some ritual implement or clothing item, although exactly what is not known. Dating this box is difficult since there is so little decoration to base an assessment on; however, the restrained and sparse rendering suggests a date from no later than the eighteenth century and maybe considerably earlier.

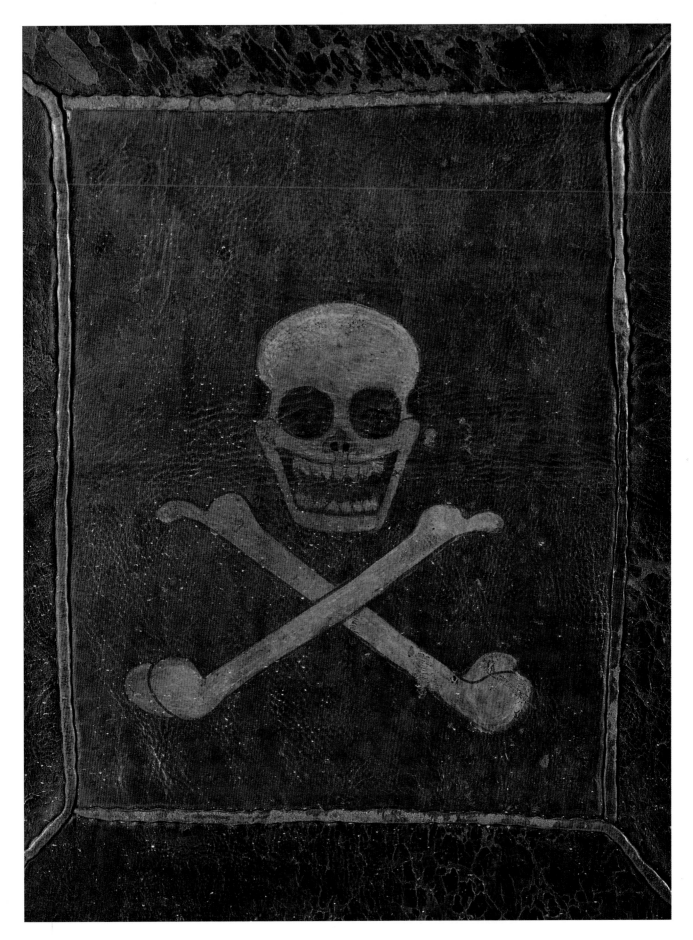

Protector Shrine Furniture

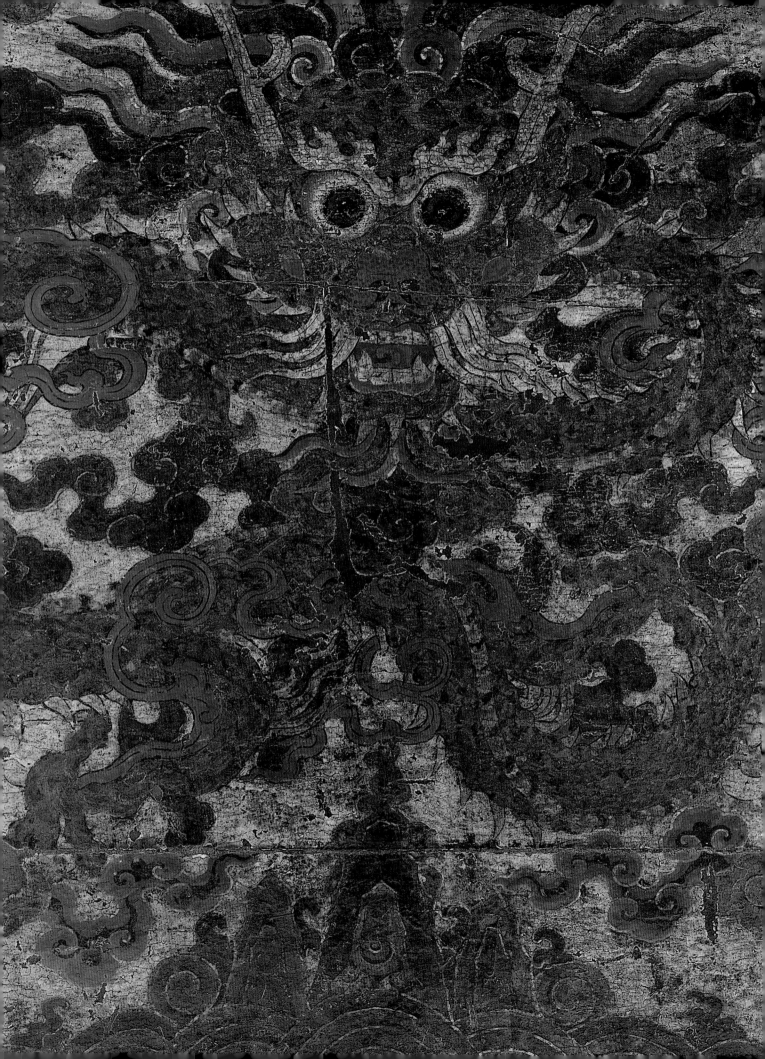

APPENDICES

GLOSSARY

Avalokiteshvara (Sans): the bodhisattva of compassion; **Chenrezig** (Tib); **Guanyin** (Chin)

bodhisattva (Sans): an enlightened being who has chosen to remain in the earthly realms to help others

Bon (Tib): indigenous Tibetan religion with many parallels to Tibetan Buddhism

Buddha (Sans): a being who has achieved a state of perfect enlightenment

Buddha, the: Gautama, or Shakyamuni (fl. 6th c BC), the historical Buddha, considedred the founder of Buddhism in our era

chagam, also **chakam, chakkam** (Tib): a storage chest or cabinet

chiru (Tib): Tibetan antelope

chakravartin (Sans): literally, "one who turns the wheel of the law" an ideal monarch, who rules over a perfect world

choktse, also **chogtse** (Tib): a small table. Also encountered in the honorific form **shöchok**

chösum, also **chösom** (Tib): a shrine cabinet or support for offerings, used in homes and temples

chuba (Tib): a cloak

chorten (Tib): a reliquary mound, typically conical or bell-shaped and painted white; a **stupa** (Sans)

Citipati (Tib): a fierce, skeletal deity and member of the retinue of Mahakala

coin design: an ancient design made by drawing overlapping circles, sometimes used for borders and lattice decoration on Tibetan furniture

damaru (Sans): a small drum used by Tibetan monks, also portrayed carried by some Buddhist deities

Daoism: from **Dao** (Chin), meaning "way," a Chinese philosophy originated by Laozi (6th c BC) for self-cultivation and governance of society

denkya, also **dentie** (Tib): a carpet platform for sitting, found in homes and monasteries

Dharma (Sans): the teachings of the **Buddha,** often symbolized by the **khorlo,** or Dharma wheel

dharmapala (Sans): fierce deities who protect the Buddhist law, or **Dharma**, and by extension religious orders and lay believers

dhoti (Sans): an Indian waist garment

dorje (Tib): a thunderbolt, symbolizing skillful means, compassion, and the male principle; **vajra** (Sans)

drilbu (Tib): a ritual bell symbolizing wisdom and the feminine principle; **ghanta** (Sans)

drokpa (Tib): a nomad, one who makes a living by tending animals and who follows an annual migration between traditional pastures

druk (Tib): a sky dragon, associated with thunder and clouds

dukhang (Tib): the assembly hall of a monastic establishment, usually the largest chapel

Fierce Offering of the Five Senses: a symbolic offering to the gods of the five human sense experiences, usually represented by five sense organs, in a skullcap bowl

flaming jewel: a symbolic offering in the form of a gem with flames surrounding it

frame and panel: a technique of cabinet construction in which the sides of the cabinet are constructed from panels set into frames, in the same way that glass is held in a picture frame

gandi (Sans): staff used to enforce monastic discipline, also portrayed being carried by **Mahakala; beng** (Tib)

gyachok (Tib): a square table

gam (Tib): a chest

Gelug (Tib): the dominant, so-called Yellow Hat sect of Tibetan Buddhism

gonkhang (Tib): a chapel dedicated to a fierce deity

guru (Sans): a spiritual teacher or master; **lama** (Tib)

Gurgyi Gonpo (Tib): a popular form of **Mahakala,** revered throughout Tibet

gyantshog (Tib): Called the Host of Ornaments, a design that portrays the characteristic attributes of a deity in order to entice the deity to appear and to reside there

Han (Chin): the majority ethnic group in China

Jambhala (Sans): an Indian god of wealth

Kalajambhala (Sans): fierce form of the wealth deity **Jambhala**

kang (Chin): a raised, heated platform in a home, found in northern China and northeastern Tibet

kang seng (Tib): snow leopard, native to the Himalayas and still found in the wild

kedi, also **keti** (Tib): Lhasa Tibetan term for a Chinese silk brocade with a squares-and-roundels design

key fret: an angular meander pattern, usually found as border design

khata (Tib): scarf, typically yellow or white, proffered or left as an offering to a revered image or person

khorlo (Tib): an eight-spoked wheel symbolizing the Buddhist teachings, or **Dharma,** and an early symbol of the **Buddha** himself; also found as an attribute of some deities in the Bon tradition

khora (Tib): the pilgrim's route around or through a temple or holy site

lama (Tib): a senior monk and teacher, equivalent to a **guru** (Sans)

lingzhi (Chin): a special fungus reputed to confer immortality

Losar (Tib): the Tibetan New Year and its associated celebrations

Mahakala (Sans): an important Tibetan protector deity; **Gonpo** (Tib)

Mahasidda (Sans): an ancient Indian sage, one of the originators of Tantric Buddhism

Mahayana (Sans): literally Great Vehicle, the form of Buddhism prevalent in China, Korea, and Japan

makara (Sans): a dragonlike creature with a nose like an elephant trunk and a foliate tail

Manjushri (Sans): the bodhisattva of wisdom

mantra (Sans): sacred words repeated many times by a worshipper to gain merit

Ming (Chin): Chinese dynasty (1353–1644)

naga (Sans): a dragon or snake associated with water

namchu wangdan (Tib): a symbol composed of merged Sanskrit syllables, symbolizing the Kalachakra Buddhist teachings

nirvana (Sans): the ulimate state and goal of Buddhist practice, described as transcending the endless cycle of rebirth

norbu (Tib): a jewel

norbu gakyil (Tib): a jewel disc; a swirling disc symbol with two, three or four sectors, resembling the **taiji** (Chin), sometimes called the yin-yang, symbol

norbu membar, also **norbu mebar** (Tib): a cluster of flaming jewels

nyma dawa (Tib): a sun and moon symbol, found over doorways in Tibet and also over the head of the **zeeba**

Palden (also **Penden**) **Lhamo** (Tib): an important Tibetan protector goddess and in particular the fierce protectress of Lhasa; ; **Sri Devi** (Sans)

pegam (Tib): a small desk specially designed for holding sutras while reading them

pema (Tib): a lotus, one of the Eight Precious Objects, or **tashi dargye**

prayer flag: a flag printed with prayers, which are transmitted to the deities as it flutters in the wind

prayer wheel: a wheel containing written prayers, which are transmitted to the deities as the wheel turns

protector deity: a god who provides protection from evil and danger to individuals or institutions

qilin (Chin): a mythical animal made up of parts of a stag, wolf, and horse, with a single horn

Qing (Chin): Chinese dynasty (1644–1911)

rank badge: a badge denoting rank worn on ceremonial clothing at the Chinese court

Rigsum Gonpo (Tib): a group of three popular protector gods (**Manjushri, Avalokiteshvara,** and **Vajrapani**) often depicted together

ruyi (Chin): an auspicious scepter with a curled shape resembling a fleur-de-lis; the word literally means "as you wish," suggesting the fulfillment of desires

Sakya (Tib): one of Tibet's Buddhist monastic orders

Sangha (San): the Buddhist community, made up of the various orders of monks and nuns and the lay believers they serve

Shakyamuni (Sans): literally, the Sage of the Shakya (clan), the name given to the historical **Buddha,** Gautama

senge (Tib): the snow lion, a favored mythical animal in Tibetan decorative arts

shizi (Chin): a "lion-dog," often seen in in sculptural pairs as sentry animals

shou (Chin): "long life," written with a character often used as a design motif

Shou Lao (Chin): the god of longevity, usually represented as an old man with a long beard and high forehead

shrine cabinet: a cabinet for holding statues and other images of gods and religious teachers

sloping-sided chest: a style of chest in which the sides have an inward slope

Song (Chin): Chinese dynasty (960–1279)

straight-sided chest: a style of chest in which the sides are parallel and perpendicular to the base

sutra (Sans): a religious text

tak, also **da** (Tib): the tiger, whose association with strength and power is represented in tiger designs and pelts

Tantra (Sans): a canonical text relating to Tantric Buddhism

Tantric: an esoteric school of religious practice, associated with meditation and visualization methods that offer practitioners a more rapid route to enlightenment

Tantric Buddhism, also **Tantrayana, Vajrayana:** the form of Buddhism prevalent in Tibet

Tara (Sans): a peaceful bodhisattva popular in Tibet

Tashi Dargye (Tib): the Eight Precious Objects, a group of auspicious symbols often found incorporated in Tibetan decorative designs

tepchok, also **tepchog** (Tib): a small folding table

tergyi bumpa (Tib): a treasure vase, held by some Tibetan gods and by sages

thangka (Tib): a portable religious painting on cloth

Theravada (Sans): the "teachings of the elders," a form of Buddhism prevalent in Southeast Asia

torana (Tib): archway over a portal leading to a space containing a sacred image

torgam, also **torkam** (Tib): a cabinet for housing butter sculpture offerings

torma (Tib): a sculptural offering to the gods made from flour and butter

thrichok (Tib): a throne table, a high table used by a **lama** seated on a high throne or platform

triple gem: a symbol consisting of three jewels, representing the **Buddha,** the **Dharma** (the Buddhist teachings) and the **Sangha** (the Buddhist community)

tsampa (Tib): barley flour mixed with butter or tea, a staple of the Tibetan diet

Vaishravana (Sans): a god of wealth, important protector god, and king of the northern direction; **Namtse** (Tib)

vajra (Sans): the thunderbolt: a symbol of Tantric Buddhism; **dorje** (Tib)

Vajrapani (Sans): one of the Three Protectors, or **Rigsum Gonpo;** his Tibetan name, **Chana Dorje,** means Thunderbolt Holder, and he carries this ritual implement in his right hand

wanzi (Chin): a lattice design composed of linked swastikas

wrathful deities: those portrayed with horrific features, who are enemies of all foes of Buddhism, including human attachment to the self and its desires

Xixia (Chin): a people of Tibetan stock and their kingdom, centered around present-day Gansu and conquered by the Mongols in the 13th century

yak (Tib): a large, long-haired wild or domesticated ox native to Tibet and elevated parts of Central Asia

Yama (Sans): a protector god with dominion over death

Yuan (Chin): Chinese dynasty (1279–1353)

yundrung (Tib): a swastika, depicted rotating counterclockwise in the **Bon** tradition, predominantly clockwise in the Buddhist tradition

zeeba (Tib): a fierce disembodied face with tendrils of foliage issuing from its mouth

zhongpa rinpoche (Tib): a tray of jewels, often depicted in Tibetan paintings

RECOMMENDED READING

This list includes books and articles mentioned in the Introduction as well as others recommended as background reading on Tibetan art and culture.

TIBETAN HISTORY

A Cultural History of Tibet, by David Snellgrove and Hugh Richardson, 2nd ed. (Boston: Shambala Publications, 1995).

Lhasa in the Seventeeth Century, edited by Françoise Pommaret-Imaeda (Boston: Brill Academic Publishers, 2003).

TIBETAN ART

Art of Tibet, by Robert E. Fisher (London: Thames & Hudson, 1997).

The Encyclopedia of Tibetan Symbols and Motifs, by Robert Beer (London: Serindia Publications, 1999).

Tibetan Art: Towards a Definition of Style, edited by Jane Casey Singer and Philip Denwood (London: Laurence King Publishing, 1997).

Tibetan Art: Tracing the Development of Spiritual Ideals and Art in Tibet, 600–2000 AD, by Amy Heller (Milan: Editoriale Jaca Book, 2000).

The Tibetan Carpet, by Philip Denwood (London: Aris and Phillips Ltd, 1974). *Tibet: Tradition and Change*, by Pratapaditya Pal, et al. (Albuquerque: The Albuquerque Museum, 1997).

Wisdom and Compassion: The Sacred Art of Tibet, by Marylin M. Rhie and Robert A. F. Thurman (New York: Tibet House, 1996).

Worlds of Transformation: Tibetan Art of Wisdom and Compassion, by Marylin M. Rhie and Robert A. F. Thurman (New York: Tibet House, 1999).

CHINESE AND CENTRAL ASIAN TEXTILES

Heaven's Embroidered Cloths: One Thousand Years of Chinese Textiles, by Chris Hall, et al. (Hong Kong, Urban Council of Hong Kong, 1995).

Traditional Textiles of Central Asia, by Janet Harvey (London: Thames & Hudson, 1996).

Treasures in Silk: An Illustrated History of Chinese Textiles, by Feng Zhao (Hong Kong: ISAT/ Costume Squad Ltd, 1999).

When Silk Was Gold: Central Asian and Chinese Textiles, by James C. Y. Watt, et al. (New York: The Metropolitan Museum of Art, 1997).

TIBETAN FURNITURE

"Painted Tibetan Furniture," by Tony Anninos, 1997. *Arts of Asia* 27 (1997) n. 1:47–65.

"Ritual Furniture from Tibetan Protector Deity Shrines," by Christopher D. Buckley, *Proceedings of the Second International Conference on Tibetan Archaeology and Arts (ICTAA II)*, Beijing, 2004.

"Tibetan Leather Boxes," by Tony Anninos, 2000. *Arts of Asia* 30 (2000) n. 1:101–7.

Wooden Wonders: Tibetan Furniture in Secular and Religious Life, by David Kamansky (Chicago: Serindia Publications, 2004).

INDEX

influence of, viii, 132, *133*, 140, *141*
chagam (chests, cabinets), 29
chairs, 24, 25
chakravartin (ideal king), 93
charnel grounds, 102, 107, 198
chests (*gam*), x, *xi*, 8, *16*, 29–37, 112–65
 Bon, 5, 69
 cabinets and, 180
 construction of, 14, *15*, 113, 116, 142, 148, 189
 decoration on, *18*, 29, 33–34, 53–54, 59, 60, *62*, 65, 66, 81, 82, 90
 from eastern Tibet, 43, 122, 128, 136, *137*, 142, 144, *145*, *146*, 147, 148
 fabric-covered, 33, 60, 117, 119, 123, 124, 130, 132–35, 148, 149, 154, 156, 161, 164
 in *gonkhang*, 109, 160
 large storage (*gam*), 22
 leather, *28*, 54, 59, 60, 82, 212–13
 leather-covered, *36*, *37*, *62*, 117
 modern, 46
 pairs of, 121, 126, 128, 129, 139, 144
 portable, 19, 20, 46, 54
 scalloped-lid, *32*, 33, 43, 44
 sloping-sided, 32–34, 43, 44, 53, 116, 143, 149, 150, 153, 156, 160
 small, 189, 212–13
 straight-sided, 33–34, *35*, 43, 44, 53, 161
 for *thangka*, 34, 122
China, 9, 26, 37, 93, 174
 chairs in, 24
 dragons in, 58, 72, 75–78
 textiles from, 50, 52, 58, 60, 62, 65
 trade with, 50, 52, 57–58
 western, 2, 43, 58, 82
 Yuan, 52, 57, 76, 117, 124
 see also Ming dynasty
Chinese characters, 52, 68, 88, *172*, *173*, 175, 183
Chinese influence, x, xi, 14, 16
 on cabinets, 184–85
 on chests, 116, 117, 124, 131, 136–39, 144, *145*, 155, 161, 163, 189
 on design motifs, 43, 50, 52, 53, 56, 57–58, 64, 68, 71–72, 86, 89–90
 on reading desks, 187
 on tables, 168, *169*, 171, 174
Chinese opera, 161
chiru (antelope), 149, 150, *151*
choktse (low table), 22, 25–28, 46, 175
chorten (*stupa*; reliquary structure), 5
chösum see cabinets: shrine
chuba (cloak), 58, 82
circumambulation, 5, 178
Citipati (god), 96
cloud motifs, 65, 161, 166, 187, 192
 on chests, 116, 124, 131, 143, 149, 156, *157*
 on offering cabinets, 195, 206, 207

coin motifs, *vii*, *52*, 59, 72, 180
 on chests, 113, 114, 117, *138*, 139
 on reading desks, 187, 188
conch motif, 66, 70, 72, 117
 see also Eight Precious Objects
construction techniques, x, xi, 14–18
 for cabinets, 14, *15*, 179, 181, 183, 201
 for chests, 14, *15*, 113, 116, 142, 148, 189
 frame-and-panel, 14, *15*, 113, 121, 166, 181
 modern, 46
 by region, 43–44
 for tables, 166, 167, 168, 171, 175, 178
Cultural Revolution, 161

D

Dalai Lama, Fifth, 211
dating
 of chests, 33, 34, 37
decorative motifs and, x, xi, 65, 72, 90, 109
 ironwork and, 53
 methods of, x–xi, 16, 17
 of modern furniture, viii, 46
decoration, 2, 49–94
 on cabinets, 17, *28*, 37, 54–56
 carved, *18*, 54, *73*
 on chests, *18*, 29, 33–34, 53–54, 59, 60, *62*, 65, 66, 81, 82, 90
 color in, 17, 50
 dating and, x, xi, 65, 72, 90, 109
decorative designs as, 50–52
 function of, 53
 genre scenes as, 161
 influences on, x–xi, 50–58, 140, *141*
 modern, *44*, 46, *46*
 painted, 16–18, 29
 patterns in, 59–93
 on prayer wheels, 41
 regional, 43, 44, 46
 religious, 50, *51*, 66, 68, 69, 70, 79, 82, 83, 85
 symbols as, 50, *51*, 52–53, 66–76
 see also particular motifs and techniques
deer, 93, 162–63, 184, 186, 194
 longevity and, 86, 87
 at Sarnath, 70, 85, 149
 wheel and, 85, 86, 88
 see also animals: antelopes
denkya (carpeted platforms), 24, 25
Dharma wheel *see* wheel (*khorlo*) motif
dharmapala see gods, wrathful protector
disc, swirling (*norbu gakyil*), 68–69, *71*
 on chests, 112, 115, 119
 on tables, 168
dorje (scepter) motif *see vajra*
Dorje Rabtenma (Palden Lhamo), *104*, 107
dragons (*druk*), 50–54, 64, 66, 72–76, 194

regional styles in, 42–46
Mongols, 52
 see also Yuan dynasty
mongoose, jewel-spitting, 90, *91*, *92*, 156–60, 191
Mount Meru, 136, *137*
Mughal period (India), 58
murals, xi, *4*, 16, 75, 196
 chests in, 29, *31*
 decorative influence of, 50, 52, 140, *141*
 gods in, *11*, 98, 99
 western-Tibet style, 44, 46
Muslims, 52, 173
Mustang (Nepal), 2, *21*, 103

N

naga (water serpent), 72
namchu wangdän (Kalachakra symbol), 192, 194
Nechung Monastery, *7*, 46, *81*, 211
Nepal, 2, *21*, 83, 85, 103
 influence of, 16, 46, 50, 57, 64, 140, *141*, 173
New Year, Tibetan, *7*, *11*, 41, 96, 104
Newars, 57, 140, *141*, 173
nomadic lifestyle, 18–19
norbu see jewel (*norbu*) motifs
norbu gakyil see disc, swirling
nyma dawa (sun and moon symbol), 82–83

O

offerings, 69, 103, 200, 201, 203
 see also cabinets, offering; Fierce Offering of the
 Five Senses

P

Padma Sambhava, 193
paint, 16–18
 gold, x, 17, 156, *157*, *182*, 183, 188, 200
paintings, xi, 16, *44*, 96
 decorative influence of, 50, 52
 Host of Ornaments type, 46, 107, *109*, 208–11
 see also murals; *thangka*
Palden Lhamo (Sri Devi; goddess), 99–100, 107, *109*, 211
paradises, 93, 152
pegam see reading desks
Pehar (god), *viii*, 211
pema see lotus (*pema*) motifs
peonies, 136–39, 143, 154, 181
pilgrimage, 6, 41
Piyang Monastery, 44
platforms, carpeted (*denkya*), *24*, 25
porcelain, 52, 57, 58, 64, 86, 89
 blue-and-white, 72, 117
 dragons on, 75, 76
prayer, 6, 41

prayer flags, 20, 40, 164, 186
prayer wheels, 22, 38, 39–41, 53, 191–93
Purang, *20*

Q

Qidan culture, 52
qilin (mythical beast), 53, 155
Qing dynasty (China), 57, 77, 93, 136, *137*
Qinghai (China), 2, 43, 58

R

reading desks (*pegam*), 22, *24*, 40, 44, 93, 186–89
 sutras and, 25, 38
red-and-gold style *see* gold-on-red technique
Red Tara (goddess), 193
regional styles, 42–46
religious furniture, 22, 38–42
repairs, 16, 17, 170
 on cabinets, 183, 195
 on chests, *134*, 135, 189
Rigsum Gonpo (three protector gods), 41, 191
ruyi (scepter) motif, *52*, 72, 126, 153, 189, 194
 on tables, 168, *169*, 174

S

Sakya Monastery, 42, 99, 174
Sakya monastic order, 6
Samye Monastery, *104*
Sassanian culture, 52
scalloped design, 195
 on chests, 115, *134*, 135, 143, 149, 150, 153, 155,
 162–63
 on lids, *32*, *33*, 43, 44
scepter *see ruyi*; *vajra*
senge see snow lions
Sera Monastery, 42
Shakyamuni *see* Buddha
Shalu Monastery, *4*, *11*, 29, *31*, *104*, 107
 dragons in, 73, 75
Shigatse Monastery, 42, 43, 46
shizi (lion dogs), 79, 184
shöchok (low table), 22, 25–28, 46, 175
shou see longevity
Shou Lao (god of longevity), 86, 87, 93
Sichuan (China), 2, 43, 58, 82
Siddhartha *see* Buddha
silk, 50, 52, 57–59, 61–64
 see also textiles
Silk Road, 6, 29, 52
skulls, 100, 109, 212, *213*
 on offering cabinets, *106*, 107, 196, 198, *199*, 204–7
 offerings in, 201, 203
 see also bone palace; Fierce Offering of the Five Senses

deer and, 85, 86, 88
see also prayer wheels
White Tara (goddess), 193
windhorse, 40
women, 103, 161
wood, re-use of, x, 2, 14

Floating World Editions
publishes books that contribute to a deeper understanding
of Asian cultures. Editorial supervision: Ray Furse.
Book and cover design: Liz Trovato. Proofreading:
Mike Ashby. Indexing: Edindex. Production supervision:
Bill Rose. Printing and binding: Oceanic Graphics, Inc.
The typefaces used are Goudy and Agenda.